See What You're Missing

By the same author

Think Like an Artist
What Are You Looking At?

See What You're Missing

Thirty-one Ways Artists Notice the
World – and How You Can Too

WILL GOMPERTZ

VIKING
an imprint of
PENGUIN BOOKS

VIKING

UK | USA | Canada | Ireland | Australia
India | New Zealand | South Africa

Viking is part of the Penguin Random House group of companies
whose addresses can be found at global.penguinrandomhouse.com.

Penguin
Random House
UK

First published 2023
001

Copyright © Will Gompertz, 2023

The moral right of the author has been asserted

The picture credits on page 319 are an extension of this copyright page

Set in 13.5/16pt Garamond MT Std
Typeset by Jouve (UK), Milton Keynes
Printed and bound in Great Britain by Clays Ltd, Elcograf S.p.A.

The authorized representative in the EEA is Penguin Random House Ireland,
Morrison Chambers, 32 Nassau Street, Dublin D02 YH68

A CIP catalogue record for this book is available from the British Library

ISBN: 978-0-241-31546-0

www.greenpenguin.co.uk

To my late parents, Frances Gompertz and Dr Hugh Gompertz, who dedicated their professional lives to the NHS, and their spare time to keeping the show on the road at home – always with love and kindness.

Contents

CONTENTS

Illustrations

Colour Plates

Introduction

The idea for *See What You're Missing* began with an unsolicited email, sent by a man called Tom Harvey, asking me to speak at an event for creative folk in Soho, London. I was working for the BBC as an arts journalist and presenter at the time, a job that generated frequent requests from viewers and listeners inviting me to judge an art competition or give a talk. I accepted as many as I could, but had recently promised my publisher that I wouldn't take on any more extra-curricular work until I had at least started writing my long-promised book on perception. In truth, the commitment to focus on the book was a stalling device. I hadn't actually formed a concrete idea about what to write on the topic of 'seeing', but I knew it was a rich subject that could be wonderfully enlightening if only I could find the right way into it and overcome the dreaded 'writer's block'.

I wrote back to Tom and declined his kind invitation to speak. I explained that, with regret, I had to say no on this occasion because I was spending every spare minute of my day gathering myself for an as yet unwritten, or fully conceived, book about art and observation.

'Fair enough,' came Tom's gracious reply.

The following day he sent me another email, in which he included the photograph below:

The sculptor Mark Harvey with his young son Tom

And in the accompanying text he wrote:

I found the attached picture the other day, taken in the early sixties, of dad and me on the beach. I send it because, for me, it's a lovely reminder of an aspect of some artists, the ability to see differently. Dad was a sculptor, he was ambidextrous and could write in mirror writing with either hand. His stance in the picture is his beach stance. He would always find the best shells and pebbles and washed-up bits of interesting stuff, and I never did. I was so fascinated by his ability to see things where others can't that I would insist on walking along the beach a yard ahead of him so I would

have the best chance of finding the best stuff. I can still remember the frustration at his exclaiming 'Oh look at this!' as he found some fascinating shell that I had passed by seconds before.

It was a lovely note to receive. It was also inspiring. Tom's story opened my eyes to what it was I wanted to explore and understand about art, perception and us. Namely, there is so much to learn from artists about noticing the everyday moments of beauty and wonder that are all around but routinely pass us by. With the help of some great painters and sculptors, we too could become more sensitive, more aware, and more conscious. Those invisible blinkers of presumption that narrow our point of view to something approaching tunnel vision could be removed. In short, we could turn to artists to help us see what we are missing.

Tom's dad isn't an outlier; all artists are expert lookers. They make it their business to visually interrogate the world and all that is in it: the people, the places, the things. Artists are the 'wise old fish' in the allegorical story told by the American author David Foster Wallace at a Commencement Speech he gave at Kenyon College, Knox County, Ohio on a hot summer's day in 2005.

After inviting the graduating students to perspire as much as he intended to (he was a notoriously nervous public speaker), the writer launched into his tale about two young fish swimming in a river. After a little while they passed an older fish going in the opposite direction,

who said, 'Morning boys, how's the water?' The two young fish carry on for a while before one turns to the other and says, 'What the hell is water?'

The wry anecdote was designed to provoke a group of Liberal Arts students, brought up on a high-fibre diet of critical thinking, to apply their analytical skills to the seemingly boring but in fact essential and important stuff concerning our quotidian existence: the supposedly dull realities of our daily lives that had been rendered invisible to them by their highly educated minds. The point being that they, *we*, live our lives in a semi-conscious state for much of the time, going from one routine event to another with our senses suppressed like zombies in a world of the undead. We don't notice the beautiful pebble on the beach, because – like those vacant young fish – so often we are oblivious to our surroundings. But that doesn't have to be the case; it doesn't have to be our partial reality. We can master how to look and experience the world with an artist's heightened awareness: to have the exhilaration of seeing the world with true twenty-twenty vision.

Of course, there are already hundreds of books about how to look at paintings, from John Berger's famous *Ways of Seeing* to Peggy Guggenheim's gloriously candid autobiography *Out of This Century: Confessions of an Art Addict*. There are also many books about art and perception, with Ernst Gombrich's *Art and Illusion* among the best I've read. But there are possibly fewer books

4

combining elements of both approaches – not only to explore how looking can add to our appreciation of artists, but also to explore how artists look, adding to our appreciation of life.

Familiarity doesn't so much breed contempt as cause a form of blindness, where we stop seeing our surroundings. Siegfried Kracauer, the twentieth-century German film critic, knew this. He wrote in his book *Theory of Film* (1960): 'Intimate faces, streets walked day by day, the house we live in – all these things are a part of us like our skin, and because we know them by heart we do not know them with the eye.'

The tree, the building, the colour of a road all become inconspicuous, not registering in our consciousness. We miss so much. Artists do not. They see with an 'innocent eye', as John Ruskin, the Victorian art critic, put it. They learn to unlearn: to see as if for the first time rather than the umpteenth. Tom's dad did just that. He paid attention, focused his mind, and lived in the moment. He taught his son to see what he was missing. It is a gift that many other artists can give: to show us how to look at our world from a different perspective, and in so doing – over time – find our very own 'beach stance'.

Before we meet them, a brief note on the book's structure and my choices of artist. The starting point for each chapter is an extraordinary painter or sculptor. It might be a contemporary star like Jennifer Packer, or a prehistoric Mexican master – either way it is an artist I admire

whose highly developed powers of observation can prompt us to see the world afresh. In each case I focus on a single work to begin a journey into the artist's mind and discover their unique way of looking, which, when applied to our own existence, stimulates our senses, heightens our perception, and encourages us to open our eyes fully.

David Hockney: Seeing Nature

Most people don't look much. Looking
is hard work. You're always seeing
more. That excites me.
There's beauty in everything, even
a bag of rubbish. But you really
have to look.

It is mid-January 2012. David Hockney is standing in the central gallery of the Royal Academy in London. He is seventy-four years old and is dressed in a loose-fitting grey suit, worn over a cream-coloured polo shirt, to which he has added a haphazardly arranged tie. If he were a door-to-door salesman you'd likely not answer his knock, but he is a famous contemporary artist and is therefore warmly welcomed wherever he goes.

He is looking at the far wall, on which hangs his colossal, billboard-sized painting *The Arrival of Spring in Woldgate, East Yorkshire* (2011). He turns to me and smiles. 'Not a bad effort, eh,' he says in that slow, wry way of his. The Bradford-born artist is not fishing for compliments or indulging in self-affirmation. He is simply pleased with

how his thirty-two-canvas painting of the woods near his Bridlington home registers when hung on the grand, mushroom-coloured walls of the RA.

It is an unbelievable work of art. By which I mean, few who have ever been to Woldgate, East Yorkshire, and felt the icy wind from the North Sea cut them in half, would immediately recognize Hockney's colourful account of his local wood. Not to begin with, at least. Violet trees and brilliant light? Come on! Soggy brown timber and slate grey skies more like. They talk of people seeing the world through rose-tinted glasses; David's are on a permanent St-Tropez setting, where everything is lit up by an explosion of bright colours in a rapturous celebration of life.

Mention this to him and he stares at you with incredulity and says it is you who are wearing the reality-warping glasses, with huge blinkers to either side to stop you seeing what is actually there. 'You haven't really looked,' he'll say. People don't – 'they scan the ground in front of them so they can move around. Look longer at something, you'll maybe see more.' It's a simple instruction that is not as easy as it sounds to carry out. Really looking is really difficult. There's a lifetime's worth of preconceptions to overcome, preconceptions that obscure. Trees are brown, their leaves are green, and paths are mud-coloured. That's how it is, the fixed image from childhood most of us have in our heads, re-enforced by everything we've seen and done since. And then one day you see a painting such as *The Arrival of Spring in Woldgate, East*

Yorkshire which offers a completely different view of reality and provokes you to look again.

I went to my local wood, and I stood and stared at the trees. They were brown, no doubt about it. And their leaves were green. And the path was mud-coloured. I could see none of Hockney's psychedelic iridescence. But I had his encouraging words ringing in my ears, to be patient: 'Trees are like faces, each is different. Nature doesn't repeat itself. You have to observe closely, there is a randomness.'

Sure enough, as I peered at a gnarly old oak tree with a wide, leathery trunk, willing it to change colour in the spirit of a Hockney painting, a ray of sunlight washed across its contorted features. And there, before my eyes, its bark turned from a mid-brown to a burnt orange to a wonderful bruised purple! Its leaves had a similar chromatic awakening, their uniform green morphing into mellow yellows and silvery greys with little golden acorns glinting on their stems like jewels. The path was still a muddy brown, but then that's like saying the Beatles were just a four-piece band. When given my full attention the path's textured personality began to emerge, too. Soon, I could see dozens of different shades of brown along its surface, the shadows caused by its undulations creating speckles of red and pink and blue, transforming a once muddy mass into an intricate pattern like a mosaic floor in a Roman villa.

There is a view among some art historians that Hockney is not as accomplished a painter as he is a draughtsman

(Paul Klee spoke of taking a 'line for a walk': Hockney takes it for a dance). The late Brian Sewell, a British art critic, described the experience of visiting Hockney's 2012 Royal Academy exhibition as 'the visual equivalent of being tied hand and foot and dumped under the loudspeakers of the Glastonbury Festival', a comment as vivid and colourful as the art he was excoriating. He thought the pictures gaudy, as in tacky and over the top. It is fair to say they are on the ebullient side, but they are not ostentatious. Not at all. They are rebellious, raucous, revolutionary: a root-and-branch reimagining of the landscape, a subject almost entirely ignored by recent generations of artists preoccupied with the mind games of conceptual art.

'They said landscape is something you couldn't do today,' Hockney mused in an interview with the Van Gogh Museum, 'and I thought, well, why? Because the landscape has become so boring? It's not the landscape that's become boring, it's the depictions of it that have become boring. You can't be bored of nature . . . can you?'

Hockney's East Yorkshire paintings are in keeping with the high-key, Matisse-inspired work he made after leaving overcast England for sun-soaked California in the mid-60s, where he discovered radiant light and acrylic paints. His intention is to bring joy into a world of misery, which is about as uncool as you can get nowadays in the art world, where sneering cynicism is routinely rewarded and applauded. That's not Hockney's game. He is too self-confident to care about being

trendy. He is a non-conformist from the tip of his half-smoked cigarette to the open toes of his leather sandals. It is his nature, it's in his blood. When he was a boy, his father, Kenneth – who, as his art-loving son would later become, was a conscientious objector – encouraged David to be independently minded and intellectually curious. 'Never pay attention to what the neighbours think,' he said. Hockney never did.

He was an openly gay student at the Royal College of Art in the late 1950s and early 60s, when homosexuality was still illegal in Britain. The codified paintings he made back then under the influence of Jean Dubuffet and Walt Whitman were audacious and subversive, cheekily tweaking the tail of a hidebound establishment. *We Two Boys Together Clinging* (1961) is the pick of the bunch, a saucy scene in a graffiti-walled lavatory rendered in oil on board. The two boys are the artist and either Cliff Richard, Hockney's favourite pop star pin-up, or a fellow student called Peter Crutch, on whom the artist had an unrequited crush. Either way, it was hot stuff for the not yet swinging sixties. It was also a long way from the formal academic painting the RCA expected its students to pursue. The faculty took a similarly dim view of his work to the one expressed by Brian Sewell all those years later: they too dismissed it as substandard, and Hockney's brushstrokes as attention-seeking daubs. Until, that is, Richard Hamilton – an avant-garde British artist whom they held in high esteem – dropped in and dished out an award to the young Hockney.

From the day he arrived at the RCA to his most recent pictures of the countryside of northern France, David Hockney has continually and compellingly explored new ways of seeing. He has dabbled in photography, set design, fax collages and photocopies. He has innovated on the iPad and toyed with perspective. He has produced etchings and made prints, presented television programmes on camera obscura, and produced multi-lens tracking shots of country roads. He has been here, there and everywhere in pursuit of one thing: the making of memorable pictures. Anybody can draw, most can paint, but very, very few can make impactful images that help us perceive afresh — images that penetrate our unconscious. Hockney can and does so frequently, which is testimony to his remarkable imagination and talent. His best pictures have a psychological charge, as is evident in his famous Los Angeles swimming-pool series of the 1960s and 70s. You could call it Neo-Impressionism: a fleeting moment distilled on to canvas to exist in perpetuity. Nowhere is his ability to capture the personal and transform it into the universal more evident than in the exceptional large double portraits he began painting in the late 60s.

Mr and Mrs Clark and Percy (1970–71), a play on Thomas Gainsborough's *Mr and Mrs Andrews* (c. 1750), is probably the most well-known of the series. It is a very good picture, but not his best. That was painted a year later. *Portrait of an Artist (Pool with Two Figures)* is the climactic apogee of the two themes for which he will

ultimately be remembered: the swimming-pool pictures and the double portraits. *Portrait of an Artist (Pool with Two Figures)* came to global prominence in 2018 when it broke the then auction record for a living artist, selling at Christie's for $90 million.

Its asymmetrical, geometric design is meticulously arranged, with every element carefully balanced and counterbalanced. A man in a pink jacket stands at the edge of the rectangular pool and looks down through the water to another man in white trunks swimming beneath the surface. They are separated by axis and environment, so close yet existing in two different dimensions. The standing man (modelled on Hockney's ex-lover Peter Schlesinger) is full of longing. The swimmer (Hockney?) is oblivious to his presence – any feelings he has are literally and metaphorically kept beneath the surface. What has happened? What will happen? The artist has thrown us in at the deep end with little to hold on to. There's only one option: to wait for this silent picture to speak.

On the warm air breezing over from the triangular hills in the distance come whispers of a story of love and loss, of heartbreak and sorrow, of redemption and friendship, of paradise and beauty. It is a terrific picture, recalling Piero della Francesca's division of space and time in *The Flagellation of Christ* (c. 1455), and Fra Angelico's two-figure masterpiece *The Annunciation* (c. 1438–47). I could list another twenty artists – from Edward Hopper to Francis Bacon – whose work echoes in this painting. But there is

only one person who could have created it: David Hockney, from whose hand, eye and heart it comes.

It is different from his later landscape paintings in style and approach. *Portrait of an Artist (Pool with Two Figures)* was not made with Hockney standing in front of his subject, but by combining two random photographs he found on his studio floor – one of a submerged figure swimming, the other of a boy peering at the ground beneath his feet. It is largely a work assembled in his imagination with the help of research photos taken in Europe.

The scene as presented to us never happened, but the elements that make up its constituent parts are all based on real experiences: Hockney's holiday in the hills of the South of France, his Californian swimming-pool, a trip to a London park with Peter. The painting represents a collection of memories capturing the reality of a moment in the artist's life when he parted from his lover. Months have been distilled into a single fabricated image that is disarmingly honest. Hockney is showing us that the act of seeing isn't always about focusing on a specific subject at a specific time in a specific place. Sometimes to really see requires gathering together multiple visual sources that can be boiled down into a single, revealing composite image, which can say more than all the others in isolation.

It is a picture-making technique into which Hockney invested a great deal of time and energy. As with everything he does, it is centred on his obsession with looking

properly. He would use a camera to take dozens of photographs of the same person or object from every conceivable angle. He would scale ladders and crawl along the ground to make sure that he had *seen* everything. Only when he was satisfied he had fully interrogated his subject would he begin to piece together a fragmented artwork made up from the multiple images.

These patchwork creations shared the same essential truth found in *Portrait of an Artist (Pool with Two Figures)*: everything we see is in context. Our two eyes immediately provide two points of view, we crane our necks to create a third and a fourth — and then we move a little. Within seconds we have undertaken a complex visual analysis of our subject. This is the reality Hockney is giving us in his composite pictures. That is why they ring true, it is what gives them their psychological power. They are not simply paintings of people and places, they are reflections on the reality of how we see.

David Hockney is in his mid-eighties now, hard of hearing and far from his physical peak. But his mind and eyes are as sharp as ever. As is his ability to see splendour in the everyday. During the early stages of the Covid-19 pandemic he sent me some joyous images he had produced of his blossoming spring garden in Normandy, France. I asked if I could post them on the BBC website. He acquiesced. Within hours millions of people had seen them, many thanking the artist for producing images bursting with life and hope at such an unsettling time. Among them was a picture of daffodils, to which

he gave the title *Do Remember They Can't Cancel the Spring*, a satirical comment on the global lockdown and nature's glorious indifference. It was typical of Hockney and his optimistic, idiosyncratic way of viewing the world. The yellow-headed daffodils are the size of trees in the foreground, dominating the purple hills in the distance. They appear to move in front of your eyes like a chorus line in a 1920s Parisian nightclub, swinging their limbs in time to the tune of spring. Where you or I might see a pleasant bunch of seasonal flowers, he observes nature at her dramatic best – full of irrepressible life and resplendent in brilliant colour. He has taken the time to have a proper look, not give a cursory glance, his investment handsomely repaid by the revelation of transcendent beauty. It is all the evidence you need to know that there is much to be gained from taking his advice to 'look longer'.

John Constable: Seeing Clouds

> Boats sail on the rivers,
> And ships sail on the seas;
> But clouds that sail across the sky
> Are prettier far than these.
> — *Christina Rossetti*, 'The Rainbow'

Clouds are like estate agents, they get a bad rap. They are forever being used as the default metaphor for negative situations. If things aren't looking too good – there's a cloud on the horizon, or, if more ominous, the storm clouds are gathering. Unable to think clearly? Something must be clouding your judgement. Look guilty and you'll be under a cloud of suspicion. Lose all your digital data and you're sure to blame the Cloud. The only good thing about a cloud is its silver lining, but that's not a cloud, it's the sun glinting behind. The sun is the good guy, the cloud is an obstructive nuisance.

We are indoctrinated with this downbeat attitude towards clouds. They are the villains in the daily weather report. Sunny days are 'beautiful', cloudy days are 'miserable'. And that is not good if you happen to live in

England, as I do. It means the majority of the year is spent struggling through one grey-day downer after another, with a couple of weeks of respite in August when the sun is so hot you can't go outside.

That's life, or so I thought. But then, one cloudy day, I found myself in the Ashmolean Museum in Oxford (avoiding the overcast weather outside) and came across a sketch by the English romantic painter John Constable (1776–1837). It was a mid-size (48cm x 59cm) landscape painted on paper, dated 1822, and was quite unlike any other depiction of nature I'd seen previously. There were no trees or rivers or fields or hills. In fact, there was no land at all. Or sea. Only sky. An English sky. A cloudy sky! A sky dense with those infamous amorphous blobs containing water and ice crystals. A sky that had been looked at millions of times before but never observed and recorded with the insight of this wealthy miller's son.

Constable's clouds weren't doomy or gloomy, they were beautiful and voluptuous and full of character. His was a skyscape of billowing shapes as joyful and carefree as hippies at a music festival. It was like sitting next to an acquaintance you had always thought a dreadful bore only to discover them to be the best company in the room. It was a strange experience, seeing something so familiar – a cloudy sky – at the same moment as seeing something for the first time – a painting of nothing but a cloudy sky. From that day to this, I see the world differently. Constable's clouds transformed my relationship

with overcast days: what was once dull has become marvellous. I now look up into a cloudy sky, not glumly but curiously, to see nature's ever-changing exhibition of 'sky sculptures'.

Constable painted clouds of every shape and size, from sun-infused clusters of plump clouds to moody intermingling tones of white and black, or grey and blue, and even pink and brown. Many of his 'skyscapes' look like the kind of Abstract Expressionist image Willem de Kooning or Jackson Pollock might have conjured up in a New York studio well over a century later. But Constable wasn't dealing in the transcendental. He's not attempting to communicate a suppressed emotion or a hidden meaning, as was the case with De Kooning and Pollock. He was painting what he saw. Truth to nature was his mission – he was a realist, an empiricist. He made this abundantly clear in a lecture at the Royal Institution in 1836 when he said:

> Painting is a science and should be pursued as an inquiry into the laws of nature. Why, then, may not a landscape be considered as a branch of natural philosophy, of which pictures are but experiments?

Constable wanted to activate our consciousness, to get us to see what was in plain sight but routinely overlooked. Overlooked not just by us but also by his fellow artists, who, Constable argued, were hoodwinking the public with fabricated images containing stereotypical classical allusions that bore no resemblance to reality.

He didn't hold back in his assessment of his peers past and present:

> And however one's mind may be elevated, and kept up to what is excellent, by the works of the Great Masters – still Nature is . . . whence all originality must spring – and should an artist continue his practice without referring to nature he must soon form a manner, & be reduced to the same deplorable situation as the French painter . . . who . . . had long ceased to look at nature for she only put him out. For the two years past I have been running after pictures, and seeking the truth at second hand.

Constable's answer was to leave the sanctuary of the studio and the conventions of academic tradition, where historical, mythological and religious subjects were considered the most appropriate for a painting. Instead, he took his oil paints outside to record the view before him. It was a radical act for the time, only made possible by his portable 'sketching box' containing brushes, glass vials full of pigment and medium, and pre-mixed paint stored in pigs' bladders. It allowed him to set up shop and paint 'in nature', or 'en plein air', a technique supposedly invented by Monet and his Impressionist friends fifty years later. Those French revolutionaries of modern art owe a lot to Constable. Not least, to his dedication to meticulously observing nature first-hand, and the trouble he took to record accurately what he saw, from a tiny detail on a leaf to the atmospheric effects of the ever-changing light.

The potency of his *Study of Clouds* lies in its veracity. The subject is instantly recognizable: the inherent beauty of an everyday phenomenon, which most of us blithely disregard. Here was an artist of extraordinary talent showing us what we were missing, or worse – dismissing.

As far as Constable was concerned, clouds were stimulating and intoxicating in a way a clear blue sky was not, an opinion that was far from universal. In the early 1820s the Bishop of Salisbury, a friend and supporter of the artist, commissioned him to paint a view of his cathedral in south-west England. Constable did as he was asked and in due course proudly presented a splendid painting of the great gothic building, framed by two trees between which its magnificent spire rose as if divine into an evocative, moody skyscape. Constable was thrilled with his work. His friend, the bishop, was not. He took one look at the picture before summarily rejecting it and asking Constable to make another version, but this time with a sunny, cloudless sky!

Annoying, for sure, but that's the way it goes if you're a pioneering artist – it takes a while for everybody else to catch up. Constable's attitude to picture-making was radically different from the accepted norm. Even his celebrated competitor, the daring J. M. W. Turner, was lagging behind John C. from East Bergholt. Turner continued to follow in the footsteps of the revered French Baroque artist Claude Lorrain (whom Constable also greatly admired), by embellishing his landscapes with mythical figures and ancient ruins, and prioritizing fixed

compositional conventions over depicting reality. This way his grand canvases could be considered history paintings, a genre that enjoyed a status far higher than down-to-earth landscape painting. Constable disagreed with the Academy's hierarchy, saying, 'They prefer the shaggy posterior of a satyr than a true feeling for nature.' His response was to go large. If history paintings were admired for being expansive and grand, why not give landscapes the same epic treatment. Instead of obeying the rules and producing tea-tray size images of rural life, Constable started to paint what he called his 'six-footers' — massive 6ft x 6ft (1.8m x 1.8m) canvases: pictures so large and realistic that viewers didn't simply look, they entered them.

The Hay Wain (1821) is his most famous six-footer, a work he made around the same time as the Ashmolean's *Study of Clouds*. It is loved for its timelessness and charm; for the way Constable has captured the Suffolk scene with a rugged honesty. The rendering of the leaves on the trees and of the light playing on the water are rightly considered masterful. People talk about the eye-catching red of the horses' saddlebags, and the dog at the river's edge. They admire the composition, and marvel that the view remains largely unchanged today. But what rarely gets mentioned is the most accomplished element of the painting, the clouds.

Constable shows us the brilliant radiance and puffy texture of a cumulonimbus, the wispiness of a cirrus, and the omnipresent proximity of a stratus. He brings

us their effervescence, aligned to a sense of drama inherent in the interplay of the dispersed sunlight in a constantly changing scene. So much better than a cloudless sky when the sun has such a monotonous and lonely job, which is to amble from east to west. A bit boring. Unlike when the clouds blow in. Then the sun has a fabulous time as Director of Ceremonies of life on earth. There is a theatricality to the constantly moving light and shade skipping across the land below as a cast of clouds go through their shape-shifting exercises, all the while being backlit by a sun slowly panning over them like the camera in a Tarkovsky movie.

The Hay Wain is more than a painting documenting country life, it is ultimately a study of light.

> That landscape painter who does not make his skies a very material part of his composition, neglects to avail himself of one of his greatest aids. [Skies] must and always shall with me make an effectual part of the composition. It will be difficult to name a class of landscape, in which the sky is not the 'key note', the 'standard of scale', and the chief 'organ of sentiment'. The sky is the 'source of light' in nature – and governs everything.

Constable's interest in weather patterns and the effects of clouds on our perception went beyond a painterly enquiry. He was alive at a time when rational truths of science were challenging the long-held beliefs of religion. It was the Age of Enlightenment, when human knowledge began to usurp Divine Provenance. Travelling

academics gave lectures across the country; science was the new religion. The Meteorological Society of London was founded, and the first books classifying the various types of cloud were published. Constable read these books avidly, making notes in the margins, many of which were his annotated corrections to what he considered factual errors in the original text.

Study of Clouds is an example of how seriously he took his investigations into matters meteorological. He'd talk to friends about his love of 'skying', when he would sit outside and quickly sketch a never-to-be-repeated cloudscape, which he would duly date and note with time of day along with a short commentary on the prevailing conditions. His purpose was to undertake research, not to make art. He probably never intended his cloud sketches to end up in museums and galleries – they were preparatory enquiries to be used as source material for future landscape paintings, such as *The Hay Wain*.

He produced the majority of his cloud studies while living in Hampstead, where he had moved in 1819 from his beloved Suffolk with his dear wife Maria, because she was suffering from ill-health (the early symptoms of tuberculosis, from which she would die in 1828). Doctors advised the couple that Maria would benefit from the elevated position of what was then a leafy, rural village to the north of London. They moved into Albion Cottage on the edge of the Heath, which offered John wonderful, far-reaching views. It is where he learnt so much about light, and he would go on to make this most

profound comment about human perception: 'We see nothing truly until we understand it.'

Constable was a countryman and a romantic. The ephemeral nature of clouds and rainbows appealed to his sensibilities. Admittedly, there were occasions when his desire for a poetic picture caused him to employ some artistic licence. In 1831 he produced another of his mighty 'six-footers', this time for his old friends in Salisbury. Once again it is of the cathedral and its 123-metre-high spire, which Constable described as 'darting up into the sky like a needle'. *Salisbury Cathedral from the Meadows* (1831) is a great painting (Constable considered it one of his best works), with a rainbow of muted colours arching over the building. It is an effective framing device, but – unusually for the scientifically-minded artist – its existence is meteorologically impossible. The position of the sun is in the west (you can tell from the light on the façade of the building) and not directly behind the artist, which physics dictates it would have to be for him to see a rainbow. What's more, according to those who know a lot more about these things than me, the rainbow is too low in the sky for the time of year.

Maybe the artist was rebelling, having been made to change his Salisbury Cathedral picture a decade earlier. Whatever the reason, the rainbow is a symbolic gesture of a storm passed (possibly the death of his wife), and acknowledgement of an old friendship that is alluded to with the rainbow landing on the house owned by the artist's great companion, John Fisher. The cloud-scudded

sky is sensational: a seething mass of emotion and devotion, of crescendo and calm. It is the type of skyscape a weather forecaster might describe as miserable and to be avoided. Constable counters such small-mindedness, showing us all the incredible beauty and theatre of a cloudy sky – something that we should not turn away from, but should turn towards and marvel at.

Frida Kahlo: Seeing Through Pain

Frida Kahlo spent her adult life in
near-constant pain after a horrific
traffic accident. In one way it ruined
her life, in another it created new
possibilities. Her pain helped her see,
it opened her eyes, and enabled her to
say what she felt in paintings that were
sad and funny, dark and joyful.

Frida Kahlo's story is well known. There's the childhood
polio. The elite female student at a predominantly male
school. The bus crash at eighteen that crushed her and
her ambition to become a doctor. The monobrow. The
early marriage to Diego Rivera, a fellow Mexican artist
and revolutionary twenty years her senior. His affairs. Her
affairs, including a brief fling with Leon Trotsky. Mem-
bership of the Mexican Communist Party. Her flirtation
with Surrealism. Her death at forty-seven. The 500 people
who attended her funeral at the Palace of Fine Arts.

Frida Kahlo's life was as colourful as her outfits. It's
been the subject of movies, of books, and of many,

many exhibitions. But her biography is not why she is famous. There are countless individuals with vivid life stories who are now long forgotten. She has risen to the status of international icon because of her art, which has connected with people across time and space. Fans from the Americas, Europe and Asia politely wait in line to see her politically charged, allegorical images. They resonate universally, even though her paintings are neither technically brilliant nor staggeringly beautiful. They are more like poems in picture form, an artist baring her soul with brushstrokes rather than a pen.

Frida Kahlo had incredible vision. She knew it. When she was nineteen she wrote a letter to her boyfriend Alejandro Gómez Arias about her uncanny ability to perceive what others could not. 'I know everything now, without reading or writing . . . I know there is nothing else beyond; if there was, I would see it.' She wasn't boasting, more lamenting. The horrific accident that turned her from being a promising medic into a fledgling artist had happened only a few months earlier. She and Alejandro were travelling back to her home town of Coyoacán on the outskirts of Mexico City when a tram crashed into the side of their bus, causing Frida to be impaled on a metal handrail. She survived, just, with a broken back, a smashed pelvis and several badly damaged organs. Her life thereafter was one of chronic discomfort and frequent operations. 'Now I live on a painful planet,' she wrote in the same letter, 'transparent as ice; nothing is concealed.'

If there was any upside to that life-changing colli-sion, it was the insight and time for observation with which it left her. In photographs subsequently taken by lovers as well as the dozens of self-portraits she pro-duced throughout her adult life, you can see Frida seeing. The expressionless face, the red lips, the dark hair, the faint moustache – and those critical eyes. With Kahlo the lights were always switched on; even when wrecked through drink and drugs, she was measuring up the world as a tiger stalks a deer. There was an inscrutability to her countenance, a stillness to her presence: we don't know what she is thinking but we definitively know that she is thinking.

It is too simplistic to say that the physical pain she endured was the subject of her highly personalized paintings. Such directness was never Frida Kahlo's style. Symbolism, metaphor and story were the foundational elements of her art. The suffering she experienced because of her injuries was central to her art, but it wasn't the only subject – it was more a way into a much broader range of concerns. She didn't see pain, she used it to see.

To understand how she saw, it helps to consider how she might have thought. Frida Kahlo made the personal political long before the 1960s feminists claimed that notion as their own. She turned herself into the embodi-ment of her beloved Mexico, a nation in the process of creating a new identity following the end of colonial rule and the country's subsequent decade-long revolution

(1910–20). Her agenda was the people's agenda, the agenda of the Mexican revolutionaries and their leaders, Emiliano Zapata and Pancho Villa. When she presented herself wounded but resolute in a painting, she was representing the spirit of a newly liberated Mexico as wounded but resolute. When her skin was pierced by a necklace of thorns, causing her to bleed, she was reflecting on the revolutionaries' blood spilt during their struggles to save the country's soul. When she split an image into two opposing halves, she was thinking of a divided Mexico. What she said, painted, wore and wrote was a statement about Mexico's independence and culture. That was her subject. Pain was the lens through which she saw it.

The constant discomfort she felt gave her access to the extra-sensory faculties needed to reveal the daily agonies and ecstasies taking place within her cherished country. You can't paint hurt without hurting. Frida Kahlo without pain is the Rolling Stones without Mick Jagger or a Margarita without tequila. The wounds and wonders she described in paint made plain her feelings, her heart pounding with joy one minute and broken in despair the next. She was a passionate woman who had many lovers, but none came close to Diego Rivera, who made her the happiest and saddest person to be alive. She once said, 'I suffered two grave accidents in my life. One in which a streetcar knocked me down . . . the other is Diego.'

Rivera was already a world-famous, well-established,

mid-career artist and revolutionary when he came to paint a mural in the amphitheatre at the school the then fifteen-year-old Frida attended. He arrived with his paints and a gun in his pocket just in case any right-wing students attempted to kill him! As soon as she saw him enter her school, Frida knew they would become lovers and she would have his babies, a prediction made impossible to realize by the injuries she would suffer three years later. But he did become her one and only husband, by which time she was his third wife of what would be four. When they married, he was forty-three, she was twenty-two. He was big and stout, she was small and thin. They became a Mexican power couple, fêted in New York and Paris and admired at home. They entertained leading artists, politicians and members of the world's intelligentsia. Theirs was a romanticized view of Mexico and, to an extent, of themselves. They described their artistic-political movement as Mexicanidad, proclaiming Mexico as a modern Marxist state free of foreign rulers and reconnected to its ancient Mesoamerican cultures of the Olmecs, the Maya and the Aztecs.

They promoted their causes through art and action, including membership of the Mexican Communist Party and a public rejection of religion. Diego made Modernist frescos celebrating a new world order of workers' empowerment under enlightened communist leadership. Frida painted Stalin as a hero. Rivera collected ancient Mexican objects with his friend Miguel

Covarrubias, which he would reference in his murals. Kahlo turned personal style into political activism by wearing the traditional clothes of Tehuana women, the indigenous descendants of the pre-Colombian Zapotec culture based around the Isthmus of Tehuantepec in southern Mexico. It was a feminist as well as a nationalist statement, a light shone on to a community in which women expressed their economic and social status through beautifully crafted dresses, skirts and blouses.

To the ancient, Kahlo and Rivera fused the avant-garde. The Mexican modernist architect Juan O'Gorman designed them a Le Corbusier-inspired his-and-hers art studio, interconnected by a concrete bridge at roof level and surrounded by a cactus fence. Diego was particularly pleased when he returned from America to see what his old friend had built. Separate studios with separate entrances were a perfect working environment for a womanizing artist. Frida largely put up with her husband's bad temper and frequent infidelity, often giving as good as she got. But there was one affair she could not tolerate.

In 1934, five years after their marriage, Diego took Frida's younger sister Cristina as his lover. Frida was devastated. 'It is a twofold grief,' she wrote to friends. 'I only had Diego and my family at home.' She went to New York to meet friends, and talked to her father – Wilhelm 'Guillermo' Kahlo – a German photographer who had moved to Mexico in the 1890s where he met and married her Mexican mother, Matilde. Frida adored

her papa, who was instrumental in teaching her to see and be seen (he photographed her a lot), but he was no good when it came to the affair, as she noted: 'My father is a wonderful person, but he reads Schopenhauer day and night, and is no help to me at all.' He could cope with complex philosophy but not his daughter's complex relationship. He disappeared into a book and said nothing.

Frida's work became fiercer and franker. The humour she once sneaked into her pieces evaporated. Satire evolved into a Freudian examination of selfhood: 'Since my subjects have always been my sensations, my states of mind and the profound reactions that life has prompted in me, I have often objectified all this in figures of myself, which were the most real, most sincere thing I could do to express what I felt within and outside myself.'

When André Breton, the self-styled founder and leader of Surrealism, visited Mexico and saw her work he immediately claimed it – and her – to be part of his movement. He adored its darkness and anger, describing her delicate paintings of nightmares and abortions as being 'a ribbon around a bomb'. He invited her to show her work in Paris, an offer she accepted – apart from anything else, she needed to get away from home.

While she worked on a series of new paintings for the show in France – and presented a successful exhibition in New York – her marriage was disintegrating. Her sister was still part of Diego's romantic life four years after the

affair had started, and Frida was not putting up with it any longer. In 1939 she divorced Diego, which led to her producing one of her most famous pictures, *Las Dos Fridas (The Two Fridas)*.

It is much, much bigger than her usual paintings, which tended to be quite small as she was frequently bed-bound, or sitting with restricted mobility. *Las Dos Fridas*, though, is a large square composition measuring 173.5cm x 173cm – not far off life-size. There are two explanations for this sudden upscaling. One is commercial. André Breton advised her to make some larger works for her Paris show, as European collectors preferred more sizeable paintings. And second, she had a lot to say. *Las Dos Fridas* is the ultimate break-up picture.

The tone is set by the background, which is stormy and ominous. In the foreground, sitting on a green wicker bench, are the two Fridas. They are holding hands, united. Their shoulders are turned slightly towards one another, but their eyes stare directly out to the viewer: this is no interior conversation piece, they are talking to us. One Frida is wearing traditional Mexican clothes, the other a colonial-style wedding dress. These are the two sides to Frida: Mexican Frida with indigenous Indian roots on her mother's side, and European Frida with her father's German heritage on the other. We suspect Diego prefers Mexican Frida because it is this Frida who is holding a miniature picture of him in her left hand. It is attached to a vein full of blood that winds itself up her arm and into her halved heart, which is exposed outside her body. The

vein exits from an artery and makes its way over to European Frida, who has the other half of the heart beating over her breast. The vein passes through another artery and makes its way down to her right hand, which holds a pair of scissor forceps, clamped over the vein to stop it bleeding. Well, not entirely. A little blood has dripped on to European Frida's dress, blending in with the red flower decoration on its rim.

You can see why Breton, with his taste for the macabre and disturbed, would have delighted in Frida's ghoulish account of her marriage. She's laid it all out there in the open: the organ failures, the hospitalizations, the anatomical knowledge from studying medicine, the dualistic nature of her background (a mestizo, meaning mixed race), her stoicism, the older and younger self, the interior and exterior, the mind and body, Madonna and child, life and death.

European Frida has blood on her hands, Mexican Frida has love in hers. The menacing sky closes in, a sign of anxiety over a future direction – Western subjugation or Mexican values? There's more. Although she was a publicly stated atheist, religion played a significant role in her painting style and outlook. It is there in the depiction of the sacred heart, bleeding and damaged, with the ventricles rising to form a cross in the hope, perhaps, of a miracle cure. The blood could be the blood of Christ, a symbol of martyrdom, unconditional love and redemption. The painting of Diego is a retablo, a small devotional picture that is part of the folk art of the Catholic Church,

into which Kahlo was born. Has she refound her faith in God rather than in an unfaithful man? Her walls were covered in ex-votos, postcard-sized pictures that offer a prayer in the form of a pictorial story accompanied by text. They were a notable influence on Frida, whose paintings owe a lot to the ex-voto aesthetic, particularly the way they favoured an easily legible image over painterly technique. There's no attempt to convincingly represent perspective, or to achieve even basic levels of academic draughtsmanship. Unnecessary flourishes are put aside to give prominence to the story encapsulated in the image. The result is a rigid, stiff composition that gives ex-voto images a distinctly spooky look: an effect Kahlo comprehensively mastered.

Las Dos Fridas didn't sell when exhibited, unlike many of her other pictures. Maybe Breton was wrong to encourage Frida to go large. He was certainly wrong about her being a Surrealist, as she made clear with this statement: 'I never painted my dreams, I painted my own reality.' That is the way into her art. Her pictures were not the whimsical meanderings Breton believed them to be. They belonged to the time and place in which Kahlo lived. She made images that were overtly political, often with more than a hint of propaganda. She was deeply committed to helping shape the future of Mexico, and did so by becoming its cultural embodiment. The artist and her nation were inseparable, and still are today.

Frida Kahlo would probably have been a doctor if it

wasn't for the bus accident. Instead of breaking her, it was the making of her. She learnt to live with the pain and to use it as a way of seeing the world and her place in it, the pain of the crash, of the miscarriages, of Diego's affairs, of her sister's betrayal, of a colonial past, of lost traditions, of an overbearing West, of her country's turmoil. She was a force of nature whom few could resist. Not even Diego, who asked her to remarry him a year after their divorce. Which she did.

Wassily Kandinsky: Seeing Music

Colour is the keyboard. The eye is the
hammer, while the soul is a piano of
many strings. The artist is the hand
through which the medium of different
keys causes the human soul to vibrate.
— *Wassily Kandinsky*

What do you hear when you look at a painting? Noth-
ing? Nor me. Let's try another art form. What do you
see when you listen to music? Still nothing? Yep, same
here. The chances are, then, that you – like me – do not
have synaesthesia, which is a neurological anomaly
where one human sense (touch, smell, sight, hearing,
taste) triggers another. For example, you smell a rose
and are overwhelmed by the taste of coffee: one acti-
vated sensory pathway has generated a response in
another. The word is derived from the Greek, meaning
joined / added (*syn*), and perception / sense (*aisthesis*).
It is a relatively rare condition said to be dispropor-
tionately prevalent among artists of all types. Duke
Ellington, Kanye West and Lorde are three musicians

among many who have been reported to live with syn-
aesthesia's multi-modal faculty. Pharrell Williams has
talked about having it and describes the neurological
phenomenon as his 'only reference for understanding'
and the basis for his talents.

The writer Vladimir Nabokov and the composer
Franz Liszt both had synaesthesia, a condition some
consider a cognitive blessing, not a curse. Apparently, it
also affected some of the twentieth century's famous
modern painters, including those two masters of
cacophonous colours: Vincent Van Gogh and Wassily
Kandinsky (1866–1944). Frankly, I'm not so sure about
Van Gogh – he had a lot of other things going on –
but there's no doubt about the Russian. On hearing a
new piece of avant-garde music by Austrian composer
Arnold Schoenberg (1874–1951) in 1911, Kandinsky
immediately reached for his paints and produced a pic-
ture called *Impression III (Concert)*, which is an image of
the colours and shapes he 'saw' while listening to
Schoenberg's music. It is a manifesto of sorts, encapsu-
lating Kandinsky's belief that it is only when we unite
the two senses of seeing and hearing that we truly feel
what we see, and see what we hear:

> Our hearing of colours is so precise that it would per-
> haps be impossible to find anyone who would try to
> represent his impression of bright yellow by means of
> the bottom register of the piano, or describe dark mad-
> der [red] as being like a soprano voice.

Kandinsky liked bright yellow. There are great swathes of it in *Impression III (Concert)*, a largely abstract image in which you can just about make out a group of eager concert-goers in the foreground leaning towards the triangular black lid of a grand piano. The scene is framed by a block of yellow paint, suggesting the event took place on a sandy beach, rather than in the chilly Munich building in which it was really held. It is a flight of artistic fancy rather than a factual pictorial account. The painting represents Kandinsky's inner emotions and sensations responding to the sound of Schoenberg's atonal composition: it is not an attempt to 'paint music', more a painted composition inspired by music. He saw images when listening to music, and heard music when looking at images.

Right now, if you asked me what I could see out of my open window I would say a gently curving coastline (I'm on holiday). If you asked for a little more detail, I would tell you about the old stone wall with a gate that opens on to an undulating lawn, which then morphs into golden sand that leads to a silvery sea in which mounds of rocks protrude and play host to seagulls and a single heron. Pushed further, I'd note the blue sky dotted with white clouds, the brightness of the mid-afternoon sun, and the small island in the distance: a rocky outpost that is home to a huge colony of gannets. At no point would I mention any of the many sounds I can hear. That is because I have learnt to look with the sound muted. Until now, that is. Here is what

I see having taken a leaf out of Kandinsky's audio-visual book.

The reddy-brown stone wall has a warm bass tone, over which can be heard the piccolo sound of the wind breezing through the spiky green grass. The golden sand of the beach has a sonorous hum that takes on the melodic rhythm of a snare drum as the sea washes up on to the shore. I won't go on and on, but I am 'hearing' as I describe, having awoken a suppressed sense in order to observe simultaneously visually and aurally. I might not have synaesthesia like Kandinsky, but his sensory-aware approach to experiencing the visual world shows us that there is more to seeing than meets the eye.

The Russian artist wrote at length about the relationship he believed existed between music, sight and painting in *Concerning the Spiritual in Art*, a famous text published in 1912. In it, Kandinsky sums up his thoughts on how music and art interrelate in our psyches with his very own piece of purple prose: 'Colour is the keyboard. The eye is the hammer, while the soul is a piano of many springs. The artist is the hand through which the medium of different keys causes the human soul to vibrate.' As far as he was concerned, great art and great music had the same purpose, which was to express the human spirit in such a way as to capture the personality of the artist and the age in which they were living. The result, if successful, would be a supreme work of art that 'vibrated' in the soul of those who experienced it, leading to a spiritual awakening.

It was a period in the Western world of post-Romantic, pre-Modernist philosophies and utopian theories, chief among which was Theosophy, a quasi-religion Kandinsky subscribed to, which blended established creeds and occult mysticism. Fired up by an age of astral plane adventure, Kandinsky began to think of music as the most spiritually enlightening of all art forms, as it was entirely abstract. After all, there are no images or words in a Schoenberg composition to remind the listener of the drudgery of day-to-day life. Instead, those present were free to let their minds explore a spiritual realm that was being evoked by the sounds they were hearing. Kandinsky was convinced art could play a similar role, especially if it moved away from depicting easily recognizable scenes or objects, and followed the path of music into a world of abstraction. So he took a break from painting the colourful landscapes of his early years as an artist, and started to focus more and more on creating non-figurative images composed of colours and shapes rather than people and places.

His was an unusual path to abstraction. The young Kandinsky had started out as a promising Russian lawyer before committing himself to art after 'seeing things' when attending a performance of Wagner's opera *Lohengrin* in 1896 at the Bolshoi Theatre in Moscow. Shortly afterwards he went to an exhibition of Monet's paintings and was struck by how the French Impressionist had prioritized colour over subject in his pictures of haystacks. Seeing them and hearing Wagner was a

double epiphany for the precocious advocate, who immediately swapped his legal books for canvases and paintbrushes.

Soon he was seeing sound in colour, and hearing colour musically. Orange, he said, was like a 'medium sized church-bell reminding one of a strong alto voice or the singing of alto violins'. Violet, on the other hand, was 'the sound of an English horn, the shepherd's flute, or the deep, low tone of wood instruments (for example, a bassoon)'. He had an equally lyrical translation for all the colours of his palette, including vermilion, which 'rings like a great horn and is comparable to the thunder of drums'.

His adventures at the intersection between art and music hit their highest notes in 1913 with a wall-filling 2m x 3m painting called *Composition VII*. It is an intense, tumultuous piece of work which has much of the dissonance he first discovered in Schoenberg's atonal compositions. It is one of ten paintings, all with the title *Composition*, that he made over three decades (the first three were lost during the war), and all of which came from a similar psychological starting point that he described with a poetic flourish:

... with slowly evolved feelings, which have formed within me for a long time, and tested pedantically, developed after they were intuitively conceived. This kind of picture I call 'compositions'. Reason, consciousness, purpose, and adequate law play an overwhelming

part. Yet, it is not to be thought of as mere calculation, since feeling is the decisive factor.

I have stood in front of *Composition VII* and been in awe of its scale and ambition. I could feel the artist's emotions radiating out like the heat of a bonfire on a cold night. Kandinsky would argue that I was experiencing the inherent spirituality of the painting, which was making itself known to me. Perhaps I was; it certainly has a combustible energy, as colours and shapes overlap and criss-cross, hopping around the canvas like a frog in a pile of leaves.

Red, black, yellow and blue dominate a technicolour show that has many of Kandinsky's favourite patterns and motifs. He believed the inclusion of a blue circle, for instance, synthesized the inner nature of things – our feelings and unconscious mind – with the external world and the universe. Then there are the triangular shapes that allude to the spiritual in art, and the dark mountainous elements, which hark back to Russian folklore and iconography. Look a little closer and you will spot the oars protruding from a boat full of travellers being tossed about on a high sea, an image much used by Kandinsky throughout his career. Beyond that, it is hard to make any coherent visual sense of *Composition VII*, other than to go with Kandinsky's flow and let its raucous energy take you away, treating it as he would have wished, like a magnificent musical arrangement.

Nearly a quarter of a century later, in 1936, Kandinsky

was working on his penultimate *Composition* piece, *Composition IX*. Meanwhile, Arnold Schoenberg, his old friend and inspiration, had taken on an American student called John Cage, a keen young man who had come to the great composer to be taught counterpoint. It was from Schoenberg that Cage, like Kandinsky, learnt how to break down and rebuild compositions, paying as much attention to the pauses (the colour black for Kandinsky, silence for Cage) as he did to the notes. Kandinsky and Cage were coming from very different places, and from very different backgrounds, but both became pioneers of abstraction owing – in part – to the influence of Schoenberg. The Russian discovered a new way of making art by largely removing the figurative element so we could 'hear' the colours and feel them vibrate within us. Cage forged a new way of making music by removing all the sound so we could 'hear' the silence and feel it vibrate inside us.

It was in 1952 that Cage, now seen as an avant-garde American composer, produced his masterpiece *4'33"*, a four-minute thirty-three-second composition for multiple instruments. The instruction given to all the musicians gathered to play the piece was to lay down their instruments and sit in silence for the duration of the three movements, which lasted four minutes thirty-three seconds. The initial response by many of those who have 'heard' the piece play is that it's a satirical, subversive gesture that owes much to the naughty-boy, early twentieth-century Dadaist movement. But that was not Cage's intention. The piece is about timing, tempo, and

the 'sound' of a pause. What you actually hear in those four minutes and thirty-three seconds when the musicians sit quietly beside their unused instruments is not silence, but the soundtrack of everyday life. You can hear people shuffling in their seats and occasionally coughing. There's the noise of rain on the roof, or of a car driving past. Wood creaks, doors shut, lights buzz. You become so hyper-aware of your sense of hearing that even touching your face seems to generate a noise loud enough to disturb those sitting nearby.

Kandinsky, Schoenberg and Cage were all exploring the role sound plays in our lives. The two musicians were doing it through formal investigations into structure and time, while the artist was exploring how to make sound visible. That he could instinctively combine both music and images was down to his synaesthesia; the fact that his art encouraged us to hear when we look is down to his talent and spirituality. His way of sonically seeing adds a dimension to how we perceive our surroundings by activating senses habitually left dormant when observing. He helps us to look afresh, to think again: to see with our ears as well as our eyes.

Yayoi Kusama: Seeing as Therapy

People queue for hours to step into
one of Yayoi Kusama's mirrored
Infinity Rooms, or a gallery she's covered
in polka-dots. She creates these worlds
to make her darkest fears visible.

Ask almost any painter or sculptor, famous or not, why
they do what they do and they'll give you the same
answer: it's a compulsion. Ask them what advice they
might have for an aspiring artist and they'll probably
caution you not to attempt a career as one unless you
feel you have absolutely no other option. The seasoned
artist knows, usually through bitter experience, that mak-
ing art can be a miserable, endless cycle of frustration
and disappointment. The French artist Paul Cézanne,
perhaps the greatest painter of the modern era, died in
1906 thinking he had failed. Even for cheerier souls such
as Britain's David Hockney – for whom making pictures
is a joy – art is a life-defining obsession. If he's not paint-
ing, which he does pretty much every day, he's thinking
about it or talking about it or looking at it. He cannot

stop expressing himself in pictures, it is an irresistible urge. The fact is, art isn't so much a vocation as an addiction.

It is an addiction sometimes born out of a need to address a deep psychological trauma. You only have to look at those tortured works by the German Expressionists in the years following their horrific experiences during the First World War. George Grosz, Otto Dix and Max Beckmann were all traumatized by what they saw and did between 1914 and 1918, which led to various nervous breakdowns and mental instability. Their jagged, fractured paintings, so full of pain and suffering, were a way of exorcizing their troubled minds. The contemporary Japanese artist Yayoi Kusama (b. 1929) is another for whom making art is a form of therapy. She, too, was left psychologically disturbed by the brutality of war, working day and night in a military factory while a schoolgirl during the Second World War, sewing parachutes and stitching uniforms for Japanese soldiers. She was a fragile, anxious teenager when two atomic bombs were dropped on her country.

Long before she made her crowd-pleasing dotty environments, when she was just out of art school, Kusama produced pictures that dealt specifically with the anguish caused by war. In 1950 she painted the dark, expressionistic *Accumulation of the Corpses (Prisoner Surrounded by the Curtain of Depersonalization)*, featuring a Dante-like circle of hell spiralling down to a central void, empty save for the charred remains of two dead trees. It's a creepy picture,

with its red and black tubes that look like a diseased human intestine. It is a long way from the conventional Japanese style the then twenty-one-year-old Yayoi had been taught – it owed more to the European Surrealists, particularly Max Ernst, than to the gentle celebration of nature typical of traditional Nihonga paintings.

'I am pursuing art to correct the disability which began in my childhood,' she said. A childhood in which an already sensitive little girl was left distraught by a mother who banned her talented daughter from painting and drawing and instead insisted she spy on her philandering father. The English writer Philip Larkin wrote a famous poem, 'This Be the Verse', about parents like Yayoi's. The 'disability' to which she referred was, and is, a psychiatric condition. From a very early age Kusama has suffered from severe panic attacks and hallucinations, episodes during which pumpkins might talk to her, which is nice, or a sense that an entire universe of patterns was eliminating her, which is not.

She has told the story many times about an incident that haunts her to this day. There she was, at home, in the provincial city of Matsumoto in the mountainous central area of Japan. She was a child, sitting at a table and quietly appreciating the red flower pattern on the tablecloth. She looked up and was shocked to see the same pattern on the walls, and the ceiling above. And then the floor below! It was horribly weird. And then she realized she too had become obiterated and disappeared in the red flowers. She got up and ran into the hall to chase the flower pattern

away, but it covered everything, including the stairs on which she was now standing. The wooden structure gave way, leaving her to fall into a huge void not unlike the one she depicts in *Accumulation of the Corpses (Prisoner Surrounded by the Curtain of Depersonalization)*. She felt herself disappearing into a limitless universe and was terrified, saying later: 'I had begun to self-obliterate, to revolve in the infinity of endless time and the absoluteness of space, and be reduced to nothingness.'

This early psychotic 'bad trip' became the basis for all her work and for how she sees. Drawing and painting are Kusama's way of coping, of countering her deepest fears. She says art is her 'medicine' and that she turns her 'psychological problems into art'. It might sound odd, but art can serve that purpose for all of us. Horror films, cautionary fairy tales, disaster movies, crime novels and action-hero comic characters all force us to confront our repressed anxieties. Relief comes from acknowledgement of a fear and a preparedness to deal with it. The primal dread of death is allayed; we survived. Not only that, we get the added benefit of the euphoric feeling produced by our body's fight-or-flight stress response system, which releases enlivening endorphins and adrenalin to course through our veins. In these moments we truly feel the life-force, an affirmation of existence Yayoi calls 'the energy of life' – this is the raw material she turns into art.

Her intention is to create her own 'Kusama World': a physical manifestation of her imagination that transforms those ghastly blood-coloured flowers with the menacing

round faces that chased her around her house into friendly red polka-dots on pristine white backgrounds (or vice versa). She began painting dots and spots when she was around ten years old and has continued ever since. They started out looking like drops of rain on the canvas, or livid nodes on a strange-looking creature. This was as far as it went while she was a young artist living in Japan, a country that she found stifling. To develop artistically and intellectually she had to escape:

Staying in Japan was out of the question. My parents, the house, the land, the shackles, the conventions, the prejudice . . . For art like mine – art that does battle at the boundary between life and death, questioning what we are and what it means to live and die – this country was too small, too servile, too feudalistic, and too scornful of women. My art needed a more unlimited freedom, and a wider world.

She went to America – Seattle at first, and then, in 1958, New York. Her English was poor but her parents were not. They owned a large flower and vegetable seed business, which might have been an early trigger for their daughter's panic attacks – and gave Yayoi enough money to survive for a while, in cash, which she sewed into the lining of her kimono. The young artist was still in her surrealist phase when she arrived in the US, and was immediately struck by the Abstract Expressionist work of Jackson Pollock and Willem de Kooning. She saw the emotional effects that could be achieved by

making big pictures with dynamic brushstrokes. Pollock was painting to lay his own demons to rest; Yayoi took notice and started to cover huge canvases with thickly applied white and black paint to deal with hers.

The result was a series of large monochrome pictures, one measuring about 10 metres long, collectively called the *Infinity Net* paintings. Kusama says the idea came to her while flying over the Pacific on her way to America, when she looked down and saw 'ever-expanding nets on the ocean'. And sure enough, her net pictures do have the appearance of a slightly choppy sea as seen from above, with curls of white impasto paint lifting off the surface like waves to reveal a black background beneath. For Kusama, the black paint represented the infinite universe into which she would fall if it wasn't for the nets. They are mesmerizing paintings to stand in front of and study, a combination of Eastern and Western aesthetics that appears benign at first but quickly becomes more troubling the closer you look – as if the dark matter below the sea is pulling you towards an eternal abyss.

These are the first paintings in which Kusama fully addresses her fears, without the distraction of over-elaboration. They are direct and pure, nothing more than monotone organic forms repeated countless times spread across a massive surface. They were a breakthrough for her and for art more generally. Although they could be read as having derived from Abstract Expressionism, their stark simplicity marks them out as

early examples of what would become known as Minimalist art. In fact, one of Minimalism's founding fathers, the American sculptor Donald Judd, not only wrote enthusiastically about Yayoi's *Infinity Nets* paintings, but was also one of the first people to buy one.

The two artists became good friends. They had studios in the same building, and, when it was time for Kusama to confront another one of her childhood anxieties, Judd was on hand to help. Her dread of 'self-obliteration' in a swarm of flowers was matched by a phobia about sex — possibly due to being forced to spy on her father being unfaithful to her mother. Once again, she turned a revulsion into art, using the same technique of endlessly repeating forms until they overwhelm, a process she described as 'accumulations': 'things piled one on top of another create an expanding world that reaches out to the edges of the universe. That is the simple image I have . . . Accumulations is the result of my obsession, and that philosophy is the main theme of my art.'

This time round the forms weren't paintings of waves but objects made from off-white sock-like material stuffed to look like penises. Yayoi and Donald spent days making thousands of phallic-shaped forms to construct what Kusama called her 'soft sculptures', chairs and sofas covered in her cloth cocks, turning objects of fear into everyday items. In one related work she adorned a rowing boat — inside and out — with phalluses and then took a photo of her handiwork and reprinted hundreds of posters to produce a wallpaper that covered walls,

floor and ceiling (a call back to that childhood episode with the flowery tablecloth). Andy Warhol liked the effect of her *Aggregation: One Thousand Boats Show* (1963) so much he is said to have copied the idea with his *Cow Wallpaper* (1966), which upset Yayoi, who felt she – a pioneering Asian woman – was being ignored and ripped off by an art establishment privileging white, Western, male artists.

The panic attacks returned, as did suicidal thoughts. Her American dream was turning bad. Still, she had one card left up her sleeve. She was a brilliant self-publicist as well as a gifted image-generator. Put those two things together and, you know, you might make the news. And she did – put them together and make the news. Kusama got the attention of the world's press with her naked New York 'happenings' in protest against the Vietnam War. Typically, these live, staged events would involve her painting her naked body in polka-dots as well as those performing sit-ins and protest walks with her. Now the press were paying her attention, pens poised, cameras clicking.

She then charmed the art world with her 'pop-up' installation called *Narcissus Garden Kusama* at the 1966 Venice Biennale, in which she laid out 1,500 mirror balls in front of the main Italian Pavilion and offered them for sale at $2 each with a sign reading: 'Your Narcisium [sic] for Sale $2'. The organizers didn't see the funny side and closed her down, but not before she could change out of her kimono and put on a paparazzi-attracting bright red

leotard in which she posed for the cameras while basking in the reflections caused by her ocean of shiny balls.

The impulsive conclusion might be to write Kusama off as a media-manipulating show-off. That was certainly the opinion the press reached in both America and Japan by the early 1970s. And they were right, up to a point. She was and is a savvy operator when it comes to attention-grabbing public relations. But with good reason. First, she had to stand out and stand up for herself to have any chance of making it as an unknown Japanese woman in the man's world that was America's post-war art scene. And second, she is her art, inside and out. She turns her panic-inducing alarm into positive, life-enhancing experiences. By going that extra step, and placing herself in her art and inhabiting her Kusama World, she is completing the artwork – the star in her universe enjoying the fantasy and the freedom: Alice in her Wonderland.

Everything came together in 1965 when she presented *Infinity Mirror Room – Phalli's Field*, an all-encompassing, 25-square-metre mirrored room filled with polka-dot covered fabric penises. It combines her anxiety around sex with her disturbing hallucinogenic episodes. It is bad karma brought to heel, bent to her will, neutralized, and then owned. She doesn't simply see her traumas, she brings them to life, and in doing so makes art that touches millions of people around the world. Young and old queue for hours to step into a Kusama mirrored infinity room, or gallery covered in polka-dots – for the chance to observe life from the artist's perspective.

Yayoi Kusama is far from unique in using art as therapy to overcome extreme anxiety; fear is one of the most common sources of creative inspiration. But her psychological experiences are unique, as are yours and mine. They could have crushed her, but instead they were the making of her. She used them to see and be seen, and to become one of the most original, ground-breaking artists of our time. She says she was born into a family and a culture that suppressed emotions, but despite resistance from her parents and periods of ridicule during her career, she has prevailed by showing the world the healing power of confronting the thoughts that frightened her. It hasn't been easy. When Kusama returned to Japan from America in 1973 she was in a desperate state, having had physical health issues and, on top of that, suffering a nervous breakdown and a subsequent depression that she struggled through on a daily basis. In 1977 she voluntarily checked into a psychiatric hospital in Tokyo, where she remains to this day. Every morning she gets up and goes to her studio a couple of blocks away, where she sits down and works all day. The irony is that she is far more famous and appreciated now that she has removed herself from the rat race. She even got invited back to the Venice Biennale in 1993 – not to reprise her pop-up installation but as the first female artist to solely represent Japan at the prestigious event. It is quite a turn-around, from a terror of obliteration to international adoration – she has shown us the world as she sees it, a world full of love and polka-dots.

Jean-Michel Basquiat: Seeing for Real

Notary is at once a snapshot of
Basquiat's mind and soul, and an
account of how we all perceive.
Whatever we might think we are
looking at, we are seeing it through a
messy montage of half-thoughts,
tingling senses and peripheral images.
Nothing is ever seen in total isolation.

Jean-Michel Basquiat's early 1980s paintings are very
good. *Notary* (1983) is a masterpiece. Nobody had made a
work like it before and nobody has since. It's a sprawling,
scrawling mass of ideas, emotions, opinions, references,
conversations, observations, portraiture, reportage, word-
play, over-painting, under-painting, redaction, reduction,
re-drawing and constant reassessment. It looks like an
incoherent mess but is actually a virtuosic compos-
ition without compare, a symphony for a city: a reflection
on the complexities of contemporary urban life and
our hyper-stimulated minds.

Art tends to be about a process of paring down to get

to the essence of a subject. Fine. But such a narrow focus is not how we actually see and experience the world. We are rarely, if ever, in a position when we can concentrate solely on one thing and one thing only. Even when locked in a cell with nothing to observe beyond its four plain walls, our minds will wander: thoughts will pop into our head, sounds and smells will trigger associated images. We are constantly juggling multiple inputs. Everything we 'see' is contextualized by an ever-changing visual collage of associated and disassociated thoughts, conscious and unconscious. There's mayhem going on up there in our heads, which is the essence of what Basquiat is revealing in *Notary*.

The painting is tantamount to a rummage around the Brooklyn-born artist's lively mind circa late 1982. He was in his early twenties, living in Lower Manhattan, and riding high after a recent sell-out show of his neo-expressive pictures. He had already made a name for himself by writing poetic graffiti on the walls of the East Village and SoHo with his old schoolfriend Al Diaz. They would sign off their oblique aphorisms (e.g. A PIN DROPS LIKE A PUNGENT ODOR) with the tag SAMO© (pronounced same-o, as in same old shit), in the hope of gaining the attention of the hipsters running the downtown arts scene. It worked. SAMO© became a thing, Basquiat came out as its mystery creator, and before he could say 'Hi, my name is Jean,' he was a Mudd Club regular and founding member of the experimental band Gray.

Not that he could play music particularly well. Back in those days all you had to do was say you were a musician, artist, model, fashion designer, actor, film-maker, writer, poet, etc., and that's what you were. No previous experience or résumé required; no limit to the number of creative professions you claimed (Basquiat was at any one time an artist, DJ, poet, actor, writer and T-shirt impresario). The Mudd Club attracted the world's wannabes and wouldbes. There was, for instance, an unknown dancer with big ambitions and rock 'n' roll attitude. She was getting some attention. Then she became a singer and got a lot more attention. Including from Basquiat, whom she dated before fame knocked on either of their doors. Her name was Madonna. Another regular was Debbie Harry from the band Blondie, who is said to have been the first person to buy one of Basquiat's paintings (apparently for $200, a tiny fraction of the many millions of dollars it would fetch today). The artist Keith Haring was also part of the crew.

It was from this bubbling cauldron of bohemian personalities, attention-seeking dandies, counter-culture creatives, and assorted oddballs and addicts that Jean-Michel Basquiat the artist emerged. He'd always been a voracious drawer, possibly as a way of coping with a difficult family life in which his Haitian father (Gerald) and Puerto Rican mother (Matilde) would fight, split up, make up, and then start fighting again. On the face of it, he was from a well-to-do middle-class family in which accountant dad could afford a smart European car, a

local tennis club membership, a brownstone house in Brooklyn, and the fees to send his young son to a private school. But the marriage was disintegrating, Jean was getting into trouble at school, and both parents would, on occasion, he said, beat him.

He ran away from home a couple of times before leaving for good when he was seventeen. He was drawn to New York's rundown downtown like a surfer is to breaking waves. He couldn't resist the energy and immediacy of the late 70s Lower East Side. It was a wreck of a place. Buildings were either boarded up or falling down, or both. Crime was rife, drugs abundant, and prostitutes and pimps hung out on every street corner. To the rich and powerful of the Upper East and West Side, downtown was a living hell. To Basquiat it was heaven on earth.

He survived on his wits. He'd drink wine with winos, drop acid in Washington Square Park, panhandle when necessary, crash out on the floors of lovers and friends, sleep rough, not sleep, and scour for loose change in the dingy corners of dodgy nightclubs. Whatever it took, basically, to stay in the multi-cultural, multi-discipline, multi-media artistic epicentre that was downtown in the late 70s. He belonged there among the punks and the poets, the hip-hop producers and subway spray painters. It was a DIY culture driven by talent and ideas, not money and big business.

Basquiat started to produce batches of home-made postcards, which he sold around the place. One day he saw Andy Warhol in a restaurant and blew in as bold as

you like and sold three cards to the Pop artist right there and then. Basquiat wanted to be Warhol. He wanted to be Warhol-famous, Warhol-admired, the number one like Warhol. He knew that then. But what he didn't know was that his hero Andy Warhol would not only collaborate with him, but also become a dear friend and mentor. Nor did he know his very own American Dream would come spectacularly true, only to turn into a nightmare.

He was already a noted East Village personality, exuding a celebrity aura. Everybody knew he was a bit special. When the skinny twenty-year-old stepped on to the dancefloor, folk stood aside to watch and admire. The media started to take notice. Then a friend gave him money to buy some art materials, which led to a series of pictures that had the hallmarks of what would become his globally recognized style. From the beginning he mixed words and images, obliterated details by over-painting, suggested no depth of field, and intentionally drew with a hesitant line. This sketchiness gave his images a sense of improvisation and directness, an effect he accentuated by carefully applying his paint to make it look as if he'd just woken up and applied it without much thought. The objective was to generate a rawness and dynamism that matched the creative urgency of the downtown scene.

When Jean was a boy, his art-loving mother would regularly take him to the museums and galleries around Brooklyn and Manhattan. The intellectually curious child couldn't help but notice there wasn't much art by

black artists being exhibited. In fact, it seemed black artists were under-represented to the point of a white-washing. Such was the paucity of paintings and sculptures by anyone with his skin colour that one of the first encounters he had with art that referenced African culture was when he saw Picasso's epic anti-war painting, *Guernica*, in real life. It was love at first sight. Basquiat had read a great deal about its stylistic origins, which, he could now clearly see, were heavily influenced by the Spaniard's fascination with the traditional art of Africa. Basquiat wanted to reclaim what Picasso had borrowed: the elliptical eyes, simplified forms and two-dimensional figures.

The bohemian scene Basquiat was documenting was ethnically diverse, liberal and inclusive. Not so the rest of New York City. He experienced racism on a daily basis, from police harassment to taxis routinely refusing to stop. He was angry and frustrated by the ridiculous, impertinent questions posed by interviewers, questions that would not be put to a white artist. For instance, would he describe his work as 'primitive', or was it true he had to be locked up in a basement to paint? Or, this from an old TV interview: did he consider himself a 'Primal Expressionist'? Basquiat found that question so dumb and so insulting he sought clarification from the journalist. 'What, like an ape?' a bewildered Basquiat asked. 'A primate?' The interviewer stumbled around unable to construct a sentence as the interviewee sat patiently awaiting clarification.

It was about this time that he painted *Notary*, having become the talk of the town. An upmarket art dealer had taken him on, provided some gallery space, and given him a solo exhibition. It was a knock-out, sell-out show. Jean-Michel Basquiat 'The Artist' had arrived in double-quick time, going from homeless hustler to a millionaire-in-the-making in a matter of months. Everyone wanted a piece of him and his art. At first it was exciting, then it was annoying. He found he 'owed' paintings to collectors whom – unbeknownst to him – had signed up to buy an as yet unmade work in advance. Basquiat felt under pressure to maintain his standards. He worried his work would suffer, that he would be rushed into making lousy pictures. The rising feeling of anxiety wasn't helped by his relationship with drugs, which was getting more intense. There were rumours that Madonna stopped dating him because he was using heroin.

It was from this heady concoction of events, experiences, emotions and influences that Basquiat embarked on *Notary*. He was called the 'Black Picasso'. He wasn't. Picasso was the great innovator, an academically trained artist who could paint and sculpt in a variety of styles, some of which he invented. Jean-Michel was also brilliant and innovative and knowledgeable, but he wasn't conducting a comparable philosophical enquiry into perception and representation. Picasso was heavily influenced by Cézanne; Basquiat was buried in reference books, visiting museums, watching TV, reading comics, following sports, and – most importantly – listening to

the jazz musicians to whom his father had introduced him. Basquiat wasn't the Black Picasso, he was the Charlie Parker of paint. Andy Warhol might have been the king of Pop Art, but Jean-Michel Basquiat was the undisputed champion of Bebop Art. He painted like Parker played, full of spirited improvisation and pulsating rhythm, bending the notes – words, colours, shapes – of his painting to incredible effect.

Jean-Michel was not an artist who enjoyed talking about his work. 'It's like asking Miles [Davis] how does your horn sound?' he said in Tamra Davis's Basquiat documentary *Radiant Child*. He did, though, provide some clues to *Notary*, a painting loaded with a cryptic concoction of references, including classical antiquity, Disney cartoons, racism, Leonardo da Vinci's anatomical studies, the slave trade, Marxist theory, the Bible, modern art, planetology, chemistry, graffiti, African tribal symbols, hip-hop and Egyptian hieroglyphics.

It starts in the top left-hand corner with the planet Pluto, which Basquiat based on Galileo's first drawing of the moon. He attached the © sign (a symbol he had repeatedly used from his SAMO© days) to the word PLUTO, apparently in case Disney tried to claim it owned the rights to the name. He crossed out the word PLUTO below because it wasn't very good. The word SALT in the bottom left-hand corner, which is repeated on the opposite side, is a reference to the mineral's use as a valuable currency in ancient Rome.

The transactional theme is continued with the inclusion

of the word NOTARY, a legal professional who authenticates documents and commercial contracts. The jagged shape below the word NOTARY, which is not unlike the crown Basquiat often used in his paintings, is a broken notary's seal. The contract has been read. The painting's mercantile message is made explicit with the writing at the bottom of the picture, below the two central figures, which reads: THIS NOTE FOR ALL DEBTS PUBLIC + PRIVATE. These are the words (including 'legal tender') that are printed on every dollar bill. Basquiat, who is under pressure to produce new work for expectant clients, is turning his art into money, using his painting as the Romans used salt, as a currency. The composition mimics that of a dollar bill, particularly the two panels to the left, where the middle lifebelt-shaped circle is indented, and the 'evil eye', as the artist called it, is peering out just as it does from the top of the pyramid on the reverse side of a dollar bill. But Basquiat has included two heads, not one, the first of which is a helmet (CASCO is Puerto Rican Spanish for helmet). The second figure is almost certainly a self-portrait, which was probably informed by the Aztec era Mask of Tezcatlipoca, the god of the night sky.

The more you look, the more you see. Blood-sucking bugs are clearly on the artist's mind: PARASITES, FLEAS and LEECHES (numbered 46 and 47 because, Basquiat said, the list of leeches is so long). Is he referring to those voracious art collectors, who he felt were sucking him dry and leaving him creatively DEHYDRATED?

What about the words in the middle? They are hard to make out at first (Basquiat thought semi-obliteration made you look harder), but read: ROACHESS DEHY-DRATED AS A RESULT OF BORIC ACID. Is he celebrating the success he's had with boric acid (a popular powder product that kills cockroaches through dehydration) in getting rid of an infestation in his studio? Or is he talking about the art world, or drugs, or making a link back to salt? And then there's the panel on the right with white lettering coming out of a black background, which says: INTRODUCTION (painted out) TO PLUTO, and above it, ACADEMIC (mostly painted over) STUDY OF THE MALE TORSO.

The only male torso depicted belongs to the black figure, which, supposing it is a self-portrait, makes sense of the scoring out of the word ACADEMIC, as Basquiat had no formal training as an artist but had intensely studied Leonardo da Vinci's anatomical drawings. The body was a subject he had been interested in since childhood after a car knocked him over when he was seven or eight, which led to a lengthy stay in hospital and the removal of his spleen. His mother gave him a copy of *Gray's Anatomy* (possibly the inspiration for the name of his band) as a source of ideas for drawings.

The Bible and slavery are alluded to in the words SICKLES and MATTOCKS, which appear in the bottom half of *Notary*'s right-hand panel. They are a cross-reference to the opening minutes of the movie *Downtown '81* (shot 1980, released 2000), in which Basquiat

stars. As he walks through Lower Manhattan wearing his trademark oversized overcoat, a voiceover introduces the character he is playing, which is basically himself:

> JEAN [voiceover]: Are not princes kings? Ancient and honourable neither sword nor spear dispersed into the four corners of the earth. For the sickles, for the mattocks, for the forks, for the axes. And the earth was formed as void. Darkness upon the face of the deepest spirit moved across the water and there was light. It was good.

You can spend days decoding and deliberating over the images and words spread across *Notary*'s huge 180cm x 401cm surface without ever being certain how they all fit together. I suspect Basquiat would have struggled to explain the logic of each and every element. He was a fan of William Burroughs's cut-ups, of Marcel Duchamp's acts of chance, of DJs' sampling. He liked the idea of revelation through random acts and oblique combinations. The concept of taking elements from different sources and throwing them together appealed to him. He would work on five or six paintings at a time, adding a bit here, removing a section there. Ideas made their way from one canvas to another as the artist built up the visual equivalent to Phil Spector's famous Wall of Sound: a full-bodied work of art that, when looked at in its entirety, is a symphonic expression of Basquiat's personality, talent and experience of life in early 80s East Village.

Notary is both personal and universal. It is a snapshot

of the artist's mind and soul, and an account of how we all think and perceive. Whatever it is we think we are looking at, we are seeing it through a messy montage of half-thoughts, senses and peripheral images. Nothing is ever seen in total isolation.

Life got better and then a lot worse for Basquiat after *Notary*. On the plus side, his art-loving fanbase continued to grow. He developed a very close and rewarding relationship with Andy Warhol, who took on the role of mentor, confidant and colleague – resulting in a poorly reviewed exhibition of collaboratively made paintings (1984–5). He also benefited from being represented by some of the most respected art dealers in the business. But there was an equally big down-side. His life was spiralling out of control, just as it did for his hero Charlie Parker. Both men were hooked on a toxic mix of heroin, booze and enablers. Of course, Basquiat knew all about Parker's early demise at thirty-four; maybe he even considered it a romantic, artistic end. 'If that's what it takes,' he used to say. When Jean-Michel died of a drug overdose in 1988 at the age of twenty-seven he left behind over 1,000 paintings and 1,000 drawings. He was prolific, but exhausted. His mind had recently turned to the idea of being a writer, a craft he had mastered in the shortest of forms in his graffiti and paintings. There was certainly more to come from him, a developing view of the world to share.

He started out wanting to be a fireman, then a cartoonist, before fixing on art at fifteen. It would become his life, and his life would become his art. His view of the

modern world as a living collage of multiple concurrent stimulations was original then and seems highly prescient now in today's social media age. He recognized that we all see through a blizzard of images, sounds, smells and feelings. Nothing is experienced in isolation; everything is contextualized by everything else. It's messy, but as Basquiat showed us, it can also be beautiful.

Rembrandt: Seeing Yourself

Rembrandt gives us a masterclass in
the art of self-perception. He never
flinched from taking a long hard look
at himself. He knew that every
twitching muscle, every little wrinkle,
every blotch on the skin, revealed
something of the inner soul.

If I could see like anyone I would like to see like Rembrandt (1606–69). The master of the Dutch Golden Age saw so clearly. It didn't matter if he was painting a wealthy merchant or drawing a destitute peasant, his inquisitive eye pierced through the external appearance to reveal a living soul. The images he produced were the polar opposite of those posed photos we see posted on social media. They, like the art of classical antiquity, often present an idealized and, ultimately, unreal account of life as it is. Rembrandt, on the other hand, cut to the chase. He had no interest in the superficial and the formulaic. He knew beauty wasn't skin deep – that it resided within. That's why he took such trouble to portray the

character and thoughts of his protagonists, which he could gauge by carefully watching the articulation of their facial features. I suppose you could say he painted people inside out.

His favourite subject was himself. Not because he was a narcissist, but because he didn't charge a sitter's fee and was readily available 24/7. Back in the seventeenth century, when Amsterdam was a major global centre such as Manhattan is today – a bustling, multi-cultural metropolis full of rich folk and job opportunities – life models were expensive to hire and in short supply. Rembrandt the model, on the other hand, didn't cost the artist a single guilder and did exactly as he was told. From his early days as an apprentice painter in his home town of Leiden, thirty miles south of Amsterdam, to his dying days as an impoverished widower, he painted, drew and etched dozens of images of himself. His last completed painting, made a few months after the tragic death of his son Titus, is a self-portrait. In fact, his final three paintings were self-portraits, one of which is owned by the National Gallery in London. It shows us a sixty-three-year-old man with a bulbous nose and rheumy eyes: an unsentimental picture of an artist coming to the end of his life.

Rembrandt peers out with an attentive, open expression – not the irascible fellow described by some of those who knew him. His days might be numbered but he remains unwavering in what he must do while still able, which is to paint. His expression is one of

concentration, of an artist fully focused on the matter in hand: a canvas is on his easel and it needs to be finished. Given his circumstances, which were gloomy to say the least (bereaved, bankrupt and out of fashion), it is a remarkably candid self-portrait.

Rembrandt was too down-to-earth a person to be interested in a purely nostalgic self-examination into the ravages of old age, although he makes no attempt to gloss over the physical toll of the passing years. His main concern was with the picture itself, with getting it right. It is, therefore, first and foremost a study of a painter at work, even though he finished it by placing his hands clasped together, resting over his ample stomach. He is looking at himself, not us. His quizzical countenance is that of a master craftsman making sure the blob of thick impasto paint heavily applied just below the left eye is giving the correct impression of a deep fold in the skin. Maybe he's not sure about the catchlight dab of white paint on the end of his nose. Is it a little too big? Or a fraction too far to the left, perhaps?

This constant to-and-fro, this process of appraisal and reappraisal, is how good artists become great artists. Rembrandt had been at it for more than forty years, evolving his technique as he went along, always striving for an effect that would reveal a truth beyond the descriptive power of words. *Self-Portrait at the Age of 63* is the result of a lifetime of experimentation by an artist who depicted people as they really were; quite literally, warts and all.

The first thing we see is Rembrandt as he physically saw himself – an old man wearing a golden-brown beret and a matching robe with a fur collar. He poses as he would when painting: shoulders at an angle, his head facing forward. Behind him is a plain, earth-coloured background; to his right is the single light source which illuminates one side of his face. Grey, curly hair sprouts out from beneath his silk hat, framing his large, wrinkled forehead with its many lines accentuated by the fall of the light. The artist's ears are full and fleshy, his nose large and pitted. Chubby cheeks glow below pensive dark eyes – his skin mottled and pale, but not his red lips, which are surrounded by tufts of facial hair.

There is no attempt to varnish the truth, no wish to idealize in the manner of Leonardo or Raphael. This is a candid picture that rewards scrutiny. It is more than a self-portrait, it is a self-assessment: a reckoning. Rembrandt has painstakingly built up the image with multiple layers of translucent paint to create this uncompromisingly honest account of how he saw himself shortly before he died. He is giving us a masterclass in the art of self-perception. Every twitching muscle, every little wrinkle reveals something about the inner spirit.

Forty years earlier, while still living in his home town of Leiden and sharing a studio with fellow artist Jan Lievens, the young Rembrandt spent many days drawing and etching himself making exaggerated facial contortions: angry, laughing, shouting, scowling, surprised and so on. His initial intention was to amass a memory-bank

of staple expressions that he could use for portrait com-
missions and 'tronies' (a Dutch word for face), a popular
genre in seventeenth-century Netherlands in which
stock characters pulled faces or were dressed up to rep-
resent a 'type' – Vermeer's *Girl with a Pearl Earring* is
perhaps the most famous example. Rembrandt made his
fair share of these commercially lucrative characteriza-
tions of clichéd expressions, but it was his early
investment in learning how to portray these 'typical'
mannerisms that would pave the way for him to venture
far beyond the booming market for theatrical poses. By
repeatedly studying and recording his own features, he
learnt how the copious facial muscles operated when
activated to produce any given expression. The human
eye gets all the credit for being the window into some-
one's soul, but in truth, it changes little beyond the pupil
dilating and contracting. It is merely a tiny peephole into
the inner character; the face is the picture window.

Over the decades Rembrandt perfected how to read
the psychological state of people from their outward
appearance. Subtle changes in how facial muscles inter-
acted would, for example, enable him to determine if a
person was smiling politely or smiling wholeheartedly.
Of course, artists have long been knowledgeable about
anatomy and muscle structures, but few have used that
understanding to such startling effect as Rembrandt.
He treated the muscles of the face as a composer uses
the keys of a piano, to develop and resolve complex
expressive relationships, to create mood, and to reveal

the true nature of his subject. All of which he com-municated with extraordinary precision through the textual effects he used when painting flesh, rendered with loose, unblended brushstrokes.

Look again at Rembrandt's *Self-Portrait at the Age of 63*. Notice the attention the artist has paid to the facial mus-cles that lie hidden beneath the surface of his blotchy skin. None are depicted in the exaggerated, fully deployed state of the experiments in expressiveness he made in his early twenties. Instead, the artist has repre-sented their unseen presence with great subtlety and skill. Those that operate the upper oral section of the face – around the cheekbones – are engaged but not tensed, in much the same way as the orbital muscles around his eyes. The muscle group beneath the cheek-bones is working a bit harder, which can be detected by the slight pursing of his lips creating a deep semi-circular crease in the lower cheek.

There were reasons beyond financial considerations and convenience for Rembrandt choosing to use himself as a model. To gain the level of understanding of how the inner personality affects outward appearance required more than the occasional glance – it demanded the sort of impertinent, close-up staring to which freelance life models might not wish to submit themselves. Rembrandt might have been a famous painter, but even his biggest fans – of whom had been many, including the rich and powerful – would baulk at having his hot, stale breath an inch away from their face for hours on end.

The artist had no choice but to cast himself as the lead in many of his paintings. Honesty was the key. Rembrandt realized that if you want to know yourself, you have to be true to yourself even if that meant an unflattering portrait. Affectations had to be abandoned, defences had to be dropped. If he had a huge spot on his face that day, so be it. This was not to be dogmatic, but because the blemish would affect how he saw himself and that would be evident in the minuscule modifications he'd notice in his expressions. For Rembrandt it was the whole truth and nothing but the truth, otherwise what was the point?

He hadn't always seen so clearly. When he was a young apprentice painter, he studied and practised Italian Renaissance styles. The young artist did his best, but the high colours and staged poses so popular with fifteenth-century southern Europeans were as alien to him as Brussels sprouts are to children. He wasn't a bright red, gold and blue sort of artist. He preferred the earthy colours, brown, green and purple, with a muted background against which he'd introduce a flickering light to pick out a cheek or a glint in the eye.

His early breakthrough was to abandon the deeply ingrained impulse of artists and patrons alike to idealize their subject matter. From the sculptors of ancient Greece who produced beautifully proportioned heroes with supermodel figures, to Qiu Ying's stylized images made during the Ming Dynasty, art has long been in the thrall of perfection. Rembrandt wasn't having any of it.

As a working-class lad from a large family of millers, he couldn't relate to a sanitized view of the world – he was far more taken with the grubby realities of normal people struggling to make a living in the rat-infested, plague-affected streets of Amsterdam and Leiden.

An Old Woman Reading (1655) is a wonderful painting, uncompromising in its unflattering portrayal of an elderly lady with a careworn, lived-in face, whose long bony fingers support a large leather-bound text resting on her knee. She is wearing a white blouse and a brown cape with a hood that surrounds her face. The open book is the only source of light, suggesting it is the Bible – the illuminating word of God. It is as the title accurately describes, *An Old Woman Reading*, with an emphasis on the verb. The picture shows her reading, not peering blankly at the pages, but *reading* them. You can detect from her facial expression that she is totally immersed in the text; there is a palpable connection between her eyes and the unseen printed words. It is an example of Rembrandt's lifelong interest in physiognomy – the revealing of a person's character and mood through their outward appearance. You can imagine the old woman's nature from the picture. She is, like most people we encounter, unnamed and unknown. She could be sitting in any train carriage or library in the world. Yet there is nothing mysterious about her.

There is something to be learnt from the great Dutch master about how we, too, can see and understand ourselves better. We're never going to compete with him on

canvas, but we can gain a better insight into our psyche by following his lead, which is to take a long, hard look at ourselves and render what we see in a self-portrait. The result might not be a great work of art but at least it'd be a selfie with a bit of soul.

Christo and Jeanne-Claude: Seeing Spectacularly

If there is a purpose to art, it is its
capacity to make us look at the world
differently: to show us something new
or to see the commonplace afresh.
Christo and Jeanne-Claude's *Wrapped
Reichstag* succeeded on both counts.

We humans have always had an irresistible urge to adorn
ourselves and our surroundings. We dress up in unnec-
essarily fancy clothes, hang jewellery from our bodies,
and decorate our skin. Our habitat comes in for the
same cosmetic treatment. From the prehistoric cave
paintings of southern Africa to the street art of modern-
day São Paulo, we like to mark our territory with
expressive designs. Typically, these are carried out by
local people working on a small scale – a Banksy stencil
here, an ancient ochre handprint there. Sometimes we
undertake a more monumental ornamental project, such
as the Great Sphinx of Giza in Egypt, or the Olmec
heads of Mexico. As a rule of thumb, though, when it
comes to the art we produce outside, it is either small

79

SEE WHAT YOU'RE MISSING

and ephemeral like a sandcastle or big and permanent like the Statue of Liberty. Occasionally, very occasionally, artists combine the epic and labour-intensive with the fleeting gesture, such as when the performance specialists Ulay and Marina Abramović walked from either end of the Great Wall of China in 1988 to meet briefly in the middle for a kiss. They were not the only art-making couple who combined the momentary with the monumental. While Ulay and Marina were concocting their dare-devil exploits, like balancing a primed bow and arrow in front of their bodies, Christo and Jeanne-Claude were hatching plans to cover the world in silk.

They were the husband-and-wife art-duo who in 1969 covered the coastline just outside Sydney with a million square feet of fabric and, in 1985, shrouded the Pont Neuf in France – the oldest bridge in Paris – in a luxurious golden chiffon-like textile. The effect was the same on both occasions: the instant transformation of the overlooked and familiar into a new, eye-catching, crowd-pleasing, media-friendly phenomenon. Unlike the Land Artists of the 1960s and 70s, who tended to make work that stuck around a while (Robert Smithson's famous *Spiral Jetty* in Salt Lake City is the most famous example), Christo and Jeanne-Claude limited their grand interventions to a few days. Photographs documenting the event ensured posterity; its temporality gave it the frisson of an art happening.

Some critics don't rate them (Jeanne-Claude 1935–2009, Christo 1935–2020), having been put off by their

cultivated public persona – her hair was dyed an improbable copper colour, he had his eccentric mad-scientist act – but that is to misunderstand the seriousness of their actions and the sincerity of their art.

Their most famous creation was *Wrapped Reichstag* (1995), a truly audacious piece of artistic showmanship. If there is a purpose to art, it is its capacity to make us look at the world differently: to show us something new or to see the commonplace afresh. *Wrapped Reichstag* succeeded on both counts. Cloaking one of the most politically charged buildings on the planet in a million square feet of silvery-grey fabric, secured by ten miles of blue rope, undoubtedly had the effect of making a lot of people view today's home of Germany's parliament in a completely different light. To that extent, it can be regarded as one of the great masterpieces of twentieth-century art, seen in person by 5 million people in fourteen days, and hundreds of millions more on television and in print. It was the work that brought international fame to Christo and Jeanne-Claude and their unique way of seeing.

Most artists consider an art gallery a controlled environment away from the distractions of normal, noisy life, in which their work can best be seen and heard. Christo and Jeanne-Claude didn't agree; they had an alternative perspective. They thought the best way to give art a voice was to take control of an environment and turn normal, noisy life into an art gallery. Christo used to describe their motivation as a desire to 'borrow

a public space to create a gentle disturbance for a few days'. Hence, erecting 7,503 metal gates draped in a saffron-coloured diaphanous material in New York's Central Park in 2005 – a 'catch-me-while-you-can' 23-mile walkway, a 'gentle disturbance' that reverberated around the world.

Their art was based on transforming a physical space for a short amount of time into an artwork that changed the nature of the subject and its surrounding environment, and, in turn, its inhabitants. They saw the potential of public icons – a historic bridge, a city park, a government building, a beloved beauty spot – to jolt people into seeing and feeling with greater intensity. Their interventions required the scale to surprise, the elegance to attract, the potential to be transformed, the fame to shock, and a fleeting quality to maximize attention. They were responding to the regulated life to which we are subjected, from the architecture of our urban centres to the layout of leisure areas. Every inch of our every step has been designed, from lampposts to pavements, hedgerows to highways. Christo talked about how we are constantly 'funnelled', twenty-four hours a day, in a *Truman Show*-like existence. Jeanne-Claude said they 'create works of art of joy and beauty'.

But their projects are much more than that. *Wrapped Reichstag*, for instance, transformed the meaning and purpose of a major civic building, from being a political structure made of cold, hard stone with a character of immutability and permanence, into a transitory public

sculpture with an air of soft fragility and gentleness. A Teutonic edifice had become a tender moment.

The artwork would not have been as successful if they'd chosen another building, say the nearby Brandenburg Gate. It had to be the Reichstag. Not simply for its dominant physical properties, but also for the way it pervades everything around it: a visual presence that becomes part of the whole piece. Christo and Jeanne-Claude did not limit their art to the structure with which they worked, they included everything within its orbit. They understood that every landscape – urban or rural – had a key motif, which, if correctly identified and interacted with, would fundamentally change the physical and psychological nature of the subject and its environment. They could see the spectacle in the spectacular.

Christo Vladimirov Javacheff and Jeanne-Claude Denat de Guillebon were born on the same day, at the same hour, in the same year – 13th of June 1935 – but in very different circumstances. Christo came from communist Bulgaria, which he loathed. His mother worked at the Academy of Fine Arts in Sofia, an institution Christo would attend before going to Prague to study theatre design. His father ran a textile factory. It is no coincidence that Christo's career would be based on his parents' occupations. He soon realized there was nothing for him in what he described as the 'stifling' and 'horrible' Soviet regime that controlled the Eastern Bloc in which he lived. On the 10th of January 1957, when he was twenty-one years old, he escaped, crossing the border between

Czechoslovakia and Austria: 'I was alone, no relatives, alone myself . . . walking in the woods.' He spoke only Bulgarian and Russian.

He went from Vienna to Geneva to Paris in 1958, where he earned money by painting portraits. The wife of a French army general saw his work and asked him to come and paint a portrait of her daughter, Jeanne-Claude. The young woman thought Christo ridiculous and was mean and rude to him. He painted her again. And again. She changed her mind about him. They fell in love, got married, had a son (Cyril), left for New York in 1964 and found a studio in the SoHo district. Jeanne-Claude continued to be mean to him, because 'he liked it', she said. He described her as 'a very critical person'. Anyway, it worked. She did most of the talking, much of the business, and looked after negotiations. He drew pictures of their proposed artworks, which they would then sell to raise the funds to realize the project. They put great store by self-funding their work, refusing commissions however lucrative they might be (there was talk of an offer of $1 million to appear in an advert on Japanese television).

An early work that set the tone for what they would go on to produce was *Stacked Oil Barrels and Dockside Packages* (1961), an installation in Cologne harbour in which Christo had assembled a precarious pile of oil barrels and covered them with a tarpaulin secured with rope. It looked more like a dust-sheet thrown over some rubbish waiting for collection rather than a piece of contemporary art, but it led to a much better work.

Iron Curtain: Wall of Oil Barrels (1962) had all the hall-marks of a Christo and Jeanne-Claude collaboration. It was a cheeky, witty, politically subtle subversion of public space. It consisted of eighty-nine metal oil barrels stacked to form a 4m-high barricade across the Rue Visconti, a 140m-long street which connects Rue Bonaparte and Rue de Seine in Paris. It is one of the narrowest thoroughfares in the city and has at various times in the past been home to Balzac, Delacroix and Racine. The allusion to the Berlin Wall, which had been built a year earlier, is obvious. But it was also referencing the capital's revolutionary past in 1830, when the streets were peppered with barricades, a year in which France invaded Algeria and began to subject the North African country to colonial rule. By 1962, when the work was installed, the Algerian War of Independence was reaching its end, with violent clashes once again taking place on the streets of Paris, with deadly consequences. By this time barricades were not the exclusive preserve of France, they had also become a symbol of protest in Algiers.

Christo knew exactly what he was doing with *Iron Curtain: Wall of Oil Barrels*. He was speaking with lived experience of state violence, having witnessed the brutal tactics of oppression employed by the Nazis and the Soviets. He had something important to say, and Jeanne-Claude, by diverting the police while the work was being installed, was his willing and able artist-accomplice.

All their best work had a distinct point of view about our world, how with an architect's rigour and an artist's

eye our senses could be reawakened to the beauty before us. They talked about the 'total irrationality' of their work, that 'nobody needed it', which wasn't to say it was pointless, only that it didn't have a specific purpose. It wasn't part of the capitalist system. It didn't have a reason to exist beyond the artists' desire to make it real, driven by their impulse to show us all something incredible. They used their spectacular vision to awaken our dulled senses to the world around us. Whether it was a giant orange curtain hung across a mountain pass in Colorado, or a fence of white sheets running along the countryside of Sonoma and Marin counties in northern California, they created a sense of awe – of the sublime – to remind us how vast this universe in which we all exist is. The reason their works were ephemeral is because life is ephemeral. The joy their art exuded was a *joie de vivre* – life is as fragile and beautiful as a silk sheet blowing in the wind.

Christo and Jeanne-Claude operated largely outside the gallery system. Their self-funded work, which cost millions of pounds, represented the culmination of a long gestation in which the project forced its way into existence through their persistence: because 'it is in our hearts', Jeanne-Claude would say. Some ideas would take years to realize, others decades. *Wrapped Reichstag* came about after twenty-four years of lobbying by the artists against naysayers as powerful as Germany's then chancellor, Helmut Kohl. He was adamant it would not happen, but the will of his parliamentary colleagues and

1. Seeing Nature: *The Arrival of Spring in Woldgate, East Yorkshire* (2011) by David Hockney

2. Seeing Clouds: *Cloud Study* (1822) by John Constable

3. Seeing Through Pain: *Las Dos Fridas* (*The Two Fridas*) (1939) by Frida Kahlo

4. Seeing Music: *Composition VII* (1913) by Wassily Kandinsky

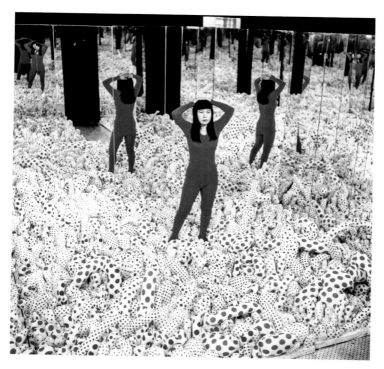

5. Seeing as Therapy: *Infinity Mirror Room – Phalli's Field* (1965) by Yayoi Kusama

6. Seeing for Real: *Notary* (1983) by Jean-Michel Basquiat

7. Seeing Yourself: *Self-Portrait at the Age of 63* (1669) by Rembrandt

8. Seeing Spectacularly: *Wrapped Reichstag, Berlin* (1971–95) by Christo and Jeanne-Claude

9. Seeing Ambiguity: *Gone: An Historical Romance of a Civil War as It Occurred b'tween the Dusky Thighs of One Young Negress and Her Heart* (1994) by Kara Walker

10. Seeing as Alternative Reality: *The Annunciation* (*c.*1438–45) by Fra Angelico

11. Seeing with Your Mind: *Earth's Skin* (2007) by El Anatsui

12. Seeing Isolation: *Office at Night* (1940) by Edward Hopper

the enthusiasm of the people of the recently reunited Germany prevailed and the project went ahead.

It cost Christo and Jeanne-Claude over $15 million, involved working with hundreds of stakeholders and required employing countless specialists, from structural engineers to 100 rock climbers to abseil down the sides of the building to unfurl the aluminium-coloured material. For a Bulgarian refugee, standing by the side of the Reichstag – once a politically divided building, now a symbol of unity through his and his wife's art – it was a moment of extreme pleasure tinged with fear. Christo couldn't banish the thought of a secret police officer surreptitiously approaching to take him away to a Soviet jail. The fact that he could stand there, a free man, nearly forty years after fleeing communism, on the scar beneath his feet left by the Berlin Wall, was something to celebrate with a beautiful, sensuous work of art. *The New York Times* sent Paul Goldberger, its architectural critic, who wrote this about what he saw: 'It billows in the wind, it glows in the sun, it is tailored as primly as a dress and engineered as heavily as a battleship. *Wrapped Reichstag* . . . is at once a work of art, a cultural event, a political happening and an ambitious piece of business.'

It's a suitably thoughtful summation of a remarkable work of art, although I'm not sure about the 'ambitious piece of business'. Christo and Jeanne-Claude appeared to do all they could to lose money. They paid for their own projects (most of which never saw the light of day), tried to avoid charging the public, and lived in a house in

New York that had buckets hanging from the ceiling to catch the water coming through the roof. Any money they did make went straight into their next project. Theirs seemed to be modelled as a Marxist practice, where the workers owned the means of production and its distribution. Money wasn't their *raison d'être*, it was art.

They imagined projects that the rest of us found unimaginable. They saw things that enabled the rest of us to see. Their subject was reality, not once-removed like most artists, but the real thing elevated to the point of visibility: a revelation through concealment.

Kara Walker: Seeing Ambiguity

Kara Walker's silhouettes open up a
discussion about identity. They explore
the gap between representation and
reality. They help us see the limitations
of certainty and the possibilities of
ambiguity.

Kara Walker's art is about many things – race, gender,
slavery, violence, humour, history – but more than any-
thing else, it is about the equivocal nature of power.
Specifically, the shape-shifting qualities of power as seen
through the eyes of a deeply thoughtful African-American
female artist born in 1969, who talks about the act of
making art as one of 'colonizing' a blank piece of
paper.

The point being that if you have power, you have
agency. If you don't, you don't. You are at risk of subju-
gation and servitude; of being a blank piece of paper on
to which the powerful can assert their will. Walker's art
explores power from the point of view of an unreliable
narrator. She is never absolute or absolutely clear about

who has it and who does not: for this artist power is not binary, nor is powerlessness – the two are complicit and intertwined. They are both open to reinterpretation and reallocation. When Walker observes power and thinks about how it relates to past events and her modern life, she sees one common, consistent thread: ambiguity.

Walker shows us power in play and power at play, but she never fully identifies it. The artist doesn't provide answers to the issues and questions she raises. That is not her intention. Her work is about making us conscious of the power of power and its slippery ways, as she has explained: 'I'm really interested in making work that explores the power struggles in history, and the mythologies that inform the way we see ourselves and perceive others. Particularly around race and gender.'

She has observed that we all live by one myth or another, an inherited version of history and cultural belonging to which we subscribe, that is neither fixed nor even necessarily real. I, for example, was brought up in Britain, a country of whose empire I was taught to be proud. It was a central part of our national identity when I was growing up in the late twentieth century. Not any more. Today it is often cited as part of a national infamy; a myth the entire nation once believed in has now been largely debunked. Walker's work is about the hold such myths have over us, influencing how we see the world and ourselves. She notes that they often go by unchallenged, which is why she makes work designed to give us a shake, to question our certainties, and to encourage an

acceptance of doubt as a way of seeing that can provide greater clarity and insight.

Kara Walker paints and draws and writes, and – on rare occasions – makes large public sculptures. Her signature medium, though, is the silhouette: an inexpensive form of shadow portraiture named after Louis XV's penny-pinching finance minister Étienne de Silhouette, whose hobby it was to cut out paper shadow portraits. Walker has breathed contemporary life into the opaque art of the paper cut-out. For nearly three decades she has been making huge, wall-filling tableaux of genteel-looking silhouetted figures behaving badly. Sex, torture and bloody deaths are rife in her theatrical narratives, which toy with racial and cultural stereotypes.

Her silhouettes look so pretty, but there's always something ugly going on. They are alluring, then alarming. That's how it's been from the very beginning, from the time her work was first shown in a public exhibition in New York in 1994. Back then, Kara was a promising, recently graduated twenty-four-year-old art student with a MFA in printmaking and painting from Rhode Island School of Design, in Providence. She'd come down the east coast looking for a teaching post, but wound up meeting a couple of curators who liked the look of her silhouettes and invited the young artist to take part in a group exhibition at the Drawing Center on Wooster Street, SoHo. She accepted the invitation, and exhibited a work called *Gone: An Historical Romance of a Civil War as It Occurred b'tween the Dusky Thighs of One Young Negress*

and Her Heart (1994). Its title is as long and elusive as the installation itself, in which the artist takes on the role of a fictional storyteller:

> I kind of like the idea of the museum kind of has to lower itself to speaking to an audience that maybe would not anticipate seeing work by a black girl. So I position myself as the Negress, some other character who has created this work from some other time.

Gone consists of a 15-metre-long series of vignettes, which might or might not be interrelated, performed by a cast of characters cut out from black sheets of paper by the artist using her trusty craft knife. Her handmade figures do little to bring clarity to the story: they are two-dimensional in every sense. We are presented with paper-thin silhouettes boasting exaggerated physical features that intentionally play to trite racial stereotypes. Individual identity and humanity are erased by catch-all cultural clichés, leaving us with stock characters taking on archetypal roles.

Except, nothing is ever quite as it first appears in a Kara Walker cut-out. Her work is a provocation, a challenge to our preconceptions of power and identity. The blank void of the silhouette is particularly well suited to creating ambiguity. It makes the uncertain appear certain. It plays on the imagination. We tend to fill in the blanks with our own prejudices and assumptions, thinking a quick glance will do when the truth can only be fully revealed with a proper look. She talks about the

'complete obliteration of the details of a scene, relying on a generalization to get the point of an image across', and describes the 'similarity between the silhouette and other forms of stereotyping, racial stereotyping in particular'.

At first, *Gone* might appear to be a charming mural making witty use of a shadow-portrait technique that was popular at the same time as the historic events being presented on the wall. A young couple lean forward to kiss in a pastoral landscape populated with people seemingly enjoying some leisure time. Given the attire of the canoodling white couple on the left-hand side of the artwork, it is reasonable to assume we are in nineteenth-century America. So far, so romantic. But the mood darkens when you notice the moss dangling from the tree to the side of the lovers, which suggests the action is taking place in the slave-owning antebellum South. You begin to realize that this is not a pleasing, bucolic idyll, but an uncanny place with menacing undertones. Welcome to Walker's world of slapstick and malevolence.

Protruding from the hem of the young woman's fashionable hoop skirt are not two legs as one might expect, but four! To whom does the spare pair belong? We don't know, but the lady doesn't appear to care, she's having a good time. The deportment of the man suggests he has the power, the upper hand, as he bends gallantly towards his fawning lover without the faintest idea of what's going on 'backstage' under her skirt. Maybe it is she who

is holding all the cards? Or the person to whom the spare pair of legs belongs. Meanwhile, the end of the soldier's sword pokes the bottom of a crouching black child who is holding a dead duck by its neck while shouting to a reclining black woman, who is possibly his mother. She is lying in the water as if she were a boat-cum-chaise-longue, which could be a reference to slave ships or to Titian's famous painting of a reclining Venus. Or neither. Behind her is a rock occupied by two young people. One is a white boy standing with his left leg out in front of his body, which has been rendered in such a way as to suggest the kneeling black girl is giving him a blow-job. I say all this, but gender, age, race, intention and action are all open to interpretation. What appears as grotesque or grim ('punch in the gut' imagery, as Walker calls it) might actually be perfectly innocent if it could be viewed in detail, rather than seen through the shadowy medium of a silhouette. There seems to be less ambiguity about the young male character floating in the air above the couple on the rock, who appears to be in possession of a massive, inflated penis that is carrying him off like the old man in the house in Pixar's movie, *Up* (2009). Then again, maybe he is being transported by the hooded figure of death. Ambiguity reigns.

Back on *terra firma* there is a dancing woman giving birth to twins, and another female figure with a broom and a kerchief headscarf spitting out a stone while impaled on the head of a well-dressed 'gentleman' figure who is carrying her blindly along. Thus, the satire-infused

story begins and ends with stereotypical Jim Crow-era Southern women – one who looks wealthy and white, the other poor and black – who have unseen heads up their skirts. And so it goes with Walker, who has spent her professional life investigating her country's past to understand how it informs its present:

The story that I want to talk about always comes back to an American mythology that involves race, slavery, and sado-masochistic construct that underlies the American history narrative.

Gone was a career-making, career-defining introductory work by the then completely unknown artist. She became established very quickly: a precocious art star who found fame immediately rather than waiting the decades it can take others. *Gone* remains a career-defining piece, seen by many as one of her best. It is now owned by the Museum of Modern Art in New York, which compares it to an epic history painting referencing power and oppression and the American Civil War via Margaret Mitchell's 1936 novel *Gone with the Wind* (a literary reference alluded to in Walker's title for the work).

To this the artist added: 'The history of America is built on . . . inequality, this foundation of a racial inequality and a social inequality . . . And we buy into it. I mean, whiteness is just as artificial a construct as blackness is.'

Within three years of the Drawing Center show, Walker was awarded the prestigious MacArthur Foundation Achievement 'genius' grant (she remains one of its

youngest ever recipients), and became a regular exhibitor in upmarket museums and galleries. She was barely beyond her mid-twenties. Things were going very well. Too well, for some, including Walker herself to an extent, who had to live – and live up to – being the young hot-shot artist. 'How d'you do it, Kara?' people wanted to know. Critical friends began to morph into critical enemies, as fellow artists from a previous generation started to call her out for making work that perpetuated racial clichés and caricatures. A letter-writing campaign was organized by an artist to persuade peers to lobby museums and insist they stop showing the young artist's work. That wasn't the end of the attacks, either. Walker faced criticism for making art for white folk and white-owned and managed spaces. Her response was to go back to work. After all, that is where her power lay. Paradoxically, Walker's art is all about exploring the dehumanizing effect of reducing people to stereotypes, the very thing she felt her critics were attempting to do to her.

Kara Walker was born in Stockton, California, to Gwendolyn and Larry. Her father was an artist and academic, who accepted a job at Georgia State University, Atlanta, when Kara was thirteen. He convinced the family – who were very happy in multi-cultural Stockton – that the Southern state that was about to become their home had changed its ways and now welcomed black families. That was not to be his daughter's experience. She quickly sensed an awkwardness around

race she hadn't experienced in Stockton, which made her question her own sense of self and identity. After high school she studied at Atlanta College of Art, a place she found to be creatively stifling and intellectually confusing. She couldn't understand why she was attracted to the grand painterly gestures made by famous European and American male painters. What power did they have over her? Did she need permission to compete? Did she even want to compete? How come they were so certain? Why wasn't she certain? What was it she wanted to say, and whatever it was, how did she want to say it?

I was really trying to explore the problematics of making art as a young black woman when constantly barraged and faced with a host of stereotypes about what it even means to be a young black woman.

Her creative breakthrough came when she left Atlanta to study for her MFA in Rhode Island. It was there that she started to experiment with the cut-out silhouette and understand its place in the history of image-making. She learnt about how the silhouette was used in the eighteenth century for pseudo-scientific studies into physiognomy, where facial features are considered a way of determining a person's character. She became aware of shadow puppet theatre and the development of modern animated films. By the time she arrived in New York in 1994 she had found a way of producing pictures that combined her ability to draw with a literary urge to tell stories. It enabled her to explore, through art, the

intellectual issues with which she was grappling, particu-
larly the narratives people create about themselves as a
way of establishing an identity and being part of a
community.

Kara Walker argues through her work that power is
often contradictory, and moral certitude impossible. Her
art opens a discussion about identity and how the idea
of someone can be very different from the actual per-
son; that representation is not the same as reality. That is
why her silhouettes are so important: they help us see
the limitations of certainty and the multiple possibilities
of ambiguity.

Fra Angelico: Seeing an Alternative Reality

Fra Angelico understood that the
world as we perceive it is not a fixed
reality. There are multiple alternative
realities. To see them, you have to
change your point of view.

Photographs trigger our unconscious. An old holiday
snap brings with it a flood of memories that instantly
take us back to that beach with those people doing that
thing. Great art can be equally transporting. It can carry
you from your world into the one the artist has created.
To stand in front of a mythical landscape by Claude
Lorrain or a patchwork interior by Njideka Akunyili
Crosby is to experience something close to time-travel.
There you are, in the space they have created, feeling the
atmosphere, relating to the events depicted.

Pictures are powerful in that way. A fact that has not
gone unnoticed by the wealthy and imperious wishing to
infiltrate our minds. Kings and queens and assorted dic-
tators have long used pictures to reinforce their status as
unassailable, positioning themselves as a semi-deity or a

commander of a vast army. Big business plays the same game. It spends huge sums of money commissioning aspirational ads for products and services we generally don't need but find hard to resist when tempted by an eye-catching glossy image. Ad agencies make a fortune from harnessing the transportative power of pictures, but they are no match for the fifteenth-century Catholic Church when it comes to the art of pictorial propaganda. It recruited the best image-makers it could find to create persuasive art that told the Biblical story while reinforcing the Catholic creed. The list of artists who have participated in this ongoing marketing campaign is long and illustrious, from Leonardo da Vinci to Andy Warhol (who made a pink version of Leonardo's *Last Supper*). Artemisia Gentileschi, Peter Paul Rubens and Raphael also did their bit for Catholicism. But few did more for the cause than a man called Guido di Pietro, a pious chap born near Florence, Italy, in or around the 1390s (nobody knows exactly when).

Facts about the young Guido are sketchy. He had a brother and a sister, and parents who were probably reasonably well off, as they could afford an artist's training for their talented son. It is thought he took up an apprenticeship with the respected painter and book illustrator Lorenzo Monaco (Lorenzo the Monk), which was a plum job. Illustrating or 'illuminating' books in the early fifteenth century was not quite what it is nowadays. Books didn't cost a few pounds back then, they could cost the equivalent of a penthouse suite in a luxury hotel.

The skilled craftsmen employed to provide illustrations and adornment to manuscripts were highly regarded and extremely well paid.

Some time between 1418 and 1423 the deeply religious, twenty-something Guido entered the convent of San Domenico in Fiesole, a picturesque town in the hills above Florence. When he took his vows to become a monk he needed a new name for his new life. Guido chose Fra Giovanni as his nom-de-monk. And that is what he was called henceforth, until some years after his death in 1455, when he was posthumously referred to as the 'Angelic painter' and became known throughout the world as Fra Angelico (the angelic friar).

The name was an afterthought, but the friar's fame and reputation were well established within his lifetime. There was no other painter in Christendom who could create images with the same meditative aura. Vasari, the sixteenth-century artist and charismatic chronicler of the Italian Renaissance, described Fra Angelico's art as 'beautiful beyond all praise', and 'full of grace and beauty'. Warming to his theme, Vasari says of Angelico's painting *The Annunciation* (c. 1438–47) that it is not 'like the work of a mortal hand, but as if it had been painted in Paradise . . . the picture appears to be the handiwork of a saint or an angel, which indeed it is; hence most rightly was this good Monk ever called Fra Giovanni Angelico'.

Vasari's fulsome acclaim was not always warranted, but on this occasion, he was spot on. Fra Angelico was

very special. He combined a formidable intellect (the Dominican Order were known as the scholar-monks), a profound spirituality, and a remarkable artistic gift. To put it succinctly, he produced some of the most exceptional paintings ever made in the Western canon.

He created what would become his magnum opus after moving down the hill from Fiesole to take up residence at the convent of San Marco in northern Florence. The complex of buildings had been the happy home to a community of Sylvestrine monks, but they were told in no uncertain terms to vacate the campus in 1418 on account of being lazy. That was not the case with Fra Angelico's more high-minded Dominican Observants, who moved into the San Marco convent, which had been newly refurbished by the super-wealthy Cosimo de' Medici.

Cosimo was a major player in the politics of Florence. He and his family had made a fortune from banking, boasting a clientele that counted the Pope among its number. There were several other fabulously rich families in the city, most of whom had also made their money from the recently professionalized banking industry. The Republic of Florence was oligarch central, a place of big egos and large wallets, which was mighty handy when it came to paying for a militia to fight off the unwanted attacks by the Duke of Milan and the King of Naples. The Florentines prided themselves on their governance and flourishing intellectual life, which saw the people-centred philosophy of Humanism thrive, thanks

to the Tuscan trio of Dante, Boccaccio and Petrarch. They had returned to the ancient works of Cicero, Aristotle and Plato to bring scholarship and literary light to the Dark Ages, and duly ushered in a new age of reason and scientific enquiry. Fifteenth-century Florence saw itself as the Rome of antiquity reborn (hence 'Renaissance', from the Middle French *renaistre*: to be born again), and Cosimo de' Medici had his eyes on the prize of being the emperor.

He was politically astute, extremely ambitious, and a master of the reputation-enhancing game of patronage. Funding the redevelopment of San Marco for the benefit of the devout Dominican monks made complete sense strategically. In the long term it bought him a place in heaven, while more immediate political and social returns could be derived from an allegiance with an increasingly influential monastic order. Cosimo's largesse went beyond building a new campus for the monks to live in and pray, he also footed the bill for a new library, and for the finest painter in Florence – Fra Angelico – to decorate many of the interiors.

Florence in the early 1400s was like Paris in the early 1900s and New York in the late 1950s: it was the centre of the cultural universe. Many of the greatest painters, writers and architects of the period had lived there: Dante, Cimabue, Giotto, Ghiberti, Brunelleschi, Donatello, Masaccio and Fra Angelico (later came Michelangelo, Leonardo, Botticelli and Galileo). They coaxed each other to ever greater achievements, to which a new dimension was

added around 1420 when the architect Filippo Brunelleschi rediscovered the lost laws of mathematical perspective, which the ancient Romans had used to design their famous symmetrical buildings. He developed the technique of 'one-point' linear perspective, enabling the architect to draw the three-dimensional structure of a building accurately and realistically on a flat piece of paper. It was a mathematical system based on having a single vanishing point into which all horizontal lines receded, to create the illusion of volumetric space. It was an epoch-defining breakthrough which provided artists with a formula to compose pictures based on Brunelleschi's system. Now, they too could accurately and convincingly create the optical effect of three-dimensional space on their flat canvases, into which characters could be correctly sized and placed.

Fra Angelico was an early adopter of Brunelleschi's laws of perspective, which he used extensively when painting the new frescos Cosimo had commissioned for the San Marco convent. Taken together, the frescos (painted with a little help from his Dominican friends) amount to one of the great works of the Florentine Renaissance. Most famous, perhaps, is Fra Angelico's aforementioned depiction of *The Annunciation*, which the monks would have encountered daily as they walked up the steep stairs to their first-floor dormitories. Today, it would be called a site-specific artwork, meaning that to fully appreciate it you really have to see it in situ. Obviously you can't right now, but it is worth briefly looking at

the picture from below by holding the book above your head. For that is the elevated angle from which the artist intended the painting to be viewed, explaining why, when seen at eye level, the perspective looks a little faulty and the shadows oddly weak. From below, though, it makes perfect sense, as a dynamic single-point perspective draws you into the image like a cool sea on a hot day.

The picture was doing a specific job. It was there to act as a mental and emotional reset for a well-fed monk climbing the stairs back to his modest cell for some post-lunch contemplation and prayer. The depiction of this famous scene from St Luke's gospel, of the Angel Gabriel informing Mary she was to be the mother of Jesus, was a popular subject in the Renaissance. Fra Angelico had already painted it more than once, but previous versions were more colourful and pictorially busy. The San Marco *Annunciation*, though, is spare to the point of austerity – and for good reason.

It was not a work of art intended for a wealthy banker or political high-roller; it was for the humble monks of San Marco. They already knew the story very well, so no need to add entertaining embellishments to gain their attention. What they needed was an image to help transport them from the quotidian tribulations of the real world to the threshold of God's magnificent spiritual realm. Fra Angelico's solution was inspired. He conceived a painting that would dramatically change the way in which the monks perceived their own surroundings. As opposed to presenting the scene in a fictional

setting, which was usual, the artist shows the meeting between Gabriel and Mary taking place in the courtyard of the San Marco convent. The same San Marco courtyard the monks had only just walked through to get to their cells.

The painting presented an alternative reality to the monks, nudging them into a different way of seeing their physical environment. Their familiar loggia and gardens had been transformed by the artist from an area for relaxation to the setting of a major Biblical event. The implication being that the convent was not merely their earthly home but a celestial dominion they were sharing with the Angel Gabriel and Mary, mother of God's only son. Fra Angelico was suggesting that the Annunciation isn't some ancient event but an entirely relatable occurrence in the Christian story that can exist in the here and now: it is relevant, it is part of their daily life. He was encouraging his fellow friars to realize there is more than one way of perceiving the world, that there is always another point of view – another reality – to be considered.

The spartan atmosphere he has evoked reflects the monks' pious existence, where simplicity was essential in order to avoid distractions, thereby freeing the mind for reflection and worship. The Angel Gabriel and Mary are dressed in plain clothes, quite unlike many Renaissance versions, which show them in highly theatrical costume. Here, though, there is a quiet intimacy, a shy exchange. The slightly flushed Gabriel leans gently

forward towards a shell-shocked Mary. Both characters have their hands crossed, Gabriel's on his chest, Mary's – unsurprisingly – on her stomach. They appear to be miming rather than talking, thereby setting the silent tone for the monks as they look up from the stairs.

In a picture with little adornment, Gabriel's angel wings stick out like a flamingo at a funeral. Maybe Fra Angelico couldn't resist showing what he'd learnt when illuminating manuscripts as a young man, or perhaps he had some paint left over. Any which way, the wings are a flamboyant moment in an otherwise sober painting that has been constructed along Brunelleschi's linear principles, with the receding columns forming converging orthogonal lines to a distant vanishing point somewhere in the forest we can glimpse in the distance.

Fra Angelico has synthesized an earlier gothic style (the flat haloes, the lack of a depth of field in the front garden) with Brunelleschi's new geometric approach. Mary is enclosed within the loggia, suggesting innocence and chastity, whereas Gabriel has the tip of one wing going beyond the column and out into the garden, a sign that he is, literally, on a flying visit. The spiritual world he represents, and Mary's corporeal existence, are separated by the central column in the foreground. She appears far too big for the space when looking directly at the painting, but not when seen from below as intended. The doorway in the background also seems too small – whatever angle it is seen from. This is no accident. Once again, Fra Angelico is preparing his

fellow monks for the coming hours of solitude and thought. The small doorway in the painting is very similar to the small entrances to their cells a few metres away. It is, to that extent, something of a trompe l'oeil, a painterly trick of the eye that the monks would find repeated when they entered their individual rooms.

Their cells were plain and simple, but also amazing. Each had a bed, and a window, and – this is the amazing bit – a fresco by Fra Angelico depicting a scene from the Bible. Once again, he placed the action as if it were happening there and then in the room, with every architectural detail mimicked to generate a sense of holy intimacy and immediacy. His psychological games went as far as adding important Dominican Order saints to the images, such as its founder, St Dominic, and first martyr, Peter of Verona. The idea was to directly link the Biblical event with the monks themselves, placing their founders in the picture as observers. The message was clear – their cell was a place to emulate what they could see in the painting: St Dominic self-flagellating, or Peter Martyr praying.

Fra Angelico's frescos are wonderful, exceptional works of art. But there is more to them than being pleasing images. They are conceptually ambitious. He was taking the monks on a journey through time, placing the Christian story in a contemporary setting to demonstrate that the physical spaces they were inhabiting could be reinterpreted and reimagined to such an extent that their sense of reality fundamentally changed.

The paintings are as much about the nature of our imagination – memory and consciousness – as they are about the Christian story. The world we see and experience is not fixed. There are alternative realities right there in front of our eyes. Take a hospital, for example, which is a place of work for a doctor while simultaneously being a place of rest and recovery for a patient. A high sea puts the fear of God into a swimmer, while being a joy to behold for a surfer. A rainstorm will ruin a summer wedding but bring the garden to life. There is no fixed reality, as this friar-painter demonstrated – it all depends on your perspective.

El Anatsui: Seeing with Your Mind

If you take a concept like the
omnipotence of God . . . you don't
have anything visible before you to
reproduce. This has been a strong
influence . . . looking at the world
through the mind. Trying to distil
essences rather than use images.
 – *El Anatsui*

One day in 1998 the respected Ghanaian sculptor El
Anatsui was pottering along a country road not far from
his studio in southern Nigeria when he happened upon
a large bag that had been pushed under a bush. Not
being one to miss the opportunity to pick up some
scraps of wood or clay for his art practice, he dragged it
out and peered inside. There was no wood or clay, just
hundreds of aluminium liquor bottle tops. The artist
delved deep into the centre of the bag and was struck by
the lightness and brightness of the tops. It wasn't heavy
to lift, so he swung it over his shoulder and carried it
home. He didn't exactly know what he was going to do

with the contents but instinctively felt the tops had potential. Not as functioning bottle caps as originally intended, but as a material with which to sculpt and communicate.

> I saw the bottle caps as relating to the history of Africa in the sense that when the earliest groups of Europeans came to trade, they brought along rum originally from the West Indies that then went to Europe and finally to Africa as three legs of the triangular trip.

This statement captures El Anatsui's way of seeing. He looks beyond an object's original purpose, to contemplate what meaning it might contain within – however humble the item. There is something to be gained from his approach, from appreciating the everyday 'stuff' that surrounds us. Where you or I might ignore what we consider to be worthless bits and pieces of rubbish – such as the bottle tops – he sees value and possibilities and histories. Not necessarily in the object's current form, but in how it could be reused and reborn. And so, an old log becomes an abstract sculpture about colonial rule and the environmental crisis in Africa. Clumps of clay waste are fixed together to create fractured pots that represent instability and flux. 'If art is about life, then life is not a fixed thing,' he said, '[therefore] the artwork should be in a form that is capable of changing.'

I'm not suggesting you spend your weekend randomly going through public bins looking for inspiration, but it is worth taking a note from El Anatsui and considering

those materials that we routinely discard in our disposable world. Might all that supermarket packaging we take home have a useful afterlife beyond going to landfill? Are we missing something in our desire to have the latest product? El Anatsui has built a career and some memorable art from upcycling the unwanted. Not because he is an eco-warrior, but because he sees the merit of working with locally sourced materials. It gives his art soul.

'I believe that artists are better off working with whatever their environment throws up,' he says. 'I don't think working with prescribed materials would be very interesting to me. Industrially produced colours and paint – you are better off picking something that relates to circumstance . . . as your practice.'

The discarded bottle tops are a case in point. For this artist, the medium is the message – the symbolism is baked in. Not only did the liquor caps refer back to the colonial slave trade, they also spoke to contemporary life in western Africa, having been made in Nigeria – not Europe – and thus uniting the two cultures in a shared history. El Anatsui takes an object and turns it into an idea: the concrete becomes a concept. He argues that the great European artists of the Renaissance made art using their eyes, whereas he 'sees' with his mind:

If you take a concept like the omnipotence of God or a concept like versatility, and you want to encapsulate it you don't have anything visible before you to reproduce. So this has been a very strong influence in my career.

This aspect of looking at the world through the mind. Trying to distil essences rather than use images.

This process of distillation was evident with the aluminium tops, which, after a considerable period of contemplation, he decided to use as a sculptural material. He experimented with bashing them flat and connecting them together using copper wire. The bottle seals, he discovered, could be rolled out into oblongs, or made into translucent rings. Soon he had built up a sheet the size of a large plate, consisting of 200 crushed metal tops arranged in narrow strips. He made another 'block' of a similar size and then another and then another. He laid them all on the floor and played around with different combinations. When he happened upon a pleasing composition he sewed the blocks together with more copper wire, which created a patchwork quilt effect in a design that was closely related to traditional Ghanaian *kente* cloth.

His first bottle-cap sculptures began appearing in 2001, with more soon following. They started big and became huge. *Earth's Skin* (2017) is colossal. At 10m x 4.5m it is roughly the size of a double-decker bus – a monumental mosaic curtain of colourful caps that have been bashed and twisted into a beautiful golden abstract wall hanging with sharp creases and deep folds. It is a miracle of sorts: worthless rubbish recycled into valuable art through the imagination of an artist who recognizes the potential in what others throw away. An

artist who uses the abundant and cheap materials which surround him and waits for them to 'suggest' something to him.

As with all of El Anatsui's aluminium artworks, *Earth's Skin* was the product of a collective, community endeavour. Thousands of individual bottle tops and seals were stitched into multiple blocks by dozens of studio assistants over the course of many days, resulting in a broad palette of colours and textures, which the artist works into an all-over design to create his copper-stitched, giant metal tapestry. 'What I'm interested in is the fact of many hands . . . when people see work like that, they should be able to feel the presence of those people,' he said in a 2021 *New Yorker* profile by Julian Lucas.

Earth's Skin is sensational in every way: a modern masterpiece that speaks of contemporary wastefulness and wanton consumption while celebrating the communal spirit of his local town and the visual culture of the region. The sumptuous abstract design is mesmerizing and alluring from a distance, yet disconcerting at close quarters, when the writing on the liquor bottle tops becomes legible and the implications sobering.

El Anatsui, now well into his seventies, has lived a fulfilling and varied life centred on art and ideas. He has become a world-famous sculptor, an exalted position achieved entirely on his own terms from his base in Nsukka, Nigeria. His works can be found in the Asele Institute in Nimo, the Museum of Modern Art in New York, the Pompidou Centre in Paris and the British

Museum in London, as well as in dozens of other public and private collections. He has been awarded the prestigious Golden Lion for Lifetime Achievement by the organizers of the Venice Biennale, and the Praemium Imperiale International Art Prize. He has received honorary doctorates from Harvard University, Kwame Nkrumah University of Science and Technology (his alma mater) and the University of Cape Town. He has also been elected an honorary member of the Royal Academy of Arts, the American Academy of Design, and the American Academy of Arts and Letters. These are just a few of the many interesting facts about the septuagenarian artist, but none will stick in your mind quite like the piece of biographical information I am about to give you. El was not his parents' first-born, nor was he their second-born, or their third – or tenth. He was the last-born, their thirty-second child.

I learnt this eye-popping fact from an excellent talk given by Sir David Adjaye, the Ghanaian-British architect, at the Haus der Kunst in Germany, in 2019. Adjaye's speech was part of a programme of events built around El Anatsui's career retrospective at the Munich museum. The architect was invited as Anatsui's friend, but also because they are collaborators. The two men share an interest in the intersection between traditional West African graphical language systems and modernist, international visual arts. Adjaye spoke of Anatsui's profound curiosity in the long-established mark-making and pictograms to be found in Ghana and Nigeria, such

as *nsibidi, adinkra, uli* and *vai*. Adjaye described them as 'A system of language that exists in West Africa, which are the codification of rituals . . . a language that can be used with the collision of Modernism to create a new language.'

He referenced the hundreds of 'scribbles' El had produced, which emerged from his intense study of these indigenous graphical systems, while paying particular attention to the works made by the women of Igbo, who decorated local walls and public objects with *uli* logographic design.

By this time Anatsui had moved from his native Ghana, to teach on the art course at the University of Nigeria in Nsukka. There he met some fellow artists and intellectuals who together would become known as the Nsukka Group. Led by the painters Uche Okeke and Chike Aniakor, founders of the art course at the university, the Nsukka Group's philosophical position was based on the idea of synthesizing traditional West African craft with modern West African society to create a forward-looking West African visual culture. The artist-teachers would also make themselves aware of, but not subservient to, contemporaneous Western art movements. It was an exciting time for Anatsui. What caught his eye in many of these traditional language systems wasn't just the signs and marks being employed, but also the negative space that was often an essential part of a design.

'I got this body of signs and spent four or five years copying them and trying to understand their structure and how they could mean those things that they said

they meant, like talking about the omnipotence of God.' Eventually he discovered the concept of 'O', meaning oneness, which, like ten, represented unity. 'It was one of the only ones I got a meaning for,' he said.

His was not a random, arcane interest, but led by an urgent and timely reintroduction of traditional West African visual culture, which had been suppressed during British rule. Perhaps it is this, more than anything else, that has shaped how El Anatsui sees. Well, that, and maybe also, being the thirty-second child!

The psychological and social effects of being the youngest in such a large family in terms of relationship dynamics is known to relatively few people, but in El Anatsui's case, at least, it appears to have given him the freedom to pursue his own path. He was born in 1944 in what was then known as the Gold Coast, a British colony until 1957 when it became part of the newly independent Ghana. Young El developed an early interest in making art, which led to his decision to become an artist, an idiosyncratic career choice given there was very little local infrastructure to support emerging painters and sculptors. The cornerstones of the modern, professionalized art scene – galleries, collectors, studios, museums, curators and dealers – were in short supply or non-existent where he lived.

But there was a palpable creative and intellectual energy in Ghana readily available for him to harness. An energy born of a desire to reclaim the African artistic traditions and culture that had been undermined by

colonialization. There was a determination to restate the Ghanaian aesthetic, in a movement captured in Ghana with the Akan sign-phrase *Sankofa* – 'go back and pick up what you left behind'. The associated proverb posited that to comprehend the present and move forward into the future, you must first understand your past.

El Anatsui went to art college and excelled, his talent and intellect officially recognized in 1969 when he was named best student of the year. He focused on sculpture, instinctively feeling it afforded him the greatest scope to experiment and communicate his ideas (he still considers sculpture the most all-encompassing art activity, as it incorporates painting, drawing, design, installation and performance). He liked his course, as far as it went. It was interesting enough but he found it hopelessly narrow, almost to the point of irrelevance, having been imported, he says, 'lock, stock and barrel' from a London art school. The dogmatic adherence to a purely Western art historical narrative troubled him, but it also provided an important provocation. There he was on the west coast of Africa looking and learning about the European art canon, intensely studying the Renaissance painters of Italy and the sculptors of ancient Greece. And yet when he went outside it made no sense to him. The art-making materials fellow students in New York or Berlin had readily available to them were less abundant locally. This was when he developed his art-making philosophy of using everyday materials that came easily to hand, from those old bottle tops to abandoned logs and scraps of clay.

In due course, El began to turn his attention to broken pieces of pottery left lying about on roadsides and in back yards. He was attracted by the fact that the pots were made from the humblest of materials – the earth beneath his feet. There was also a political message contained within both the original material and the structure of the sculptures he made from them. The pots had come from the West African soil and had been moulded by the hands of a West African artist who was reclaiming the culture and language of his land after the destruction wrought by the British subjugators who had left just two decades earlier. For El, the damage done by the British was analogous to the broken pots: a culture shattered by a colonial power remade by an African artist, their breakage signalling not the end but a new beginning, a transformation from one entity to another, as Anatsui explained at his 2019 retrospective in Germany:

> In its whole form it might be a soup pot, but the moment it breaks it passes into so many other uses. One of the uses I found intriguing was it was used as a vessel to serve offerings to the gods – a pot having died being used to serve offerings to people who have departed.

Inspired by the potential of the void as applied in *uli* designs, El thought about how the notion of negative space might be transferred to his terracotta sculptures. It was an unusual way of looking, emphasizing what was not there rather than the opposite – a conceptual rather

than literal approach. Once again, the artist was 'seeing' with his mind. He produced a series of 'broken pots' made up of fragments of fired clay and old 'grog', which he combined with other bits and pieces of cracked pots he had found. The final sculptures were awkward-shaped objects: the remnants of bowls and jugs – vessels – that were now useless as receptacles as originally intended but took on a new life as artworks.

Generally, Anatsui worked with clay when making smaller sculptures. When he wanted to go large – before the liquor top discovery – he would turn to wood. By which I mean he would find some pieces of old discarded timber of varying sizes and carve signs and shapes on to their surface. Not, I should add, with a hand chisel necessarily, but with a whopping great chainsaw! Sometimes he would paint over the marks, other times he would burn them with an acetylene torch. The finished sculptures look both ancient and modern at the same time. These works reference both the ongoing environmental catastrophe occurring across the world, and also, he said, to the destruction of colonization, describing them as 'a metaphor for the way in which Western powers had carved up and brutally divided the African continent amongst themselves ripping through and destroying both local history and culture'.

El Anatsui learnt how to see the world anew by rooting his work in the arts and crafts of Ghana and Nigeria. Instead of walking past a pile of wood on the roadside, oblivious to its presence, he recognized the potential for

transformation. After all, why shouldn't discarded timber or pottery or aluminium caps not be artist's materials just like marble or paint? They were what *his* environment had provided.

His international reputation as an artist of the highest calibre had grown steadily over the course of his long career. And then he stumbled upon those bottle tops when in his mid-fifties. His rise to prominence went from being steady to meteoric. El Anatsui became an artworld superstar. That he is one of the twenty-first century's finest artists is beyond doubt. He is a brilliant, pioneering sculptor with a singular vision: art should be of the place from whence it came. It is not a limiting idea but a liberating concept. Look around you, pay attention to the established traditions, think about the current issues, be willing to use what is readily available as a material, and leave the rest to your mind's eye. As El says, 'You are in the world but you don't know the world.'

Edward Hopper: Seeing Isolation

> Great art is the outward expression of
> an inner life in the artist, and this inner
> life will result in his personal vision of
> the world . . . The inner life of a
> human being is a vast and varied realm.
> — *Edward Hopper*

1924 was a great year for Edward Hopper. After two decades of struggle, frustration, depression and increasing reclusiveness, the forty-two-year-old American realist painter became an overnight sensation. The late-career recognition followed a sell-out exhibition of his watercolours at the Frank K. M. Rehn Gallery in Manhattan, the owner of which had only recently come across the atmospheric pictures produced by the 6ft 5 inch tall artist. It was a much needed, but wholly unexpected success for Hopper, who was making a living as an illustrator at the time, having sold just two paintings in the previous twenty years. Better still, the introspective New Yorker with a reserved countenance had also found a soulmate. Josephine Nivison was a fellow artist whom he'd originally

met at art school, then bumped into occasionally during the intervening years, and started seriously courting in 1923 when they were both well into their middle age. They married the following June, sealing a union that turned out to be the start of his art career – and the end of hers.

Galvanized by Jo's confidence in him as an artist, Hopper started to paint with oils, a medium he had long abandoned in favour of the immediacy of watercolours and etchings. She became model and muse for his paintings, often also providing a suitable title for a finished artwork. The thanks she received from her husband were not great. He insisted they lived a hermit-like life in their top-floor New York apartment overlooking Washington Square Gardens. He would routinely belittle her as an artist and when the mood took him, which was often, he would ignore her for hours on end, if not days. They had few friends, even fewer luxuries, and fought verbally and physically in the course of a marriage in which they stayed happily unhappily a couple until Edward's death in 1967. Jo died ten months later, having said she always hoped they would 'go together', writing in her diary that 'Ed is the very centre of my universe.'

Edward Hopper rightly gets the credit for his achievements, but it is no coincidence that his career was going nowhere fast until he met Jo. Theirs was a creative collaboration that produced some of the most memorable images of twentieth-century America. Landscapes, cityscapes, urban interiors and country retreats all feature in a

body of work that is remarkable for its consistency and psychological force. There are many ways to read Edward Hopper's paintings, but in essence, they are all of exactly the same subject: Edward Hopper.

The abandoned mansion on the hill, the desolate lighthouse, the guy at the bar lost in his own thoughts, the sunlit empty room – they are all Edward Hopper. He spoke very little about his work, or anything else for that matter, but occasionally he was willing to talk about the autobiographical nature of his pictures. In 1933 he wrote a short essay called 'Notes on Painting' to accompany a major monographic exhibition of his work at the Museum of Modern Art in New York. In it he wrote:

> I believe that the great painters with their intellect as master have attempted to force this unwilling medium of paint and canvas into a record of their emotions. I find any digression from this large aim leads me to boredom.

He revisited the autobiographical theme in a television interview in 1961 in which he said:

> The painter himself is the only one who can know really [what their work is about] and he doesn't make any conscious effort perhaps to reveal himself to the public but that is the aim of painting, eventually.

If anyone was left in any doubt that his paintings were about him and his relationship with the world and the woman he married, he made it crystal clear when he said:

'Great art is the outward expression of an inner life in the artist, and this inner life will result in his personal vision of the world . . . The inner life of a human being is a vast and varied realm.'

Lest he should forget the purpose of his art, he kept an amended quote by the German writer and critic Johann von Goethe in his wallet: 'The beginning and the end of all literary activity [Hopper adds: 'for literary, substitute artistic, it works for that too'] is the reproduction of the world that surrounds me by means of the world that is in me, all things being grasped, related, recreated, moulded and reconstructed in a personal form and an original manner.'

To know this is to begin to understand Edward Hopper's haunting, ambiguous paintings, in which a sense of alienation and isolation pervades. The temptation is to invent a story to fit the picture. In fact, the urge is irresistible. Within a few seconds of looking at *Office at Night* (1940), you find yourself constructing a novella around the erotically charged scene. The painting's title tells us a time and a place: an office at night. Given the social conventions in New York at the time it was painted, it is reasonable to conclude that the woman with bright red lipstick and a tight blue dress is a secretary, the anxious-looking man, her boss. We know the scene is set in the evening, and can assume – judging by the open window and billowing blind – that it is high summer. The source of light coming through the window and shining on the back wall is not obvious. The sun has set, and the office

is many floors up (according to Hopper) in a high-rise block, so it can't be a street light. It can only be coming from another office or apartment in an adjacent building, which also has its blind open, suggesting our furtive protagonists can be seen by their voyeuristic neighbours. The female figure stands at the filing cabinet looking down at a piece of paper that has fallen on the floor to the side of the desk at which the man sits. He is looking at a letter but not reading it. His mind is elsewhere. He seems worried, nervous – unsure, for sure. There is the suggestion of an illicit affair between the two. Is it over or about to begin? They are not letting on, but there is no escaping the room's uncanny and foreboding atmosphere.

It is like one of those 'spot the ball' images, where the subject of the characters' motivation has been erased. Is it the note on the floor? Or something that has just been said, or is about to be said? Or done? Or is that too reductive, too simplistic? Probably. The artist said that his pictures were not to be read as 'obvious anecdote, for none is intended'. Even so, we know, in this instance, that the original idea for the scene came when Hopper looked up at the deserted eighteenth-floor office interiors at night when travelling on public transport. After that, not much. It is a typical Hopper painting, demanding an explanation without providing one. Until you remember that the image is not about two strangers, it is about the artist and his psyche.

Jo posed for him in the role of the young secretary,

wearing, as he instructed, a figure-hugging dress that would show her calves. The man at the desk is a Hopper avatar. The composition had been playing on his mind for some time; his pictures, he said, came slowly after 'a long process of gestation in the mind, and a rising emotion'. This period of 'gestation' is evident in the preparatory studies he made for *Office at Night*, in which he experimented with various arrangements. At one point there was a large, framed painting on the back wall, with the man at the desk turned towards the woman at the filing cabinet. Another, earlier iteration shows the wooden chair to the side of the secretary in the final picture initially placed in the foreground, near the typewriter. The scrap of paper on the floor was a late addition.

All art is self-portraiture to a greater or lesser extent, but Hopper's is more knowingly so. Not in terms of producing a likeness of his outward appearance – although he is recognizable as the male figure in many of his paintings – but of his temperament, or, as he put it, his 'inner experience'. His work was both an exploration and a revelation of how he saw the world. Beyond the obvious pent-up sexual energy in *Office at Night* (he was always keen apparently, Jo not so much), it is, like all his paintings, a study of solitude. 'It is probably a reflection of my own loneliness,' he said, adding, 'I don't know – it could be the whole human condition.' It could be? It is! That is why his images resonate with us so much. Hopper's genius was to expose a widely relatable truth in

paintings that were deeply personal. Few are as solitary or spartan as Edward Hopper, but a predisposition to introspection or melancholy is not so unusual. We all know what lonely feels like, and immediately recognize it when the emotion is made visible by the artist. He saw himself as an objective, realist painter who '. . . uses natural phenomena to communicate. That has always been my aim. Perhaps, because it is a universal vocabulary.'

The natural phenomena to which he referred tended to be transient and fleeting: the light catching a man's face when glancing at a letter; a breeze blowing through a room and ruffling a blind. The loneliness he depicted with such piercing accuracy was not the obvious, such as a prisoner in a cell or a person lost in the desert. New York was his hunting ground, one of the most densely populated places on earth. There, he sought out alienation like a heron catching fish by a river bank, waiting patiently for the briefest glimpse of his prey, and then seizing it when it appeared for a fraction of a second and immortalizing it on canvas. He hunted it down in Manhattan's office blocks and cafés, and in its bars and buildings. His beady eyes saw it in the sun-soaked façade of a Victorian family house, and a late-night diner on a quiet Wednesday in summer. He slowed the world down to a standstill. Unnecessary pictorial details or adornments were edited out in a laborious process of paring back an image to its fundamental components. Light always played a central role in his paintings, to such an extent that it became an additional character. He used it

to both illuminate and intimidate: a ghostly, ephemeral presence that appears through open windows like a spirit from another world.

In an alternative life Edward Hopper would have been a film director. He loved going to the pictures. He used it as a way of trying to jolt himself out of a creative impasse, saying once, 'When I don't feel in the mood for painting I go to the movies for a week or more.' There is a noticeable nod towards legendary Hollywood stars like Cary Grant and Lauren Bacall in his buttoned-up characters inhabiting paintings that not only have a cinematic quality, but, on occasion, have cinema as the subject.

New York Movie (1939) is one of the most famous of his much-loved images. It is set in an empty cinema save for a middle-aged man and felt-hatted woman sitting two rows apart. They are watching a film. Our point of view is at the end of a row towards the back of the cinema, allowing us to see the exit and the stairs beyond. A blonde-haired usherette (Jo, once again) is leaning against the far wall by the stairs, oblivious to the movie playing on the other side of an ornate column, which divides the picture into two parts. The couple of customers are lost in the fictional world of the film, the usherette is lost in her thoughts. Needless to say, being a Hopper character, she looks troubled. The red trim of her outfit echoes the red curtains framing the stairs, the blue element of her uniform is repeated in the patterned carpet on which she stands. Shakespeare wrote plays within plays; Hopper painted a movie within a movie.

His admiration for film-makers was reciprocated from his day to ours, with directors reverentially referencing the artist's moody aesthetic. Think Howard Hawks's *The Big Sleep* (1946), or Alfred Hitchcock's *Rear Window* (1954) and *Psycho* (1960), or Terrence Malick's *Days of Heaven* (1978), or Todd Haynes's *Far from Heaven* (2002), or Wim Wenders's *Hammett* (1982) and *The End of Violence* (1997). The artist would have been pleased to know the regard he is still held in by the masters of his favourite pastime.

The movies, though, were not his primary artistic influence. A trip to Europe in 1906 proved to be the formative experience which would shape Hopper's style and thinking. He saw Rembrandt's *The Night Watch* at the Rijksmuseum in Amsterdam and realized for the first time the dramatic possibilities of accentuating light and shade. Then came a prolonged stay in Paris, where he discovered the Symbolist poets Verlaine, Baudelaire and Mallarmé, leaving him with a lifelong love of French literature and culture. While there, he was able to study Manet's paintings and Rodin's sculptures. But, more than anything else, it was the work of the French Impressionist Edgar Degas that taught him how to make evocative pictures with dark undertones. Degas's paintings of ballet dancers and barflies showed Hopper the dynamism that could be generated by aggressively cropping an image, the voyeuristic frisson evoked by taking an elevated viewpoint, and the narrative potential of having your protagonist look away from the viewer.

To this list of compositional tricks Hopper added the deployment of a bold horizontal element in the pictorial foreground to provide a structure for his psychodramas: a solid piece of scenery against which the mind games can commence. He also took liberties with perspective, cheating pictorial logic not just for his own benefit (lighting effects, etc.) but to add to the image's psychological sense of something not being quite right. He did just that with *Office at Night*, in which he simultaneously presents us with two separate framed viewpoints. The first is a bird's-eye view as seen when standing directly in front of the picture, focusing attention on the seated man. The second perspective is at a 45-degree angle and closer to eye-level. It is constructed from the vertical line of the near-side doorframe and the diagonal line established by the front edge of the desk on which the typewriter is placed. From this point of view the woman takes centre stage, with her concerns dominating the narrative.

The doubling-up of viewpoints is more than an optical trick. As with everything Hopper did, there was an implicit message attached that complemented the action taking place on the canvas. He never spelt out what exactly it was he wished to say – if he did there would be no need for a picture. But it is not unreasonable to think at least one of his concerns was the uncertainty of life: there are different ways of seeing, alternative viewpoints to consider.

We get to see what Hopper saw each and every day,

we just don't notice it like he did. A fleeting moment of self-doubt comes and goes without recourse or recall. It is only when we look at one of his pictures that the moment is remembered. Not specifically, but enough to elicit a reaction in the pit of our stomach. That slight feeling of fear and uncertainty we've buried, that passing sense of hopelessness and isolation we've ignored.

He felt them keenly and often, he knew how to place those emotions in the pensive gaze of his characters. Edvard Munch had his protagonist scream against the world, Hopper's silently yell into their souls. They are us, we who deceive with our fashioned appearances, but who if observed over time will momentarily let the mask slip and reveal an inner anxiety. That was when Hopper pounced. The man who spoke so little that when awarded a Gold Medal by the American Academy of Arts and Letters he gave a two-word acceptance speech: 'Thank you.' His medium was paint on canvas, that was where he communicated best, where he was more eloquent than most with his pensive, unsettling pictures of isolation; pictures that speak to all us lonely souls.

Artemisia Gentileschi: Seeing Dramatically

They say history is written by the victors. Maybe it is. But Artemisia Gentileschi brilliantly, gorily shows us that there is more than one way to look back at the past and tell its story.

Most art produced over the centuries has been created by men for men. The gender inequality is long-standing and embedded and evident in museum collections across the world, which are full of works that overwhelmingly present a male point of view. It is a historical bias that has gifted men the unchallenged privilege of codifying many of the narratives in art. For instance, in Western paintings, women are often portrayed with a child, or naked, or being submissive – or all three at once, such as in Giorgione's *The Tempest* (*c.* 1508), Agnolo Bronzino's *An Allegory with Venus and Cupid* (*c.* 1545), Guido Reni's *Reclining Venus with Cupid* (*c.* 1639) and Paul Gauguin's *Te Rerioa* (1897). That is to name but a handful from a very long list of the objectifying tropes of female representation designed to please the male gaze.

The situation is not quite as dire nowadays, although it is still far from perfect. Female artists rarely receive equal recognition for their work either in terms of critical response or market valuation. That's today – imagine what it was like 400 years ago in Baroque Italy, where a woman had no choice but to be in servitude to a man: a father when a child, a husband when a teenager (the union / business transaction arranged by the men) – or, failing that, a lifetime of devotion to Jesus Christ hidden away in a convent. There were almost no political rights for women, precious little access to education, and the option of living independently was all but legally denied.

All of which makes the achievements of Artemisia Gentileschi (1593–c. 1654) so astonishing. Not only did she manage to circumvent the misogynistic culture of the time by establishing herself as a leading artist of the age, but she did so by producing paintings that radically shifted the perspective of familiar Biblical and historical stories – a staple subject for Renaissance and Baroque painters – to focus the action on bold and heroic women.

Artemisia Gentileschi successfully introduced an entirely new perspective and persona to art in the most hostile of circumstances. She gave us something as rare as sunstroke in a coalmine: the outlook of an independent, fearless, talented woman who presented popular Old Testament tales from a female point of view. Beefy blokes were recast as leery oafs, weedy women were given the old heave-ho. In their place

came female figures with attitude and agency. None more so than the young widow, Judith, whom the lecherous Assyrian army officer Holofernes invites into his tent. He has no good intentions towards her or her homeland, which he plans to destroy the following morning having had his wicked way with this local lady. But he has misjudged the situation and underestimated Judith, who encouraged him to drink too much. Which he did. And then passed out. Big mistake. No sooner had he started snoring on his bed than Judith picked up his sword and used it to remove his head from his shoulders.

Judith Beheading Holofernes (1612–13) is as gruesome a painting as you'll ever see. Blood gushes as the artist captures the ghastly moment in this most horrific scene. Holofernes's eyes bulge as the auburn-haired widow grips his beard with her left hand, while using the sword in her right hand to decapitate the inebriated soldier. In the background stands Judith's maid, a willing accomplice to her mistress's gory act.

The fable had been painted many times before, most notably, perhaps, by Caravaggio (1571–1610), whose techniques and style Gentileschi adopted, then adapted. But her interpretation of the protagonists is quite different from that of the recently deceased Caravaggio, who portrays Holofernes with the beefcake idealization of an ancient Greek male nude, with light catching the general's rippling muscles, while his biceps bulge and his nipples stand erect. Artemisia, however, gives us a rather different perspective. Her Holofernes is an

altogether flabbier figure, lacking any of the erotic vitality of Caravaggio's version. The difference in characterization is clear, but not as obvious as their alternative portrayals of Judith. Caravaggio shows us a blonde ingénue whose facial expression suggests she's fretting over a flower arrangement rather than chopping off a warrior's head. Artemisia's Judith is far more assertive. She is not a dainty individual of the male imagination; she is a determined young woman going about her business with the concentrated intent of the local butcher on a busy Saturday morning. Her forearms are bulky, her hands are the size of plates. There is no hint of squeamishness in her unsmiling expression, she is cool and professional.

Gentileschi's picture is more than a contrasting depiction of the same event painted by Caravaggio a decade earlier. It is a revolutionary moment in art, in which a female hero is presented by a female artist with what were considered 'male' qualities. Judith is a strong, unemotional leader displaying daring and brutality in equal measure. We are presented with an old story that has been given new life by a painter willing and able to challenge preconceived ideas. She refused to accept standardized versions of Judith as being accurate; she knew what it was to be a woman in a man's world, which didn't have to mean automatic subservience. She knew what it was to fight to be heard, to be believed, to be taken seriously. Judith wasn't hoodwinked into entering Holofernes's tent – it was all part of her plan. She

recognized that you had to fight fire with fire, as Artemisia knew only too well from first-hand experience.

She was born in Rome in 1593. Her father, Orazio Gentileschi, was an artist who had befriended Caravaggio and learnt his dramatic chiaroscuro lighting technique, where the painter accentuates the contrast between light and dark to model forms and create a sense of drama. Orazio soon recognized that his daughter shared his artistic talent and made her an apprentice in his studio. She quickly made an impression.

In 1610, when still only sixteen years old, Artemisia painted *Susanna and the Elders*, another classic Old Testament story. It tells the tale of the virtuous Susanna – who is trying to have a private bath – being spied on and harassed by two lecherous men. They threaten her by saying if she refuses to succumb to their advances they will accuse her of adultery, a sin punishable by death.

It's a remarkably accomplished picture for one so young, completed under the tutelage of her father, Orazio, who possibly had a hand in its creation. The modelling of Susanna's nude body, the colour-mixing used in the rendering of the garments, and the play of shadows are all techniques she was still learning from her father. But the emotion and palpable menace the painting transmits are pure Artemisia. For her, it was personal.

Unwanted and uninvited sexual advances were not unknown to her. She could relate to Susanna's ordeal. And more. Around the time she was working on this

painting her father began a collaboration with an artist called Agostino Tassi, who aggressively pursued Artemisia. She rebuffed him. He attacked her. She fought back. But he was too strong.

Tassi stood trial for her rape in 1612. He was convicted, but not before the court had tortured Artemisia by crushing her fingers until she screamed. They wanted to be sure she was telling the truth. 'It is true! It is true! It is true!' she testified through the pain.

It is an event that has come to define Artemisia Gentileschi as an artist and as a historical figure. Some commentators suggest that *Judith Beheading Holofernes* is a piece of revenge art. It might be, in part. But to limit it and the woman who created the picture to such a reductive reading is to underplay, and possibly miss altogether, her significance as a major figure in the history of art.

First and foremost, Gentileschi was an exceptional artist. Her mastery of composition, colour and line is there for all to see. Her rendering of figures is highly sophisticated, as is her dramatic use of light. Added to this is the atmosphere she conveys in her pictures, which is unrivalled. Artemisia Gentileschi should be considered among the all-time greatest painters, regardless of her back-story or gender.

True, she might well have pictured Tassi in her mind as the blade plunged into one of the many male characters in her shock-and-awe paintings. But that was not why she made them. They were commissions. Such scenes were all the rage in seventeenth-century Italy,

where Baroque art, with its exaggerated flourishes and operatic theatricality, lent itself to bloodthirsty grand narratives. There is a cinematic quality to her work that has influenced film-makers from Orson Welles to Martin Scorsese. Nowadays people go to the cinema to see a horror picture. Back in Baroque Italy, folk queued up to see horror paintings.

Artemisia left for Florence after the trauma of her trial, with a newly acquired husband whose job was to play second fiddle to her talent. She announced her arrival with not one, but two versions of *Judith Beheading Holofernes*, followed by the fantastically furtive *Judith and Her Maidservant* (1614–15), which gives us the next scene in the story, showing the two young women looking to make a dash for it with the freshly severed head of the soldier in a wicker basket.

The paintings were designed to have an attention-grabbing quality, which helped them catch the eye of the rich and discerning in Florence, including the all-powerful Medici family. Artemisia went on to make a name for herself in one of the most competitive markets for an artist in the world. She became the first woman to be accepted into the Accademia delle Arti del Disegno. Collectors wanted her work, which was every bit as good as that of her male peers but had the added allure of novelty. Artemisia knew this perfectly well, and wasted no time pressing home her advantage by producing a number of self-portraits in the guise of female martyrs. They had the double benefit of being excellent

promotional vehicles for her talent, while also being relatively cheap to make (she didn't have to pay the sitter).

Self-Portrait as Saint Catherine of Alexandria (1615–17) sees Gentileschi as the fourth-century Christian martyr Saint Catherine, another woman who had endured torture at the hands of men. She faces us in three-quarter pose, head slightly tilted, with an inscrutable expression on her face. Her left hand rests on a broken wooden wheel (Catherine wheel) inset with metal spikes, a modification designed to break her bones before killing her. Her right hand, which holds the martyr's palm, is held against her heart.

Its golden arch is echoed by her halo at the top of the picture and her shawl at the bottom of the frame. A single light source catches the white sleeve of her shirt, accentuating its presence at the front of the picture plane. Your focus is then drawn towards the folding fabric of her red silk dress, before moving upwards where you catch her beady left eye, which meets you with a hint of admonishment.

To that extent *Saint Catherine* is a self-portrait of Artemisia Gentileschi, an artist who succeeded because she had the wit and the skill to not accept blindly conventional narratives but to see them afresh. She removed the blinkers of assumption and presumption and showed us what we had been missing in all those classic stories – a female point of view.

Agnes Martin: Seeing Feelings

Agnes Martin did not observe the subjects she painted with her eyes, instead she pictured them bubbling up through her unconscious mind and then reproduced the sensations she experienced. Contemplation and meditation were her ways of seeing.

To say Agnes Martin (1912–2004) was ascetic would be to describe the Joker as naughty. It doesn't quite cover it. Agnes didn't so much get by without mod cons, she got by without any cons whatsoever. She lived alone on an isolated mesa in New Mexico with no running water or mains electricity. Admittedly, she did have a bath. Not tucked away in a cosy corner of her adobe shack, mind you, but outside in the yard. She would fill it with buckets of cold water at 10 a.m. and hope by 4 p.m., shortly before the sun went down, it would be warm enough to bathe in.

The story goes that she once told a man who thought they were pals that she didn't have any friends, and he

was one of them. If you were to form an instant opinion of this reclusive artist who spent forty years of her life drawing fine-gauge grids on 190cm x 190cm canvases, the inclination would be to conclude she was a dyed-in-the-wool oddball.

Neighbours who popped round offering cake and cookies were welcomed with the business end of her gun. Paintings she made that failed to live up to her exacting standards were lacerated and destroyed with a knife, accounting for about 95 per cent of her life's work. And, if inspiration didn't call, she wouldn't paint that day, week or month. On one occasion, after a very successful show of her geometric abstract art in the 1960s, she downed tools completely. For seven years.

There are two explanations for this seemingly erratic behaviour. The first was her Zen-like approach to making art, which required long periods of undisturbed solitude, and, second, she was a schizophrenic. Whether the two are interconnected matters not, the point is Agnes Martin wasn't an oddball. She was chronically ill, deeply spiritual, highly intelligent, sensitive, focused, talented and very methodical. Solitude was her source material just as a landscape painter draws from nature and a portraitist from a sitter. Being alone enabled her to see.

She was a hunter in the jungle of her imagination: stalking, watching, sensing, readied. Her prey wasn't ideas or dreams or anything associated with the material world; it was something much, much harder to track down.

Visions were her quarry, images floating up from deep within her unconscious that would appear as fully formed compositions to be transposed on to the canvas she had primed in expectation. She would sit hour after hour, day after day on a little wooden chair set against a bare, plastered wall in the corner of her sparse front room. There she would wait. And wait. And wait. Trying all the time *not* to think, knowledge being the enemy; she had to find a mode of being in which her mind was totally free to roam wherever it wanted. Thoughts were roadblocks, any disturbance catastrophic. A mentally disengaged, meditative state was the objective. Only when this had been achieved was it possible for the anticipated visual apparition to occur. Finally, when one eventually did show up, it would take a predictable form: a 190cm square, two-dimensional shape based on a linear pattern of horizontal and / or vertical lines over-painted with a muted colour. They were always abstract in appearance but categorically not in meaning. This is important. It is what sets Agnes Martin apart and makes her such an unusual and rewarding artist to know.

It is true she described her geometric grids as being Abstract Expressionist, belonging to the Color Field school that emerged in New York a decade after the Second World War when the likes of Mark Rothko and Barnett Newman painted their canvases all over in one or two colours to evoke a spiritual-like response in the viewer. Their purpose was non-objective art, art that had no hint of the real world for the viewer to latch on

to and associate with – it was designed to free us from the wearisome nature of everyday existence. There was no subject beyond the colours and patterns the artist had created and the psychological effects they might have on us. Agnes Martin *did* have a subject, which sets her apart from the pure Abstract Expressionists. In fact, she was, at heart, a figurative artist.

Her abstract images were not intended to simply evoke a feeling from a gallery-goer, they were more ambitious in design and concept. Agnes's objective was to make our inner feelings visible. Optimistic human emotions were her subject: those interior communications that we can sense but cannot see. What does the feeling of happiness look like? Or innocence? Or love? These are questions we rarely stop to ask but Agnes Martin spent the last five decades of her life trying to answer. That's what all the sitting around was about. Waiting for what she called 'an inspiration', the visual manifestation of an emotion so she could make tangible the intangible.

Ironically, for someone who professed in later life not to have any buddies, one of her most famous works is *Friendship* (1963), a 190cm-square, gold-leaf, abstract composition depicting the emotion felt when someone cares about you, and you care about them. It was painted at a time when Agnes very much did have friends, long before her six-panel pastel meditation on isolation *With My Back to the World* (1997). Before that, in the late 1950s, before her back was turned, she lived in an artists'

enclave in the semi-derelict old sail-making lofts on the Coenties Slip in Lower Manhattan. Her studio overlooked the East River, so close to the water she 'could see the expressions on the faces of the sailors'. Fellow artists Ellsworth Kelly, Robert Indiana and James Rosenquist were part of her hipster set and would drink coffee and smoke cigarettes on the roof of the building while Hans Namuth (the man who took those famous pictures of Jackson Pollock striding round pouring paint from a tin on to a canvas taped to the floor) photographed them.

Friendship captures that time in her life. It is an uplifting painting: a masterpiece celebrating affinity, which Martin arouses and exposes with joyous ebullience. This is what the feeling of friendship looks like: warm, rich, glowing and textured – an optical effect she achieved by incising a graph-paper-like grid pattern into the gilded surface revealing a red gesso beneath.

The painting is the product of decades of trial and error that saw Agnes go from portraiture to the biomorphic surrealism of Joan Miró. Almost all of this early work ended up on a bonfire. Finally, in her mid-forties, which was in the late 50s, she found a style of painting (the grid), together with a subject (feelings), that would sustain her for the rest of her life. Piet Mondrian (1872–1944), the Dutch pioneer of the stripped-back composition who also worked with horizontal and vertical lines, was a major influence. For him, the X and Y axis represented all known opposites: good / bad, hot /

cold, male / female, night / day. The primary colours he used were to express all known emotions. His paintings were always asymmetrical, a structural device he used to produce a delicately balanced tension that arrests the viewer, who is confronted simultaneously with perfection and imperfection. He makes you look.

Agnes developed Mondrian's methods to come up with her own system for producing images that had the power to attract. She took his concept of opposites, mixed in Plato's philosophy of ideal forms, and came up with a new formula of combining the flawless with the flawed. It was based on presenting what initially appeared to be a perfectly symmetrical composition consisting of a square canvas, on to which she would carefully draw a rigid grid based on a complex logarithm, before applying thin layers of paint. Order, order, everywhere. Until, that is, you take a proper look (Martin modestly recommended spending at least one minute studying one of her paintings). At which point that perceived order is undermined by the error-prone limitations of the human hand. What appeared a precisely drawn grid from afar is full of mistakes when seen up close, as the little squiggles and uneven application of her graphite pencil reveal how it jumped and jagged over her primed but unfinished (not sanded) canvas.

The gold leaf she used in *Friendship* was an anomaly for an artist who practised humility, distrusted materialism and detested pride. Typically, her palette consisted of less ostentatious colours. She began with greys,

browns and blacks before settling on pastel shades of blue, pink and off-white. The grids, the horizontal lines, and the large square canvases remained throughout. As did her hand-drawn technique, which gave a musical quality to her flat surfaces: a shimmering vibrato playing in front of your eyes.

Agnes Martin's paintings are an antidote to the exhausting relentlessness of our twenty-first-century lives. While we rush about, she sat still under the influence of the ideas and ideals of Buddhist meditation. She shut out all the noise and allowed herself to reach a state of complete calmness. 'Without awareness of beauty, innocence and happiness, one cannot make works of art,' she said. Into this stillness an image would materialize in her imagination. She didn't know where they came from, but she did know that they would come. For Agnes, seeing meant closing her eyes. And what she saw was emotion manifest. Beauty isn't something you see, she insisted, it is something you feel.

She used to play a little perception game with young children, in which she would show them a rose and ask if they thought it beautiful. 'Yes,' the child would say. And then the artist would put the rose behind her back and ask the child if the rose was still beautiful. 'Yes,' the child would say. Ah ha! Point made! You don't need to see a rose to know that it is beautiful – the very word 'rose' is enough to elicit an internal response, a feeling. Agnes's quest was to show the child – and us – what that sense of transcendental beauty actually looks like, which

she duly did in another of her 190cm creations, *Rose* (1966).

At first glance it doesn't look much. A big, square canvas with a barely discernible repeating pattern partially obscured by the application of thin layers of cream-coloured acrylic paint. At first, there is a temptation to dismiss it as a vacuous piece of modern art, yet more new clothes for the delusional emperor to parade in. But stay a while, tune in to Agnes's wavelength, let the painting come to you, and you will be rewarded handsomely. You will notice a rosy glow beneath the watery, mushroom-brown surface, and a soft, pulsing dissonance coming from the hand-drawn grid caused by the faulty squares fading in and out of focus. It is as though it has an internal life of its own, transmitting a lightness and purity through its complex surface. 'My interest is in experience that is wordless and silent,' the artist once said, before adding, 'And the fact that this experience can be expressed for me in an artwork, which is also wordless and silent.'

I was surprised when I saw *Rose* on display at the Peggy Guggenheim Collection in Venice. I became emotional, which I hadn't expected; in truth, I was a little overwhelmed. I had always known what beauty felt like, but I had never *seen* the feeling before.

There is little doubt that Martin's fragile mental state informed her paintings. She was seeking tranquillity and order among chaos; to create images of innocence and happiness to dispel horrible and dark thoughts. She did

so by looking inwards, by shutting the world out so she could see it more clearly. The hiatus between 1967 and 1973 when she stopped making art, having given away her paints and canvases, was a recalibration after becoming something of an art world star during her time in New York. She found the attention and plaudits intolerable, both creatively and morally. Pride was raising its ugly head, as was the pressure of collectors wanting pictures. It was all too frivolous for a woman born into a no-nonsense Presbyterian household in Saskatchewan, Canada.

She went away to learn how to look again, and found she could notice more when alone in nature without fuss or distractions, where she fully realized seeing wasn't about thinking, it was about *feeling*. All you had to do was sit and wait patiently for an inspiration. And that is what she did until the day she died in 2004, aged ninety-two.

Jennifer Packer: Seeing What's Not There

Jennifer Packer observes absence. It is a
way of perceiving partly informed by
her academic knowledge of Western art
history, and partly by her experience as
a black woman in America in the third
decade of the twenty-first century.

Sometimes you come across an artist who doesn't just
make you see afresh, but also makes you think afresh.
The African-American painter Jennifer Packer does just
that. The Bronx-based, Yale MFA graduate has a very
particular perspective, which gives her portraits and still
lifes a distinct sense of longing. Unlike many of us, when
she visits one of the great art institutions of the Western
world – full of famous Leonardos, Rembrandts and
Picassos – she doesn't passively marvel at the master-
pieces on the walls. She looks with an unusually critical
eye. 'When I walk through museum collections,' she
says, 'I see all the things that aren't there.'

Jennifer Packer observes absence. It is a way of per-
ceiving partly informed by her academic knowledge of

the history of Western art, and partly by her experience as a black woman living in the United States in the early decades of the twenty-first century: a post-colonial age when activist-led movements such as Black Lives Matter are shining the light of truth on endemic racism and inequality.

'I'm thinking about Black representation in portraiture,' she said on the eve of her 2020–21 exhibition at the Serpentine Gallery in London. 'I'm thinking about walking through the Met and looking at the Rubens, or any other large paintings of that nature, which are about a decadence that was funded through procuring riches from other parts of the world in questionable ways.' She notices how few black faces are depicted, and the almost complete lack of work by black female artists. She thinks about the overlooked and rejected, about what we are missing. It is 'a kind of erasure I'm interested in contradicting', she says.

We have been taught since childhood that art is for looking at, but Jennifer Packer shows us how to see beyond it. She's like a detective, using the paintings and sculptures she comes across as an intellectual provocation to fill in the blanks. A work of art is the starting point, not the endgame. She talks about going to the Contarelli Chapel at San Luigi dei Francesi in Rome when a student and encountering Caravaggio's famous Saint Matthew series (1599–1601), and understanding for the first time 'what a painting could do'. The religious art she had seen before by the likes of Michelangelo was

nice and polite, whereas Caravaggio was knee-deep in blood and guts in what she describes as a 'dark representation that seemed almost blasphemous'. He had shown her what wasn't there in earlier Italian Renaissance painting.

Unlike the even lighting in Giotto's fourteenth-century frescos or Raphael's sixteenth-century portraits, Caravaggio's paintings were full of dramatic changes between light and shadow. It meant that Christ wasn't always radiant in his paintings, as he often was when depicted by other Italian artists of the period. Caravaggio put Jesus in the shade. Not to belittle, but to humanize. For all the apparent showmanship of his painting, Packer detected a tenderness.

If 'seeing what is not there' is Packer's default position when looking at art, it manifests itself in her paintings with their recurring theme of absence. It crops up everywhere. Take, for example, *Jordan* (2014), a medium-sized portrait of three fellow artists. There's the eponymous Jordan Casteel lounging on the sofa, Tschabalala Self sitting in an armchair leaning forward, and – if you look very carefully – the face of her friend Devan Shimoyama in profile up in the top right-hand corner. They are all there but not entirely. There's an ambiguity about their presence as the figures fade in and out of view like small boats on a high sea. Tschabalala appears to melt away into her green chair in a slow disappearance – or appearance – made explicit by the time-lapse effect created by a ghostly repetition of

her head and shoulders. Devan is barely visible, a figment of Packer's imagination maybe? Jordan lives up to her star billing: she is front and centre of the picture, looking back with a relaxed expression at the unseen artist, her purple form dissolving into the sofa as object and subject become one. You sense they've been there for hours, days even. Coming and going. The painting has an abstract quality in all senses of the word; in its redacted visual information, its indefiniteness, and its abbreviated narrative. It's telling a story, but not the whole story.

Packer gives us something and takes it away at the same time. On the one hand she seems to be saying, 'Here are my friends, this is the intimate atmosphere we create together.' And then, on the other, 'You can't see inside us, this moment has passed.' She called her exhibition at the Serpentine Gallery *The Eye Is Not Satisfied with Seeing*, a line taken from the Old Testament:

> All things are full of labour; man cannot utter it: the eye is not satisfied with seeing, nor the ear filled with hearing.
>
> The thing that hath been, it is that which shall be; and that which is done is that which shall be done: and there is no new thing under the sun.
>
> — Ecclesiastes 1:8–9 (KJV)

It is rare, in my experience, to encounter art of any type – literature, music, film, painting, etc. – that

immediately excites and takes you completely by surprise. When it happens, you remember. Right down to the time and date. It happened to me when I saw Willem de Kooning's painting *Rosy-fingered Dawn at Louse Point* at 11 a.m. on the 15th of March 1992. And it happened again on the 3rd of December 2020 at 10.14 a.m. at the Serpentine Gallery in London. It was a period when we were in and out of lockdown during the Covid-19 pandemic and I had popped in to use their facilities unaware the main gallery was open. It turned out it was, and presenting a new exhibition of expressionistic paintings by Jennifer Packer. I went in not knowing what to expect. I left two hours later having experienced one of the best shows I have seen this century. Her canvases vary in size and subject: there are small flower paintings, medium-sized portraits of friends, and vast, wall-filling interiors. All are in oil, and there was not a dud among them.

Tia (2017) is a 63.5cm x 99cm portrait of a female figure sitting, feet up, in a red armchair. She leans back, head resting on a pillow, eyebrows slightly raised above a pair of spectacles that have been scratched into the surface of the paint. The sitter looks directly at the viewer with a slightly quizzical expression, a warm, calm individual in orangey-yellow clothes framed by fiery red furniture: hot colours, cool character. And then there are all those little details that Packer adds to her pictures to create a mood. The pillow is decorated with green, purple and blue flowers that chime with the floral pattern on Tia's socks: ornate flourishes on a flattened

picture plane that remind me of Henri Matisse's famous *Red Room* (1908).

His is not the only name that comes to mind when looking at a Packer painting. Her exquisite neo-gothic pictures of funerary bouquets, captured moments before the flowers wilt and wither, hark back to the Dutch 'vanitas' still lifes of the sixteenth and seventeenth centuries. And then there are the nineteenth-century French painters Henri Fantin-Latour and Édouard Manet, who brought a similar psychological weight to art-making. To them you can add Giorgio Morandi's Modernism, where the edges of his ensembles of bottles and vases vibrate on the canvas as if charged by an electric current. And then, to the artists of today, among whom you must count Kerry James Marshall, the Chicago-based painter who, like Packer, has sought to insert the black figure into the Western canon. Finally, there is her own sensibility, which is, in part, informed by the politics of America.

Sandra Bland was a twenty-eight-year-old black American woman driving her car on a main road in Texas when she was pulled over by a state trooper in Waller County for failing to use her indicator to signal a lane change. As trivial traffic offences go, it was at the inconsequential end. Yet, within minutes, the situation had escalated, with the officer forcing Ms Bland out of her car, while she repeatedly questioned the necessity for his aggression and actions. She was restrained, arrested and jailed. Three days later she was found hanged in her cell, a life cut tragically short in what some consider to be suspicious

circumstances. When the news broke it angered a lot of people, particularly the African-American community, who have been subjected to centuries of injustice and murderous violence simply because of the colour of their skin. Jennifer Packer was among those deeply troubled by Sandra Bland's death, and mourned her passing although she never knew her personally. It was another absence, another black woman erased. In 2017 she made a painting in her memory.

Say Her Name (2017) is a 121.9cm x 101.6cm contemporary classic, a still life with a pounding heart. It is a botanic eruption on a background that fades from yellow to black: an unravelling, unkempt flower arrangement made up of smudged green leaves, scumbled stalks, and the occasional pop of blue and pink blossom.

The lighting is ethereal and dramatic. You think of how the artists of the Dutch Golden Age employed the tricks of chiaroscuro to create a similar sense of emotion by using dark backgrounds and bright light. Packer achieves the same atmospheric effect but with far greater subtlety. She employs accelerated tonal transitions and a light source that blushes the surface to pull you into the dark matter of her explosive composition. It is a painting of life and death. Or, more precisely, a painting of a life after death.

What more can she say or do? Black lives matter. 'We belong here,' she said in an interview. 'We deserve to be seen and acknowledged in real time. We deserve to be heard and to be imaged with shameless

generosity and accuracy.' Her mural-sized *Blessed Are Those Who Mourn (Breonna! Breonna!)* is a mighty response to the killing of Breonna Taylor by Louisville police officers in March 2020. Fatally shot by police at her home, hers was another life cut short. Another absence. It is a monumental piece of work, made during the first Covid-19 lockdown in spring and summer of 2020. It was a moment when the world had time to think and reflect on the callous murder of George Floyd by a Minneapolis law enforcement officer.

Blessed Are Those Who Mourn (Breonna! Breonna!) has a lightness despite its size. The largely yellow palette brings peace and harmony to a room where violence seems impossible. The space is partly reconstructed, partly imagined, and partly drawn from Packer's own living room – it has a semi-fictional element, like all her work. Oil paint has been applied as if watercolour, the wet substance dripping down the white steps that dominate the left-hand side of the image. They lead to a central sofa on which a black man in blue shorts lies, his body cooled by a fan sitting on a sideboard above which is a square block of flat pink paint suggesting a cupboard.

It has an energy and sketchiness suggesting an artist working at top speed – one of those picture-a-day types. But that is not the case, as becomes apparent with closer inspection. The liveliness of the surface is the result of days, weeks and months of working and reworking – a process that takes the figurative towards the abstract.

Elements fade in and out of focus, there one minute, gone the next. The structure of the composition is rock solid, the contents as stable as a rumbling volcano.

It is another painting about absence, another image depicting something missing. Jennifer Packer has developed an eye-opening and unusual way of looking. She has taught herself to see what is not there, and to show us that what is not present tells us as much about our world as what is.

James Turrell: Seeing Light

My desire is to set up a situation to
which I can take you and let you see. I
am interested in light because of my
interest in our spiritual nature and the
things that empower us. My art deals
with light itself, not as the bearer of
revelation, but as revelation itself.
 — *James Turrell*

It is the 28th of August 2010. We, the Gompertz family,
are driving down the M1 motorway on our way from
North Berwick in Scotland to our home in Oxford, Eng-
land. We had risen early and left before 8 a.m. to avoid the
weekend traffic. The car is fully loaded: two adults, four
young children, a black Labrador dog, three sets of golf
clubs, two footballs, six suitcases, five pairs of welling-
ton boots, a single wellington boot (size 3), my wife's
wooden surfboard, a wardrobe-ful of raincoats, and
most of the contents of a local supermarket on which
we are now snacking as we make our way south.

It has become blindingly obvious that we are not the

SEE WHAT YOU'RE MISSING

only people to have adopted an early getaway strategy. The road is crawling with traffic as armies of holiday-makers return home after a long summer. The weather is good, the car is hot, and the dog is dream-chuntering. It is now 2 p.m.

We've played I Spy, Twenty Questions, Who Said What?, Spot the Intro, and the portmanteau game. We've filled up with petrol, stopped for the loo, stopped for the loo again, phoned the grandparents, tried all available radio stations, discussed who the greatest footballer of all time is, and eaten too many molten Maltesers. We've been travelling for over six hours and are not yet half-way. The traffic is getting worse. We're in second gear.

Now we're in first gear and fed up. A brown sign says Yorkshire Sculpture Park (YSP) in one mile. We've never been there, always been too busy rushing home. Not this time. We're marooned in a sea of petrol fumes and lurching cars. We exit the motorway and drive through the YSP's elegant wrought-iron gates. A sweeping road takes us to a car park. We stop, get out, and look at the view. It is fabulous. We can see for miles, all the way across the vast valley. This is the green and pleasant land William Blake wrote about in his poem 'Jerusalem'. There are several eye-catching sculptures dotted about between us and the horizon. We make our way to a large Henry Moore bronze of a seated figure, which has been theatrically installed in a large field leading down to a lake. Stiff legs from the car start to ease as we relax and roam. To our right is a low-level stone building dug into

the hillside: an old deer shelter, it says on the map. We wander in.

It is too hyperbolic to say that what we saw changed our lives, but it has certainly enhanced them. Maybe it was the element of surprise, or the late summer sun, or the relief of being out of the car and in nature. Whatever. We went in and we were awestruck.

Running around the perimeter of the modest shelter's inner walls was a continuous stone bench. It added to the chilly atmosphere, amplified by a desolate interior notable only for having a puddle stain in the middle of the concrete floor. We sat down and looked up towards the only source of light in the shelter, which came from a large rectangular opening that had been cut out of the roof (hence the puddle stain). It had razor-sharp edges, framing the space up to the cloudless sky above. The effect was extraordinary. What one imagined would be an infinite view into space became a close encounter with colour. The hole created a visual effect that made the rich blue sky appear to be pressing hard up against the rectangular frame in the ceiling only a few feet above us. It was weird and beautiful and mesmerizing. It pitted brain against eye. What seemed flat, static and fixed, one second, became detached and voluminous the next. Thirty minutes earlier we'd been bored and restless in a stuffy car, now we happily sat quietly transfixed in a damp shelter peering through a hole that was changing the way we saw the world and our place in it.

It was incredible how one simple incision in the ceiling

of a stone hut had altered our relationship with the earth's atmosphere and the universe beyond. The sky had been framed in a way that brought an uncanny focus to what is infinity: the firmament seemed almost tangible, within reach even. The scene morphed constantly, often imperceptibly, as the atmospheric conditions above perpetually altered as the sun moved and air currents shifted. We were seeing and experiencing our planet as never before, sensing minuscule changes in light to which we would normally be totally oblivious. We left having been amazed and exulted by a modern masterpiece, experienced in rural England but – we later found out – with roots in metropolitan Los Angeles.

James Turrell is a heavily set, heavily bearded American, with a great shock of white hair. He looks like a physics professor but is, in fact, an award-winning contemporary artist whose ground-breaking work is highly sought after by collectors and museums the world over. Some artists use oil paints, others carve stone: Turrell creates art with light. He is interested in our perception of the 'thingness' of light, an interest he developed as a young boy growing up in a Quaker family where 'the light within' was an idea to be contemplated. And if that wasn't enough to get a young, bright lad interested in optical phenomena, there was the added stimulus of the very particular nature of the place where he lived.

Baby James was born in Los Angeles in 1943, slap bang in the middle of Hollywood's Golden Age. They call it the City of Angels, Damien Chazelle named it the

City of Stars in his film *La La Land*, but really it ought to be called the City of Light. The bright sun and clear skies of Los Angeles are two big reasons the movie moguls set up shop there in the first place, even though it was 3,000 miles away from New York, where Thomas Edison's Kinetoscope had helped kickstart the film-making business. The inventor's original studio had a retractable roof to let in sunlight to illuminate the actors, an idea that migrated to Hollywood, where a director of photography would ask for the studio's retractable roof to be opened to let in 'God's light'.

Turrell liked the movies, but he loved flying even more. His father was an aeronautical engineer with a large library of books on and around the subject. His son devoured the texts, had his pilot's licence at sixteen, and soon after was flying missions across the Himalayas to rescue monks caught up in the Tibetan rebellion of 1959. This was not a typical training programme for an artist.

The young pilot thought deeply about perception when flying, noticing how light could sometimes appear to create space within space. He would occasionally see a contrail (a condensation trail in an aircraft's wake) intersected by a shadow, creating a division reaching vertically all the way down to the earth. The sight appealed to the teenage Turrell, a philosophical intellectual with a taste for the scientific and experimental. He went to study perceptual psychology at Pomona College in Claremont before pivoting into art when enrolling on

the Art Graduate Studies course at the University of California in 1965. He was never going to be a paint-on-canvas kind of art student, although his interest in light had been shared by artists for centuries, from Caravaggio to Monet. Turrell wanted to develop the investigations into light undertaken by the past masters a step further. He thought there might be some mileage in removing the intermediary step of producing a painting to consider the effects of light. He could see potential in cutting out the middleman and making art directly with light. That is, making art that isn't simply about light, but is made of light.

Not long after graduating, he stumbled upon the disused Mendota Hotel near the ocean in Santa Monica, Los Angeles County. To his surprise it only cost $125 a month to rent the entire building, a bargain for a studio-cum-living space. Plus, it was huge and therefore perfect for his large-scale investigations into light as an artistic material. He picked up where he left off at college and began experimenting with light bulbs mounted in high-intensity slide projectors. He discovered that if he covered all the windows in his studio and completely blocked out all other light sources, while also smoothing every surface, he could create an environment for a light 'sculpture'. With a double helping of mathematics, and a fair bit of trial and error, he found he could hide the projector in one corner while shining its beam into the opposite corner to create a remarkable effect: a bright white cube appeared as if suspended in mid-air, halfway

up the wall. It looked like a three-dimensional object, which rotated as you walked around it, as long as you kept your distance. As soon as you approached the brilliantly illuminated box it dissolved into two distinct planes of light. Turrell had made a ground-breaking piece of 'Perceptual Art'.

He continued to experiment along the same lines, manufacturing a variety of similar optical illusions by building false walls and using coloured slides or bulbs in his projectors. And then, another breakthrough. The artist scratched some lines in the paint he had used to black out the windows of the studio, thereby letting some light in from outside. His interventions were extremely specific, allowing, for instance, the lights of a car to enter the space, or the red of a traffic signal. He called this series of optical illusory works the *Mendota Stoppages* (1969–74), which were to become his first foray into making art that united inside and outside.

Turrell has talked about Plato's allegory of the cave, in which the ancient Greek philosopher tells of a group of people living imprisoned in a dark cavern without any knowledge of the world outside. The only illumination they have within the cave comes from a fire behind them, which throws shadows on to the walls of the plants and the animals that pass by on the other side of the flame, well out of view of those inside. The prisoners are convinced that the reflections are real, and talk with great authority about the shadows, not realizing they are merely phantoms. Enlightenment is beyond

their perception and, therefore, also their comprehension. One day a male prisoner finds his way out of the cave by following a light coming from above and duly discovers the wonders of reality. He returns to tell his friends what he has learnt, but they couldn't care less and plot to kill him, which, Plato suggested, was the fate of many a wise philosopher.

Not so James Turrell, a long-serving and respected artist who was not only responsible for cutting the hole in the roof of that animal hut in the Yorkshire Sculpture Park, but for a series of similar architectural interventions with the collective name, *Skyspaces*. One critic astutely described them as 'celestial observatories', which perfectly sums up our experience of being in the YSP's *Deer Shelter Skyspace* (2006). There we sat at the bottom of an ocean of sky looking up in awe to the heavens.

The idea of a light-admitting hole in a ceiling is not new, of course – it harks back thousands of years. The most famous example, perhaps, is the Pantheon in Rome, with its 9-metre-wide oculus: a spherical aperture in the middle of its dome built nearly 2,000 years ago. It was designed to let in the light from all the gods – a divine vault at the disposal of all Roman deities. Turrell's *Skyspaces* are not intended as religious works in quite the same way, but they do evoke a spirituality. Encountering one encourages a meditative silence that his Quaker parents would have approved of, even if they were a little sceptical about contemporary art in general. There is a

transcendental sense of peace and revelation as you see our world in a completely different light. A light that at once obscures and illuminates, divides and unites, appears ephemeral and substantial, and exists inside and outside – one expressing the other. Turrell says his art is a way of resetting our 'prejudice perception', and that 'we are part of creating what we think we perceive' – which takes us back to Plato's cave.

He also talks of the sky being his studio (he is still a frequent flyer and has owned several aeroplanes), and considers himself a landscape painter using light not oils, whose art does not end in perceiving a new physical object; rather, the object is a renewed physical perception. In a world of mediated experiences delivered through digital photography and media, he has said that his work is different from most contemporary art, in that it looks better in real life than it does in an Instagram post. I can attest to that. After discovering the *Deer Shelter Skyspace*, I have sought out Turrell's experiential art in galleries and in sculpture parks. I've stood in front of walls of constantly changing light that aren't walls at all, and I've been entombed in a spherical contraption called *Bindu Shards* or *Perceptual Cell*, in which you are blasted with music and light while lying trapped inside, not unlike an MRI scanner. I am entranced by his work. And, in one specific case, frustrated.

In 1974 James Turrell acquired a large ranch in Arizona. He had no real interest in raising cattle, but he was

fascinated by the extinct volcano that sat in the middle of the 155-mile plot like an abandoned citadel. It is called the Roden Crater and is at the top of my bucket list of artworks to visit, an ambition easier stated than realized. After nearly half a century, the work remains unfinished and inaccessible, other than by a private invitation. It takes his *Skyspace* concept to an epic scale. It is a *Skyspace* in a volcano! Those fortunate enough to have visited report it to be an extraordinary work of art, especially when experienced at sunrise or sunset. Nature framed by nature where light is turned into space, and space turned into light. It is a monumental artwork made with minimal interference; nature is the architect, Turrell the director of photography.

They used to call the Quakers 'children of light'. James Turrell's parents subscribed to that notion, as does the artist himself, who has spent his career encouraging us all to be children of light. I am a subscriber. The American artist's light-centric art has opened my eyes and broadened my mind. Added to which, it is much better and a great deal more fun than sitting in a sweltering traffic jam on the M1 motorway in a packed car on a hot summer's day.

Alice Neel: Seeing Souls

Alice Neel knew how to truly see people. To get a good view you need a way through their defences. Her technique was to charm, then disarm – knowing the only way to see into someone's soul is by giving them the opportunity to show it to you.

Alice Neel (1900–1984) was in her seventies in the 1970s, when she looked like an archetypal granny, what with her friendly face and jolly personality. She laughed like some people swear, easily and often. Her eccentricity was charming, as was her 'kooky-old-lady' act with interviewers, of whom there were many once she had been 'discovered' late in life.

Her anecdotes were long and rambling, frequently veering off into 'another funny story', which usually turned out to be not in the least bit amusing, but it mattered not because she was Alice Neel and everybody loved Alice Neel. Except, everybody didn't know Alice Neel. That cuddly, comforting granny persona she

presented in public was a façade behind which dwelt an implacable, troubled portrait painter with a sharp intellect and a psychiatrist's fascination for exploring the unconscious mind.

Those who did know her described a Jekyll and Hyde character, an assessment she readily endorsed. She couldn't explain why she smiled so much, she said, it wasn't how she felt, it was how she got by. It was a mask worn by the great unmasker: a portraitist with penetrating eyes that saw through a sitter's artificial countenance to reveal their true identity, for better or for worse. People came to her studio to be depicted; they left exposed. She used to boast that she could have made a lot of money from being a shrink, but it was 'more fun being an artist'.

In 1973 she painted *The Soyer Brothers*, two old friends and fellow artists of a similar age. She shows them sittingpensivelyonaredcouchinthefront-room-cum-studio of her apartment on the corner of Broadway and 107th Street, NYC. Moses and Raphael Soyer were the sons of Russian-Jewish émigrés who'd struggled their way through their careers, with modest recognition for their talents. The same art-world ambivalence applied to Alice, at the time. The brothers appear to be contemplating an uncertain future with a mixture of resignation and apprehension. They sit there, exuding a sense of vulnerability and hopelessness. It is a typical Alice Neel picture. There is something of Edvard Munch about it, of his angst-ridden man standing alone on a bridge.

Except Neel doesn't release the Soyers' pent-up anguish with an existential scream, she dwells on it like a cat teasing a mouse. The two middle-aged men sit pensively doing what many of us tend to do – bottling up their feelings of dread deep inside where they think nobody can see their pain. But Alice can: 'I love to paint people torn to shreds by the rat race in New York,' she said late in her career.

The Soyer brothers' anxiety is their problem, the fact that we recognize how they're feeling makes it ours. It is the very opposite of an Instagram image. The painting is not about the loose-fitting suits the men are wearing, or the location they are in – it is about their inner lives. You can't photograph what Alice Neel painted. Her ability to simultaneously show a sitter's conscious and unconscious state, and imperceptibly morph the two, was a magic trick of sorts. It took sleight of hand and a detective's insight to produce her uncompromising dispatches from her front room. She didn't simply paint faces, she revealed souls.

There was a well-honed method to her way of seeing. The hidden truths she exposed were not always easy to uncover; for her it was like panning for gold – a bit of sifting was required. Moses and Raphael probably didn't show up at Alice's apartment full of doom and fear. They might well have been in a great mood. After all, they were friends: coffee would have been drunk and gossip exchanged. And then, after a while, Alice would get to work. First, she'd ask them to sit down on the sofa

while she went to the stool behind her easel a few feet away. All the while she would be talking. Talking, talking, talking. Doing her eccentric bohemian act, putting her sitters at ease – not quite hypnotizing them, but certainly coaxing them to drop their guard. She didn't tell people how to pose, she waited for whoever she was painting to find a position in which they felt comfortable. This was the first step in her elaborate plan to have her subject reveal his or her true self.

If Alice thought the pose boring, she wouldn't ask the sitter to move into another position. She'd wait for them to wriggle around until they found a comfortable repose and then fix them there with an enthusiastic 'Oh, yes! That's very interesting.' The clothes the sitter chose to wear were important to Neel – she thought them an integral part of the composition. On occasion, she would paint her subject nude – she loved to paint flesh – but whether or not clothes were on or off, the artist would be talking, talking, talking.

You can sense the effect her constant chatter had on the Soyer brothers, who we see leaning forward and listening. Alice knew you learn more about someone when you watch them react to what you are saying than you do when they are in a more performative conversational mode. She has them where she wants them: attentive, silent, defences down.

To make room for the psychological complexities she wants to convey, Neel simplifies the composition. There is little obvious pictorial detail, but she has meticulously

constructed the image to draw the viewer into the personalities of the two grey-haired men sitting on her sofa.

Raphael's brown suit and blue shirt are echoed in Moses's blue suit and brown tie, a simple colour combination repeated in their faces, and again (in different tones) in the relationship between the back wall and carpeted floor. The composition has much in common with Edgar Degas's equally gloomy *The Absinthe Drinker* (1876), a painting in which the French Impressionist takes a similarly elevated view of his subjects, who are also set against a wall in the immediate background, effectively pushing them forward towards the front of the pictorial plane. The paintings share the same dynamic diagonal line running left-to-right, which is accentuated in *The Soyer Brothers* by Raphael perching a little forward of Moses on the sofa.

There is a major difference, though. Whereas Degas was evoking a mood of general despair among the alcoholics of the Place Pigalle in Paris, Neel's is a far more personal examination into the human spirit. Degas was interested in what people did in everyday life; Neel was interested in what everyday life did to people.

Ultimately, the Soyer brothers' portrait draws you to a single entry point, which is their hooded eyes. It was always the eyes with Alice Neel, for they are, as we know, the windows to the soul. As usual, she has slightly enlarged them to allow us a better look into the depths of their being. Moses's mind appears to be elsewhere as Alice talks 'off camera', while Raphael listens intently. As

she talks, she looks. As they listen, she paints. She sees by letting her subjects show themselves without knowing it – by putting them off their guard, distracted by her constant chatter. As they relax and react to what she is saying, her eyes narrow and she finds what she is looking for: the anxiety within.

In the same room in the same year but on a different sofa sat Linda Nochlin and Daisy. Nochlin was a prominent art historian who'd made her name a couple of years earlier with an essay, 'Why Have There Been No Great Women Artists?' Daisy is her daughter. They are painted in bright colours, sitting on a green sofa set against the same light blue background with the same dynamic diagonal line through the pyramidal composition.

They are in near-identical poses – Ma and mini-Ma – left hands resting on the arm of the sofa, big eyes wide open and looking directly at the artist. Daisy is keen and engaged, innocently waiting to hear yet another story from the unseen Neel. Her mother is more circumspect. She appears defensive, stiff-jawed and uptight: protective of her naive child, whose curly golden locks flow freely in stark contrast to Professor Nochlin's soberly gathered auburn hair.

That, at least, is what immediately strikes you when you see the picture. But the first look at an Alice Neel portrait is only ever the hors d'oeuvre. Look again and you see the apprehension behind Daisy's eyes and a hidden anger behind her mother's. Why so? What's up? Does Prof Nochlin regret agreeing to the artist's request

to bring her daughter along? Is she fed up with Neel's barbed comments and penetrating blue-eyed stare? Had she seen the work in progress and been disappointed that she, a person of happy disposition so she thought, is portrayed as hard and inscrutable?

Look once again at that painting and the picture will show you something quite different. The anger and uncertainty have been replaced by a powerful sense of unity between mother and daughter: an inseparable devotion bound by trust and warmth. They are in this thing together.

Linda Nochlin is still peeved, but that is superficial, it is not at the heart of the painting. The true subject of this painting is requited love: the profound affection that exists between a mother and her daughter. And that, for this particular artist – who painted a lot of mother and child pictures – was a subject she knew plenty about.

Alice Neel was high-born and carefree until she married a young Cuban painter called Carlos Enríquez, whom she'd met while at art school in Philadelphia. They went to live with his parents in Havana. Alice tried to settle and was given her first solo exhibition, but she longed to return to America. And so she did – six months after their first daughter, Santillana, was born in December 1926. She took a job in a bookshop, while Carlos posted illustrations to a Cuban magazine. Tragedy struck. Santillana died of diphtheria shortly before her first birthday. Alice and Carlos were heartbroken. Eleven months later they had a second daughter, Isabetta, which

led to a painful conflict for Alice. She adored her little girl, but then there was her painting. Carlos took Isabetta back home to Havana and didn't return. Alice's life fell apart. She had a nervous breakdown, attempted suicide, and took up with a sailor.

When all the hipster artists moved to downtown New York, she went north to live in Spanish Harlem among the poverty-stricken Puerto Ricans. She could afford a big apartment but not much else. She had two more children with two different men.

Nobody was very interested in her pictures of local black and Hispanic folk. Nor did they much care for those with white skin, either. Macho Abstract Expressionism was all the rage. Alice Neel was largely dismissed as out of step with the time, an irrelevant artist who persisted with boring old figurative painting. Luckily, she had plenty of space at home, which came in handy: all those unsold canvases had to be stored somewhere.

These were not tough years for her, they were tough decades. But, as they say, what doesn't kill you makes you stronger. Her palette became more vibrant, her painted line looser and more fluent. All the while, Alice Neel beat her own path, saying later: 'You can do anything you are willed to do if you are sufficiently tenacious and interested. You can accomplish what you want to accomplish in this world.' She knew what she wanted to accomplish, which was producing what she called 'pictures of people' that reflected the culture of the time in America. She was making a social document and a

political statement, painting the poor and the downtrodden as well as the rich and successful. She found in them all an inner truth, a vulnerability and a strength that gave them their humanity.

The Abstract Expressionists made paintings about their own anxiety. Alice Neel made paintings about ours. She talked a lot but she saw much more. She knew you can't truly see anything or anybody when the defences are up. If you want to get a good view, you need to find a way over, under, or through the barriers. Her technique was to charm, then disarm – knowing that the only way to see into someone's soul is by giving them the opportunity to show it to you.

Paul Cézanne: Seeing with Both Eyes

Within the painter, there are two things:
the eye and the mind; they must serve
each other. The artist must work at
developing them mutually: the eye for
the vision of nature and the mind for
the logic of organized sensations,
which provide the means of
expression.

— *Paul Cézanne*

Game-changing moments are rare in art. There was the invention of woodblock printing in China, but that was over 1,000 years ago. More recently came the development of geometric linear perspective, *only* around 700 years ago in Renaissance Italy. After that nothing much happened for hundreds of years beyond the introduction of canvas as an alternative to wood panel as a medium for painters. Tradition was respected, rules were applied. Until, that is, the middle of the nineteenth century when not one, but two game-changing events occurred at roughly the same time. The first was the

invention of small tubes with airtight lids which could be filled with oil paint. At once, artists were liberated from the confines of their studios to go outside and paint *en plein air* in front of their chosen subject (a mountain, a lake, etc.). Now, at last, they could finish their picture in situ wherever they happened to be rather than go through the laborious process of sketching outdoors in pencil, ink or watercolour, before returning to their studio to make the final oil painting. It also meant their pictures, created in real time, could accurately reflect the atmospheric changes occurring before the artist's eyes. The manner in which artists looked at, and recorded, the world fundamentally changed, with the likes of Claude Monet, Pierre-Auguste Renoir, Berthe Morisot, Mary Cassatt and Camille Pissarro leading the way under the collective banner of the Impressionists. There was another among their number, a rather grouchy individual called Paul Cézanne (1839–1906). It was he who transformed how we would all experience the world. His unfussy pictures stripped out the tiny pictorial details in favour of a pleasing overall design, an approach which directly led to twentieth-century Modernism. It was a radical new style brought about by the other game-changing event that occurred in the mid-1800s: the invention of the camera.

Photography revolutionized art like the aeroplane revolutionized travel. Artists were no longer compelled to act as visual documentarians, any more than holiday-makers were limited to a fortnight up the road at

Granny's. The camera set artists free; it let them loose to experiment with different ways of seeing.

All those thousands of paintings in museums around the world that were painted BC (Before Cézanne) are a little dishonest in both conception and realization. European academic painting was designed to deceive, to create the illusion of a three-dimensional world on a two-dimensional canvas. It was a visual trick made possible by composing an image from a fixed point of view with a single vanishing point (linear perspective), which had the effect of fooling the viewer into perceiving a depth of field when there was none. Their imaginary 'box of air' was achieved by artists painting their subjects as if observed with one eye only: a single lens making a single vanishing point possible. That was all well and good until the camera came along with its own single mechanical eye and challenged artists to do better. It could create an image with linear perspective far more quickly and cheaply than an artist, and with more authenticity. But its strength is also its weakness – it is a monocular machine. We, on the other hand, have binocular vision: we see with both eyes, with two lenses. Artists had been pretending to see as if they had one eye for centuries; now, at last, they could remove their metaphorical eye-patches. It was time to seriously re-think painting.

Cometh the tricky problem, cometh the tricky man. Cézanne, the loner from Aix-en-Provence in the South of France, accepted the intellectual and technical

challenge of responding to the camera with commitment and determination. He knew the fundamental problem to solve was how to represent the spatial depth of the real world convincingly on a flat surface while being true to both subject and medium. He realized the answer lay partly in artists depicting their subject from a truly human perspective, which meant showing it from two slightly different points of view – the left eye and the right eye. Of course, doing so would mean devising a markedly different compositional style, which would probably go down with the art establishment like a dodgy prawn on a cruise ship. Still, Cézanne started to experiment by painting fruit on a table-top from two separate points of view in the same image: one front on, the other from an elevated position.

Paintings such as *Still Life with Milk Pot and Fruits* (*c.* 1890) didn't so much break the rules of linear perspective as bend them completely out of shape. The horizontal table-top that once would have receded into the distance was now tilted vertically towards the viewer, effectively compressing that illusory three-dimensional 'box of air' against the flat surface of the canvas. By the rules of Renaissance perspective, the apples and lemon should be rolling off the table and on to the floor, but Cézanne had them still and steady and shimmering with life. A new way of seeing in art had been invented – using both eyes!

The result of bringing all the visual information to the front of the picture plane was the creation of images

of startlingly original intensity and veracity. There was an equality among the pictorial elements that produced an all-over design, where the composition of the whole picture was given far greater importance than any individual entity. It was a quantum step forward in how reality is recorded, but it also caused a whole heap of technical problems to solve. Chief among which was how to arrange all the various pieces of visual information into a single picture if foreground, mid-ground and background were all brought to the front, which, in effect, was like slamming the brakes on in a car causing all the contents to be thrown forward against the windscreen. Things get messy pretty quickly. According to many observers at the time, Cézanne had indeed produced a pictorial car crash ('barbaric art', they said), with a host of competing details fighting for space on the face of the canvas like rock fans in a mosh pit.

As with all great adventurers, Cézanne was guided by the wisdom of the past and the opportunities of the present. Although he had been part of the Parisian avant-garde in the late 1860s and early 1870s, and had his work included in the first Impressionist exhibition in 1874, he was not concerned with modernity to the same extent as Monet and the others. Cézanne wanted to combine the freedom technology had given artists to look at the world afresh with the great studio pictures of the old masters. He would visit the Louvre Museum regularly, to stand before the famous works by Da Vinci, Claude and Poussin and contemplate how he could match their sense

13. Seeing Dramatically: *Judith Beheading Holofernes* (1620) by Artemisia Gentileschi

14. Seeing Feelings: *Friendship* (1963) by Agnes Martin

15. Seeing What's Not There: *Tia* (2017) by Jennifer Packer

16. Seeing Souls: *The Soyer Brothers* (1973) by Alice Neel

17. Seeing with Both Eyes: *Large Bathers* (1894–1905) by Paul Cézanne

18. Seeing Intimately: *My Bed* (1998) by Tracey Emin

19. *Everyone I Have Ever Slept With 1963–1995* (1995) by Tracey Emin

20. Seeing Cycles: *Quattro Stagione* (1993–5) by Cy Twombly

21. *Quattro Stagione, Primavera* (1993–5) by Cy Twombly

22. Seeing Strangers: *An Education* (2010) by Lynette Yiadom-Boakye

23. Seeing Space: *Akari* lighting (1951 to present day) by Isamu Noguchi

of grandeur and permanence. Monet's investigations into the fleeting changes of light on haystacks were fine, but such ephemeral concerns held no appeal for the independently minded Cézanne. He wasn't interested in transience; his search was for the immutable facts of life.

His was a career-long pursuit in which he discovered the answers he sought were invariably to be found in nature, although they weren't always obvious. He wrote in exasperation to his friend and fellow artist Émile Bernard in 1904, saying, 'I am proceeding very slowly. Nature appears to me very complex, and the improvements to be made are never-ending. One must see one's model clearly and feel it exactly right, and then express oneself with distinction and force.' He talked often about needing the right temperament to make pictures: 'Within the painter, there are two things: the eye and the mind; they must serve each other. The artist must work at developing them mutually: the eye for the vision of nature and the mind for the logic of organized sensations, which provide the means of expression.'

He reasoned that we look with our eyes but comprehend with our brain, which, in turn, triggers the emotional 'sensations' felt in our response to any given subject. A painting, therefore, must capture not only the pictorial 'facts', but also how those 'facts' affect their environment and the viewer. 'To paint from nature is not to copy an object; it is to represent its sensations,' he said. In that short sentence Cézanne gives us his manifesto for looking, for how to appreciate the world anew.

Cézanne's aim was to show how the entirety of what we see at any one moment interrelates and combines to form a single image in our mind's eye made up of a patchwork of colours and shapes. That is why he was just as interested in an old shoelace as he was in the sitter's face when it came to painting portraits. It was the reason why he gave as much consideration to a blank wall as he did to a frilly shirt. For Cézanne nothing existed in isolation – each and every element was part of an overall spatial, formal and tonal relationship. When we look, he believed, we see a unified picture, not individual components.

He painted farm workers playing cards, still lifes with jugs and apples and pears, and landscapes of rural France, all of which he presented as fully blended compositions in which the whole was greater than the sum of its parts. That was his non-fiction oeuvre. But he also applied his new theories of representation to classical and mythical subjects, determined as he was to connect the art of the past with the art of the present. He was particularly inspired by two long-dead Venetian painters, Titian (*c.* 1488–1576) and Giorgione (1477–1510). There was one painting in particular that caught his eye, which, unusually, has been attributed to both artists at different times. *Concert Champêtre* (1510) or *The Pastoral Concert* depicts a popular Renaissance theme featuring naked women at leisure in a beautiful, tranquil landscape. Cézanne said of the characters represented in the pastoral idyll: 'They are alive. They are divine. The whole

landscape in its russet glow is like a super-natural eclogue, a moment of balance in the universe perceived in its eternity, in its most human joy.'

The picture inspired him to attempt his own version of the classic sylvan scene. *Large Bathers* (1894–1905) features eleven naked women gathered in private by a lake in the woods. They have fruit for sustenance and white towels for comfort. We see them in relaxed repose on the warm brown earth and lush green grass by the water's edge. Beyond them are the trees that line the far side of the pool, and behind those trees are some light clouds hovering in an otherwise deep blue sky. The female figures have been sketchily rendered, a thick blue outline defining their shape, dabs of light and shade suggesting volume. Hands, feet, eyes and facial features are all dispensed with in order to make sure the overall rhythm of the picture is not interrupted by extraneous visual 'noise'. They could just as well be statues or stones; their role is as much architectural and structural as it is narrational. The woman standing on the left and the one seated on the right of the picture give it a triangular structure. Those between them accentuate the pyramidal design, in which the eye is drawn into the scene by the artist's masterful use of light (note how the women's hair colour lightens as they go further towards the water, and then drifts up into the clouds like a puff of smoke). Cézanne builds his picture up in horizontal blocks of colour, with 'accents' repeated throughout to unite the composition. Although we are presented with a

traditional foreground (the women), mid-ground (the unseen pool) and background (the clouds and sky), he has dramatically foreshortened the perspective, and instead used a geometric grid to suggest breadth (the horizontal elements) and depth (the vertical elements).

We have been led to believe by the camera and by the old masters that when we look out at a landscape everything we see is in focus. Cézanne is showing us such an assumption is a misapprehension. When we look out at a landscape all is not in finely tuned focus, and what we actually see is a series of overlapping, interconnecting shapes and colours – sensations, Cézanne would say – each one affecting the other as well as us and our emotions.

This is one of the three *Large Bathers* Cézanne produced in his final decade; the other two are in public collections in Philadelphia. All three share a medley of elements and moods that gives them an extraordinary atmospheric quality. The various pictorial elements are beautifully arranged into an orchestrated composition in which colours and forms blend seamlessly to create a harmonious work of art. Staccato brushstrokes act as the individual notes that are repeated throughout, to produce visual 'chords' that resonate through the picture in sonorous, melodic waves.

The *Bathers* theme was one Cézanne returned to time and again. Some had male protagonists, others female – clothes were rarely worn. The great Fauvist painter Henri Matisse owned an early version, which he treated

as a prized possession. Matisse kept it in his studio for thirty-seven years before eventually gifting it to the French nation with a note saying the picture had 'sustained me morally in the critical moments of my venture as an artist; I have drawn from it my faith and my perseverance . . . my admiration for this work has grown increasingly greater ever since I have owned it.'

Cézanne completed *Large Bathers* (1894–1905) a year before he died, shortly after which it was shown in a memorial exhibition of his work in Paris. Many of the world's leading artists made regular pilgrimages to see the show, including Picasso, who – like Matisse – credited Cézanne as being the founding father of Modernism. Within months Picasso had made the masterpiece that would come to be called the most important painting in the modern movement: *Les Demoiselles d'Avignon* (1907) – the first great Cubist artwork. When you line it up against *Large Bathers* you can see immediately where Picasso's inspiration came from: the stylized naked women, the fruit in the foreground, the compressed depth of field, the white towels, the flattened image. All of these are direct quotes from Cézanne's late, great painting; a painting that would lead to the aesthetics of today.

Cézanne's determination to seek to truly represent a three-dimensional subject in a painting while not attempting to deny the two-dimensionality of the canvas was revolutionary. As was his decision to portray what he saw from two different points of view – left eye and right eye. It led directly to Picasso's and Braque's experiments with

Cubism, where they looked at their subject from multiple angles, and that led to a visit to their studio by the Dutch painter Piet Mondrian, which led to his abstract geometric grids, which in turn influenced the design style of the Bauhaus, Modernist architecture, and – eventually – Braun toasters and Apple iPhones! It all started with Cézanne and his pioneering paintings of interconnected shapes and tones and the sensations they generate in us. The nature of the reaction they cause in us is dictated by personal taste, or what the Master from Aix would call our temperament.

Tracey Emin: Seeing Intimately

There are people who don't know what
they think until they've written it down.
Tracey Emin makes art to reveal how
she feels. Delving into her most
intimate, troubling memories and
experiences and formalizing them
into a painting or sculpture is her way
of seeing.

There is an old saying about keeping your messy private
life private: 'Don't wash your dirty linen in public.' It is a
piece of cautionary advice in the form of a metaphor
that was taken literally by Tracey Emin, who became
world-famous for displaying her dirty linen in public. In
1999 the London-born contemporary artist presented
an installation called *My Bed* as part of her entry for the
prestigious Turner Prize. The artwork consisted of her
unmade bed covered in the dishevelled and dirty linen in
which she had slept for many days and nights – dirty
linen that she had no intention of washing in public.
The point was to exhibit it unwashed, her messy private

life unapologetically and unashamedly there for all to see on her stained bedding and dirty knickers.

The press and politicians were appalled. One critic dismissed the artist as a self-regarding bore, while the British government's culture minister complained that her bed gave the country a bad name abroad. Having read and heard this chorus of disapproval from the establishment, one lady drove 200 miles armed with a big bottle of detergent to give it a good wash, saying, 'I thought I would clean up this woman's life a bit.' Perhaps it was a gesture founded on kindness; it was certainly based on ignorance. The very reason Tracey Emin was making a public spectacle out of her dirty linen was in order to clean her life up a bit.

A year earlier she had spent several days lying semi-comatose in that bed, hour-upon-hour wrapped in those soiled sheets surrounded by overflowing ashtrays and empty vodka bottles. She was in bad shape. She had been drinking far too much and eating far too little. Her spirits were low, her mental health poor. Dark thoughts rattled round her troubled mind (when she showed an earlier version of *My Bed* in 1998 in Japan she hung a noose directly above it). It was, she has since said, a descent into oblivion: a dreadful downward spiral only arrested when she went to the bathroom. She returned to her bedroom to crash out once more, but stopped in the doorway, seeing for the first time the wreckage of her life reflected in her unmade bed. In such moments careers re-ignite or fizzle out. Emin had a choice: go

back to bed and give up, or straighten herself out and get to work. She chose the latter, starting there and then. Her bed would no longer be a sordid mess into which she would sink; instead, she would transform it into *My Bed*, a work of art – something she was uniquely placed to do.

There was nothing new about a dishevelled bed as a subject in art history. Jeff Wall, the Canadian artist-photographer, made a work in 1978 called *The Destroyed Room*, in which an overturned bed has been thrown against a wall, its mattress slashed and engulfed in a storm of dirty sheets, underwear, shoes and clothes. Emin's *My Bed* owes something to Wall's picture, which is itself a riff on Eugène Delacroix's famous painting in the Louvre, Paris, *The Death of Sardanapalus* (1827). It's a huge, stunning picture of the eponymous Assyrian king resting on his luxurious bed among his pleasures and treasures shortly before taking his own life. Emin is clearly nodding towards that great Romantic masterpiece, as well as Delacroix's watercolour *Le Lit Défait*, painted around the same time as the Louvre picture, which is compositionally similar to her unmade bed. Then there's Robert Rauschenberg's *Bed* (1955), which is also a messy affair. The American conceptual artist produced his *Bed* in New York, partly as a tongue-in-cheek response to stuffy art critics, who took their work and themselves very seriously. Rauschenberg had a lighter touch, a twinkle in his eye too often missing in art. His *Bed* is made out of his own sheets, pillow and quilted blanket stretched out like a canvas and covered in paint in a style to mimic Jackson

Pollock. *Bed* was an ironic comment on the art world and everyday life. Emin's *My Bed* is different. Contrary to what the tabloid press might say, she wasn't having a laugh at the public's expense. The artwork is sincere and disarmingly honest.

Regardless of the medium in which she is working – film, painting, drawing, woodblock, neon, sculpture or installation – everything she produces is autobiographical: her art is a form of self-portraiture. You rarely see her likeness but she is always there, front and centre. The ancient Greek philosopher Socrates famously said, 'The unexamined life is not worth living', a maxim Emin has made her modus operandi. She's examined her life like an obsessive forensic scientist at a crime scene: there's no detail too gory to be picked over, no body part too private to analyse.

She has been accused of being a narcissist, a solipsist and a raging egomaniac. She is not. What's more, the put-downs entirely miss the point. Exploring her most personal, private feelings – the sort of feelings many of us have been told to suppress since childhood – helps her make sense of the world. It's her way of working out a problem. There are people who don't know what they think about something until they've written their thoughts down. Emin doesn't truly know how she feels about something until she's made it a work of art. Delving into her most intimate, troubling memories and experiences and formalizing them into a painting or sculpture is her way of seeing.

Hence, no other artist could have made *My Bed*, although technically it can't have been that hard to create. It was, as they say in the art world, a 'ready-made' – a pre-existing object that changes its meaning when contextualized and presented as art (Marcel Duchamp's urinal, or Damian Hirst's shark). Emin's great gift as an artist is her talent for storytelling. In another life she could have made her name as a writer – for a while that's what she thought she might be – but art has an intensity that matches her character. A written story can be told over hundreds of pages, whereas a work of art has to do the same job in a single image. It's harder to do, but arguably more powerful when successful. It certainly is with Emin, whose stories are unique to her lived experience but resonate widely with the public. She is a specialist at the artwork memoir.

It was a chance meeting with a young art dealer called Jay Jopling in the early 1990s that gave her the opportunity and belief to tell her story her way. He was an assured, smooth-talking Old Etonian, she was a working-class woman with a Thames Estuary accent and – he has said – 'a wayward attitude'. No matter, they had plenty in common. They were born a month apart in 1963, they both felt the pull of art from an early age, they have the same entrepreneurial instincts, and share an ambitious nature. Jopling had met Emin at a pop-up dinner ('He impressed me by pushing the arm of his glasses up his nose'). She boldly introduced herself and invited him to invest in her 'creative potential'. For £10,

the thirty-year-old artist would send him four pieces of hand-written mail and a personalized letter. It was an offer she was making to anybody who came to The Shop, a retail space-cum-artists' drinking den she opened in 1993 with her friend Sarah Lucas (who breezily described Emin at the time as being 'a nightmare'). Situated in London's East End, at 103 Bethnal Green Road, The Shop quickly established itself as a hip store and meeting place. At this point Emin was thinking of giving up on art and instead looking for what she described as 'International Man' (a fictional character to whom she had been sending love letters) at Heathrow airport. But a combination of the support and encouragement of boyfriend Carl Freedman, Sarah Lucas and Jay Jopling persuaded her to stick with art. It was a good decision. Shortly afterwards, Jopling offered her an exhibition at his small but fashionable London contemporary art gallery, White Cube. Tracey wanted the show to be immensely personal.

She called her inaugural exhibition *My Major Retrospective 1963–1993*, figuring it was likely to be her first and last show so she might as well go out with a bang. The dates in the title refer to the thirty years she had been alive. She made an autobiographical show containing reproductions of every image she had created in the past decade. This was no mean feat, as she had destroyed many of the originals when at a very low ebb after suffering the trauma of a botched abortion (the doctor failed to notice she was carrying twins). The exhibition acted as a kind of 'This is My Life' in art, each picture hand-sewn on to a

tiny canvas. Alongside them was a small section dedicated to her uncle Colin, who had died in a horrendous road accident when a juggernaut pushed his car under a bus at a set of traffic lights, instantly killing him. It had what were to become familiar Emin motifs: a bird representing the soul, love and freedom, a hand-written note, an everyday object (a packet of crushed Benson & Hedges cigarettes that uncle Colin had been holding at the moment of impact), and a dramatic story of personal trauma.

According to Jopling, not much work sold, but visitors did buy into the Tracey Emin persona. Her brutal honesty, uncompromising directness, and willingness to wear her heart on both sleeves made her a timely artist for those proto-reality-TV days and the rise of individualism. She didn't play by the normal rules. She would say the unsayable, and do the unacceptable, such as appearing drunk on national television, swearing profusely and walking off mid-broadcast. That was in 1997. Two years earlier she had produced one of her best and most memorable works, which was subsequently destroyed in an art warehouse fire in 2004.

Everyone I Have Ever Slept With 1963–1995 was a small blue pop-up tent, the inside of which had been decorated with the names of the people with whom Emin had shared a bed during her life. There were 102 names in total, each one appliquéd on to the tent's inner walls. The title is knowingly provocative, designed to grab attention and rile a stuffy establishment who thought her

loud and crude and overrated. But for those who with-held judgement before seeing the work, the reality was quite different. Yes, there were names of lovers, but there were also friends, and the twin brother with whom she grew up in poverty in Margate, then a rundown sea-side town in the south-east of England (where T. S. Eliot wrote passages of *The Waste Land* and J. M. W. Turner painted the North Sea). Most poignant of all were the two embroidered patches bearing the names 'Foetus I' and 'Foetus II', a moving reminder of the traumatic termin-ation five years earlier. She described applying those 102 names as 'carving out gravestones': a painful experience, she said, during which she dredged up memories – some very good, others very bad – and relived them in what is an extraordinarily intimate work of art.

There is so much noise around Tracey Emin that it can obscure the importance and originality of her work. Few artists, male or female, have been so candid about themselves: making work that openly cries out for a love that has never materialized (she married a rock in 2016), that screams of remorse, and rages with feeling. She hones these intense existential thoughts into an intense image that seethes with emotion: a cry from the soul we can all understand. Her pain is real.

She was born to parents who happened to be married to other people. Her mother was English, her father a Turkish-Cypriot who wasn't around for long periods of time. She was sexually abused as a child and raped when thirteen years old, a horrific assault. She left

school at thirteen, went to London, lived in a squat with the trendy Blitz Club crowd, and met the then unknown Boy George, who asked her to join his band (she couldn't play an instrument but was confident she could master the bass given time). She studied print-making at Maidstone College of Art, and then painting at the Royal College of Art in London, where she felt as welcome as mould in the bathroom. Then came the abortions, the insecurity, the drink, the lifetime's search for a partner, the despair. We know this, she has told us, she has shown us. And, through doing so, she has touched us.

Tracey Emin might not have been lucky in love, but she has been fortunate to be able to get to the very heart of life – to be intensely alive and aware. She has done it by being willing to look beyond her suppressed memories, to risk being hurt again and again and again, to find out what she truly thinks and feels. Only then can she make art, because only then can she see properly. The same applies to us all, as Socrates knew only too well when telling the Athenian court, shortly before they sentenced one of the greatest thinkers of all time to death, that a life unexamined is not worth living.

Cy Twombly: Seeing Cycles

Quattro Stagioni – the Four Seasons –
consists of four magnificent paintings
the size of cathedral windows. They
are a homage to nature's never-ending
cycle. See them and marvel at what it is
to be part of this great, tumultuous
energy we call life.

I was having a leisurely breakfast with family friends, drinking strong coffee and over-buttering my toast, when the table chat turned briefly to this book and this chapter. I mentioned the artist about whom I was writing, to which the collective response was, 'Who?' Fair enough. Cy Twombly (1928–2011) is far from a household name, and – it is reasonable to say – was an artist who produced work that is an acquired taste. His largely abstract paintings and sculptures are like Chandler in *Friends*: hard to like at first, but totally irresistible after a few encounters.

One of my breakfast companions googled him. An image from his late series of *Bacchus* (2006–8) paintings

popped up. 'Looks like ketchup,' was the response from the head of the table. 'It's a mess,' was the assessment of an equally nonplussed diner. Neither judgement was entirely wrong. The artist's intention was to make a cycle of big, ketchup-red, exuberant canvases with more than a hint of improvised splodginess. He wanted to overwhelm the viewer with a painting that erupted with an ecstatic impulsiveness – of drunken abandon or wanton destruction. Unsurprisingly, some of that exuberant, emotional fervour is lost when reduced from a massive 3m x 4.5m canvas to a palm-sized photo on a smartphone.

That said, even when seen in real life in a gallery, Twombly's *Bacchus* paintings do initially appear to be nothing more than a simple, incoherent scrawl like those loops you make when trying to get the ink flowing out of an old ballpoint pen. They are prime candidates for the infamous modern art put-down, 'My five-year-old could do that', a comment at which the late American artist would not have taken offence. It is remarkably hard to paint like a child when you are a highly trained adult artist. You have to break so many rules, snub convention and unlearn hard-wired academic techniques. As Picasso is said to have said, 'It took me four years to paint like Raphael, but a lifetime to paint like a child.'

Twombly's apparent lack of sophistication does have a juvenile quality, which is entirely intentional and in the spirit of Picasso's remark. Look a little longer, though, and it becomes apparent that the series of *Bacchus*

paintings is by a highly sophisticated mark-maker with an uncommon ability to marry the ancient with the modern, knowledge with naivety, and poetry with paint. Look at the canvas! he appears to be saying, and see yourself in its circular pattern.

Hence the huge loops of life in these paintings, which celebrate Bacchus, the Roman god of wine, a mythological figure famous for his drunkenness and excesses, whom the ancient Greeks called Dionysus. This is information a five-year-old might know, but the technique with which Twombly created the pictures was way beyond any young child I've ever met. The Virginian-born artist strapped a fully-loaded paintbrush to the end of a ten-foot pole before approaching his giant hanging canvas like a medieval knight at a jousting contest. With impressive strength and precision, he painted top-to-toe looping, interlocking spirals that flow across the enormous surface. The artist was channelling the spirit of a Bacchus-inspired creative frenzy, an altered state of mind the mischievous god was said to elicit in his acolytes. Twombly allowed his paint to trickle down the surface of the picture as if it were red wine dripping or a wound bleeding. Or, both. Bacchus could be either a fun guy or a violent maniac when drunk. Twombly's vermilion paint against his calm light tan background harmonizes the picture: it is both lull and storm.

The *Bacchus* series is about the extremes of nature and human behaviour, when the blood is up and there are cartwheels of emotion. They take us to a high peak

before descending like a rollercoaster at a fairground – and then repeat and repeat and repeat: a metaphor for life's cycle. If you can put aside any perfectly under-standable scepticism and trust the artist's talent, you will become entranced by the mesmerizing effect of his work. After which you might want to seek out more Twombly images, such as his four-panel masterpiece, *Quattro Stagioni* (Four Seasons).

It might sound like a pizza, and to some eyes the canvases might even look like a pizza, but get beyond those first impressions and these pictures will take you on the most incredible journey from life to death and back again. They will distract you from the twenty-four-hour deluge of emails, news and messages, and whisk you off to sample nature's magnificent loop of seasons and sensations.

The artist made two slightly different versions of *Quattro Stagioni*, which he produced between 1993 and 1995. The first set can be found in the Museum of Mod-ern Art in New York, the second is at Tate Modern in London. Both consist of four portrait-shaped painted canvases the size of cathedral windows, on to which the artist has scrawled and scribbled notes. Each of the four paintings represents a season: Autumn (*Autunno*), Win-ter (*Inverno*), Spring (*Primavera*) and Summer (*Estate*). They are individual images but the artist considered them a single artwork, describing *Quattro Stagioni* as a painting in four parts.

The sense of a journey taking place is more obvious in

the MoMA edition, which features an ancient Egyptian funerary boat (modelled on the artist's photograph of an old Celtic vessel) rowing across three of the four canvases. Its role is to transport the human soul from an earthly existence to a purely spiritual realm in the afterlife. First, though, there is some bacchanalian fun to be had.

The series begins in the autumn before the wooden boat arrives. This is the season of plenty, when the harvest has been gathered following months of long, hard work in the fields. It is a time to celebrate, to kick back; to eat and drink and be merry. We see over-ripe red berries and engorged grapes seemingly splattered against the canvas's cream-coloured background. A full-blooded moment of abundance is upon us, partly inspired by an annual wine festival near Twombly's summer home in Bassano, to the north of Rome, which was taking place while he was making the painting.

Fragments of barely visible hand-written poetry occasionally come to the surface of the canvas, as if floating up through the thin layers of white paint. You can make out the word 'SILENUS' above the big red splodge at the bottom of the picture, which is a reference to the end-of-days party that's going on. Silenus was the hard-drinking sidekick of the Greek god Dionysus, who, as we know, was Bacchus in Roman mythology, whose name also appears (faintly scribbled on the left-hand side just above the purple paint). To the right are the words PURE WILD SEX, making explicit the bacchanalian, debauched mood of the piece.

Autunno is a beautifully balanced composition, a wonderfully observed seasonal evocation. But it is only part of the story, as the deep reds and dark purples, mixed in with a sombre black paint, blow you on a westerly wind to the next season: a snowy winter, *Inverno*.

Here we meet the boats that are taking us from the darkness of the afterlife towards the yellow sun of spring and a dawning renewal. In the MoMA version, the truncated words come from *Summer Solstice III* by the modern Greek poet Giorgos Seferis. They urge the funerary barges to continue their journey across the ocean from death to life: *As the poet / You must get / Out of sleep.*

The diagonal line running bottom left to top right of the composition generates a progressive, rising dynamism. The life force is irresistible as the boats arrive in an eruption of spring colour in *Primavera*, the third part of the quartet. The vessels are now fuelled by the pulsing blood of life, as they continue to travel towards the rising sun in the east. To the left- and right-hand margins of the New York canvas are beautiful bouquets of flowers. Sandwiched between them are more scrawled words taken from Seferis:

> You were talking about things they couldn't see
> and they were laughing.

Could this be the artist responding to the stinging criticism he had received decades earlier when showing his work in New York? Quite possibly. It's worth noting that Twombly uses completely different text on the

London version of *Primavera*, in which he quotes from Austrian poet Rainer Maria Rilke's tenth *Duino Elegy* about happiness not flowing but falling.

The choice of poet might be different, but the overall themes are the same in both spring paintings. They represent a meditation on the transience and mutability of life, drawing on mythology, classical antiquity, art history and literature. They are all there in the final painting, *Estate* (Summer), the sun-baked summer season. This was the painting Twombly found hardest to complete, complaining that all he could see – morning, noon and night – was wretched yellow!

He made *Estate* some months after the others, having relocated to another of his houses, along the Italian west coast at a fishing port in the Bay of Gaeta. His studio was up the road on the hillside, from where he could see the harbour beneath the curving cliffs – the hot sun reflecting on a warm sea is ever-present in *Estate*. Yellow paint oozes down the picture like hot egg yolk running across a white porcelain plate. More words have been scratched and scribbled on the translucent image, the New York version of which shows the bright red boats finally arriving.

Edwin Parker Twombly – know to all as Cy – was a Europhile American, whose father had been a professional baseball player. It was from him the nickname 'Cy' came, having been bestowed upon his ball-playing dad in recognition of his pitching skills, which resembled those of the legendary Denton 'Cy' Young, a man

who threw the ball so fast it could smash a fence as if it had been hit by a cyclone. The young Cy didn't share his father's sporting prowess, but soon discovered he too had a special talent. Cy could draw as his dad could pitch – fast and accurate, with a beautiful line and steady hand. Young Cy took lessons from a Spanish artist who had moved to his neighbourhood in Lexington, Virginia, as a refugee from the Spanish Civil War. The tuition helped Cy win a scholarship to the Art Students League of New York, where he met another young artist destined for greatness called Robert Rauschenberg. They became good friends and travelled across North Africa and Europe, a trip during which Cy fell hopelessly in love with Rome, saying, 'It's been like an enormous awakening of finding many wonderful rooms in a house you never knew existed.'

By now, Twombly had reached his mid-twenties and was duly drafted into the United States Army for a stint of national service. It wasn't really his thing, but it proved crucial to his artistic development. Each weekend he would take a small room in a hotel to get away from everybody so he could quietly draw, read and think. He started to experiment with the Surrealist technique of 'automatic' mark-making, which entailed entering a semi-conscious state by drawing very late at night, when extremely tired, using his non-dominant hand, with the lights off. The idea was to find an inner authenticity in contrast to the mannered techniques he had been taught

at art school. He later said that the scrawls and scribbles he produced during those long nights would go on to inform all his future work.

He left the army and returned to civilian life and his work as an artist, emerging as a one-to-watch thirty-year-old well on the way to establishing a following in New York. So far, so good. But he still hankered after Rome's promise of *la dolce vita*, an itch he got to scratch when Betty Stokes, an old friend from back home in Lexington, invited him to come and stay with her and her wealthy and well-connected new Italian husband on the outskirts of Rome. Cy had barely unpacked his suitcase when an early introduction into Italian high society led to him meeting a well-known patron of the arts called Baron Giorgio Franchetti. The Italian nobleman loved Twombly's work, while the six-foot-four American artist loved Tatiana, Franchetti's sister. He married her two years later, after which Cy never had to worry very much about money again.

He continued to travel across Europe, North Africa and America. He took a house back in Lexington, to go with his three Italian residences and his lengthy stays with friends here, there and everywhere. He rarely watched television but read prodigiously, particularly the Symbolist and Romantic poets and the literary classics such as Homer's *Iliad* and *Odyssey*.

Cy Twombly's paintings are never straightforward. They are always a little enigmatic, often featuring calligraphic elements intermingled with abstract shapes and

paint dripping vertically down the canvas. They have a sense of time passing, of an ageing process, which starts with a pristine canvas that gradually becomes a historied surface reminiscent of an old Roman wall covered in graffiti and paint. He described himself as a romantic symbolist, which is a fair summation of how he observed the world.

Twombly's view encompassed the events of his day – from moon landings to wine festivals – which he contextualized through the works of the great poets and painters of the past. He saw life as it is, a cycle. What goes around comes around. Hence the elliptical quality to his work. It is not static – the gestures he made come and go in rhythmic compositions that speak to nature's circular cadence. This is what we see in *Quattro Stagioni*, four magnificent paintings best seen in 'the round', with one on each wall of a square gallery. That is the ideal configuration – it allows you to immerse yourself fully in the constant loop of birth, growth, bloom and death. And to sense what it is to be part of this great cyclical energy we call life.

Lynette Yiadom-Boakye: Seeing Strangers

We know art imitates life, that it is
fictional, so why not create a wholly
fabricated reality: an illusion within an
illusion? It's a question the British painter
Lynette Yiadom-Boakye asked herself.
The answer, she discovered, opened up
an entirely new way of looking.

In October 1996, a fresh-faced British politician called
Tony Blair made an impassioned speech at the Labour
Party Conference. He was the party's ambitious young
leader, hell-bent on usurping the ruling Conservative
Party at the forthcoming general election in May '97. 'Ask
me my three main priorities for government,' he said to
an enthralled audience, 'and I will tell you: education,
education and education!' Applause rang out across the
Winter Gardens conference centre in Blackpool, as the
gathered Blairites smelt the heady scent of power. Their
optimism was well placed; seven months later Tony Blair
led the Labour Party to a landslide victory and the dawn
of the 'Cool Britannia' era.

At the very same time, nineteen-year-old Lynette Yiadom-Boakye, the London-born daughter of two Ghanaian nurses, was studying to become an artist. She too, believed in education. So much so that she attended three separate art schools, completing her Master's at the Royal Academy in 2003. It was while there that she first started to realize that knowledge is not necessarily always the liberating force it is said to be. In fact, she found, it can be stifling. There was one particular circumstance where an attempt to comprehend was actively limiting her search for understanding.

Yiadom-Boakye describes her art education as being classical. She said her training involved 'spending a lot of time in the life room, working from whatever was in front of me. Whether that was an object or a figure, but always with this attempt to translate reality on to a piece of paper or canvas.' Initially she was happy learning the art of portraiture, but she found as time went by that she was becoming less and less interested in the sitter and their specific features. Her concerns were developing more towards the technical process of painting a figure on canvas. She wasn't the first artist to feel this way. The revered Post-Impressionist painter Paul Cézanne would make his life models sit for days on end, until the poor souls became so bored and frustrated with the interminable process, they would ask how the portrait was coming along. On one occasion, the artist – annoyed that his concentration had been disturbed – growled, 'I am quite pleased with the shirt.'

Cézanne wasn't remotely interested in the character of the individual; he was much more concerned with making a successful painting. It didn't really matter to him if the subject was a person or a bowl of fruit or a landscape: the Frenchman was focused on the formal problems of applying marks and colours to a canvas in order to produce an image that worked. Yiadom-Boakye had a similar preoccupation with the process of painting, a comparable compulsion to concentrate on the intellectual and technical obstacles an artist has to overcome to make a composition that resonates. So, what was the young painter to do? Although she still found the human figure a compelling subject and wanted to work with it, she felt stifled as an artist by the expectation to render a true representation of a sitter's form and personality.

The solution was simple, like so many good ideas. Yiadom-Boakye stopped thinking about portraiture and started thinking about painting. People would remain a core subject, but not based on a person sitting in front of her expecting their likeness to be realistically captured. She had done enough of that. There was an alternative way . . .

The inspiration came from another side of her creative life; Lynette is also a fiction writer ('I paint what I can't write,' she says). If making up characters on a page was OK, why not make them up on a canvas? Inventing her 'sitters' immediately freed her from the portraitist's primary duty of realistic visual reportage (it is said that

portraiture is the one genre of art in which the subject is often more important than the artist). Instead, she was at liberty to explore the mechanics of making a painting, without having to worry about getting a likeness wrong. She could bend her fictional characters to her will, ensuring that they were playing the part as she wanted in an overall narrative that was developing in her head while making the work. She was able to focus on the fundamental issues, such as the effect one colour has on another when placed side by side. And how certain combinations generated recognizable moods, which might then trigger an improvised story in her imagination. Thereafter, protagonists are introduced, attitudes adopted, personalities suggested. Lynette Yiadom-Boakye had made a major conceptual breakthrough.

> The freedom it allowed me as soon as I let go of the idea of trying to depict people I knew, or trying to get a focus on a specific likeness, as soon as I lost that there was all this freedom that a body could be anything, a person could be anything, a figure could mean anything – there was kind of infinite possibility.

The fledgling artist turned her art education on its head. Instead of trying to interpret reality when painting a portrait, she was painting fictional portraits to try and produce something real. After all, the subject of a painting is only ever a depiction of a subject, it is never the subject itself. You can't eat the orange in Cézanne's painted fruit bowl. We know art imitates life, that it is

fictional, so why not create a wholly fabricated reality: an illusion within an illusion? To do so would be to open the door to another way of looking. A way of looking that was based on compiling a visual database of many people you have seen or heard, and then boiling all that information down into a single visual entity to capture the essence of a fictionalized character that represented a universal truth. It necessitated Yiadom-Boakye building up a memory-bank of stored images that her imagination could call upon at any moment to provide the visual reference for a pose or a smile or a gaze she needed for a painting. The way in which a friend might twist their body when leaning cross-legged on a sofa, or expose their teeth through a half smile, was now part of her day-to-day research. The world had become her life model.

Armed with this rich resource of observations, she started to make paintings with muted, mottled, nondescript backgrounds in front of which her fictional figures appeared. The pictures still look like portraits of friends or relations, but they are not. For all their apparent individual humanity, the characters are, in fact, composites drawn from memory and scrapbooks, old photos and found images. The majority of Yiadom-Boakye's paintings feature a single protagonist, some have two people, a few are of a group of three or more. Among those group pictures is *An Education* (2010), in which four men are standing together. A muddy, olive-green palette dominates, the lighter tones providing the background, the more sombre shades used to depict the men's

jackets, jumpers and trousers. Their dark brown skin continues the warm tonal transition of colours, accentuated with a gentle yellow light falling across their faces. The stark contrast created by their bright white shirts is like the cymbal clashing in Tchaikovsky's *1812 Overture*, bringing a sharp focus to the composition.

The picture's title – *An Education* – is an additional element in the story unfolding before the viewer's eyes. It is not intended to be descriptive, more an augmentation. Or, as the artist says, 'another mark, an extra brushstroke'. It is part of the painting, not about it. The scene is open to interpretation; there are infinite possibilities.

To me, it appears that the slightly older man standing in the middle of the group and facing us is the one dispensing an education to the other three. His easy-going manner and open-palmed gesture – together with the good humour and attentiveness of the younger men – suggest an established and respectful friendship. They could be lecturers at a university, doctors at a conference, or a father chatting to his three grown-up sons. It's up to you. As with all Yiadom-Boakye's work, there is almost no pictorial information as to where or when the action is taking place. Or as to what is being said. The artist's intention is for the painting to be non-specific in terms of time and space – that way it can be limitless, universal.

It is a big picture with a palpable presence. When you stand in front of *An Education* there is a moment of realization when you become aware that you have joined the

conversation. At this point, your relationship with the painting dramatically changes. You are no longer looking at it, you have become part of it. The man in the middle is not speaking to his companions, he is directly addressing you, which is awkward. You hadn't intended to break into a private conversation, and yet here you are, right in the thick of it!

An Education is like all Yiadom-Boakye's work, in that it looks deceptively simple and economic, but each one of her compelling paintings reveals itself to be complex and captivating. Not least because so many of her fictional characters take up residence in your imagination.

She has spoken of being influenced by the work of American painter John Singer Sargent, and the French realist Édouard Manet, evidence of which can be seen in certain figurative poses they used that she has subsequently borrowed for her own characters. I wouldn't be surprised if the Spanish Romantic artist Francisco Goya wasn't also among those who have inspired her. And, from the contemporary pool, I imagine paintings by artists such as Kerry James Marshall, Marlene Dumas and Peter Doig would have caught her eye. But the artist to whom she gives most credit for helping to develop her own unique style is the Camden Town painter Walter Sickert (1860–1942). He too was a keen exponent of an earthy colour palette and an atmospheric narrative. His major influence was Edgar Degas, the French Impressionist painter who famously painted ballet dancers, a subject Yiadom-Boakye has also explored (her

dancers are men in tights, Degas's were young women in tutus).

Sickert was drawn to loveless domestic interiors and London's shadowy, sordid nightlife, which he painted with the eye of a master colourist. Yiadom-Boakye has a similar feel for colour and tone, if not for the macabre. Her scenarios are more ambiguous, her unknown cast of characters eternal. They have a Shakespearian depth and breadth. The beautiful man in a turquoise silk shirt with a ruffed collar in *Greenfinch* (2012) could be Puck from *A Midsummer Night's Dream*. The young boy and young girl in her diptych *A Fever of Lilies* (2016) have the coquettish air of Romeo and Juliet.

Harold Pinter, the twentieth-century British playwright, said his dramas always started with an image in his mind's eye, from which he would build out and out until a fully formed play had revealed itself. I feel the same about Yiadom-Boakye's paintings, which give a snapshot of a story – it could be the beginning, middle, end, or all three captured in a single image. It rather depends on what you see at any one time. They are endlessly fascinating in that way.

The decision to paint fictional figures gave her licence as an artist, just as it does us as viewers. Her paintings offer us a different perspective on the world: a sense that what we see and feel is limitless. The difference between fact and fiction often comes down to perception, not reality, which, looked at in a certain way, is wonderfully liberating.

Isamu Noguchi: Seeing Space

> If sculpture is the rock, it is also the
> space between rocks and between the
> rock and man, and the communication
> and contemplation between.
> — *Isamu Noguchi*

The American pavilion at the 1986 Venice Biennale featured an exhibition entitled *What Is Sculpture?* The show aimed to challenge its audience to question their preconceptions about the medium of sculpture by displaying mass-produced lamps, a 120-tonne marble slide, and designs for playground equipment, all of which were presented as sculpture. The artist showing this provocative collection was eighty-one-year-old Japanese-American sculptor Isamu Noguchi (1904–88). Coming towards the end of his life, the exhibition provided Noguchi with a chance to reflect on his career. His decision to exhibit domestic lights and a slide to represent his life's work reveals a lot about how the artist saw art's role in the world. If a beautiful object was left untouched in a display case behind a museum

rope, it was enfeebled to Noguchi. For him, it was the interaction between people and the artwork that gave sculpture a purpose. The end goal of art was not simply to be admired – 'Sculpture,' he believed, 'exists only to give meaning to the space.'

He argued that a statue, for example, not only catches our eye, but also changes the way we see the area around it – our overall perception of our environment is altered by its presence. 'If sculpture is the rock,' he said, 'it is also the space between rocks and between the rock and man, and the communication and contemplation between.' Noguchi was not interested in telling us how to view art, but with showing us how the objects we interact with every day change the way we see. He thought the purpose of sculpture was to provide us with a 'more direct involvement with the common experience of living'. As far as he was concerned, any physical object could be considered sculpture – from a television set in your living room to a tree in the park – as long as it was 'born without hindrance into space', by which he meant it had been intentionally placed to enhance our relationship to a given physical area. So, if you were to carefully arrange a vase of flowers and put it in the middle of the kitchen table because you thought it looked great – then it could be deemed a sculpture. Whereas a pile of books thoughtlessly plonked down on a chair could not. For Noguchi, a work of art – be it a vase of flowers or a Greek statue – goes beyond the physical object and includes the location in which it has been placed. He wanted to give a 'sense of

sculpture as part of the landscape', as a punctuation mark into a space.

With his *What Is Sculpture?* exhibition, Noguchi presented the theory that sculpture was not finished when an artist put down their tools. It could only be completed through interaction with its audience, with every fresh pair of eyes reacting to the object and its surroundings in a different way. He said each individual's imagination allowed them to complete the artwork from their own unique perspective, thereby changing the essence of the sculpture and the space around the individual. 'Sculpture is more than the creation of objects of art. Sculpture is an experience that is wide and involves the total environment.'

Born in the United States to an American mother and a Japanese father who wanted little to do with him, Noguchi never felt completely at home in either culture. His complex sense of identity was brought into sharp focus following the Pearl Harbor bombing of 1941, which led to a wave of hostility directed at Japanese-Americans living in the United States. By May 1942 the artist was feeling so betrayed by the country of his birth and its anti-Japanese stance that he voluntarily referred himself to the Poston War Relocation Center in arid Arizona, an internment camp for Japanese-Americans. While there he thought a great deal about his dual nationality and an alternative vision for a future America, in which he dreamt about a 'nation of all nationalities' strengthened and enriched by 'racial and cultural intermixture'.

It was this version of America that Henry Geldzahler, the curator of the American pavilion at the 1986 Biennale, asked Noguchi to present in his exhibition. He saw the artist's 'calm and meditative sculpture as the antidote to the image that Europeans have of American culture as aggressive and uncouth – the land of Reagan and Rambo'. Noguchi felt the invitation to represent his country at such a prestigious international event was a chance to show the world another aspect of American culture; a more idealized, tolerant version that he had envisioned over forty years earlier. Hence the room full of blob-shaped paper lamps he chose to display, to which he gave the collective name *Akari*.

Now, of all the artworks featured in this book, here is one you might actually be able to afford to buy. In fact, you might already own an *Akari* light sculpture, or have owned one in the past. You might even be illuminating this page with an *Akari* lamp right now without realizing it is a famous work of art.

Most of us do not know *Akari* light sculptures by the name given to them by their creator, but we can instantly recognize one in a shop window or hotel reception. They are those globe-shaped paper lampshades which have been copied and mass-produced the world over. A cheap imitation costs a few pounds from a homeware store. The real thing – handmade in a factory in Japan – costs a few hundred pounds. The only obvious differences between the two are the materials used and the artist's specific design instructions, adhered to by the Japanese

factory but approximated when in mass production. The overall effect and purpose in both instances are largely the same.

Since making the first prototype in 1951, Noguchi created roughly 200 *Akari* designs, including an entirely new selection specifically to fill a room at the Biennale. Despite being created as a commercial product, Noguchi always held a deep affection for these lights, calling them 'the one thing that I've done out of pure love'. The artist's choice to include the *Akari*, despite the risk that the Biennale's sniffy critics would not receive them favourably, shows his dedication to the lamps. In many ways, the lights embodied Noguchi's sculptural ideals and his desire to disrupt the medium's norms.

Made from *washi* paper manufactured from the bark of mulberry trees, *Akari* were the antithesis of established ideals that sculptures should be solid and permanent. Noguchi chose the word *Akari*, which simply means 'light' in Japanese, to convey the impression of both brightness and weightlessness. Not only were the sculptures paper-thin, but they could be collapsed and carried around. In creating a piece that emitted light, Noguchi broke another tradition of sculpture by moving our focus away from the object and towards the effect it has on the space around it. Noguchi wanted his *Akari* to convey 'the idea of no object, [but] of space and luminosity'. He believed that the power of his art didn't come from beauty, but from 'being in relation to other people'. Just as the *Akari*'s light could reframe the atmosphere of a room,

anyone could change the essence of an *Akari* by switching it on or off. Crucially, Noguchi wanted his *Akari* to be affordable and ubiquitous, rather than residing in an exclusive exhibition to be admired by art-lovers and tourists. He would, no doubt, be delighted to know that his *Akari* now adorn fashionably furnished living rooms all over the world.

The idea arose from two of his primary influences: science and tradition. Noguchi always held an interest in craft and innovation, which became cornerstones of both his work and his world view. During his lifetime he witnessed many of humankind's most significant technological advancements. He was born just twenty-five years after Thomas Edison switched on his electric light bulb, and by the time Noguchi died the moon landing was old news and most households in America spent their evenings glued to their colour televisions. Having witnessed frequent small steps and giant leaps for mankind, it is no surprise that the sculptor considered inventors to be 'the real artists of America'. Much of his early work was closely entwined with new technology. He designed Zenith's Radio Nurse, the world's first baby monitor, in 1934, and collaborated with inventor and friend Buckminster 'Bucky' Fuller to produce a prototype for a pointy-nosed futuristic car in 1933.

Science, and the theories behind it, were also largely responsible for Noguchi's obsession with affecting space. Inventions like the telephone, television and aeroplane fundamentally redefined how we understood both space

and time. Journeys that took weeks during Noguchi's childhood were reduced to a matter of hours, and communication became instantaneous regardless of distance. Einstein's theory of relativity, which explained that the world was constantly expanding, was particularly intriguing to Noguchi. The theory redefined emptiness, framing it as a complex network of gravity and other invisible forces that maintained the planet's stability. Using sculpture to draw attention to, and ultimately alter, the nature of this space became a central thread running throughout the artist's career. The effect his *Akari* or his other public sculptures had on their surroundings was just as much of a concern to the artist as the objects themselves.

He travelled extensively throughout Europe and India between 1949 and 1950, studying ancient architecture, classical statues and prehistoric heritage sites such as Stonehenge in England. The following year, Noguchi made a trip to Japan, his first visit to his father's homeland since 1930. The artist had a deep appreciation of the country's culture, and immersed himself in the traditional methods of creating terracotta figures, taking instruction from master potter Jinmatsu Uno.

It was during his trip to Japan in 1951 that Noguchi designed the first *Akari*, having been approached by the mayor of Gifu, who asked the sculptor to help resuscitate the town's dwindling lantern-manufacturing industry. The solution to the mayor's request was obvious to Noguchi – he would respect tradition while using

science to drag the lanterns into the twentieth century. In doing so, he could also prove that science was still a force for good, following the destruction it had enabled during the Second World War.

His first order of business was to swap the internal candle for an electric light bulb. This modernized the lamps while maintaining the peaceful effect they transmitted, by giving the impression that the paper itself, rather than the light source inside, was luminous. Maintaining the traditional material of *washi* paper, Noguchi found a way to reinforce the inner bamboo ribbing that supported the structure with a wire skeleton, which increased the area of paper that the light was able to reach, adding to the sculpture's impression of weightlessness. With some of his later designs, the artist was able to showcase his love for pure, theoretical science. One light sculpture was formed of two spirals, inspired by DNA's double helix, which had been discovered in 1953. Not only did this link the *Akari*'s structure to that at the heart of nature, but on a practical level the spirals reinforced the strength of the sculpture. Noguchi's *Akari* were 'a true development of an old tradition' – maintaining the essence of traditional *washi* lanterns, while representing modernity through electricity.

At the Biennale, the weightless, ephemeral *Akari* were juxtaposed with the exhibition's centrepiece – a large, monstrously heavy marble spiral slide, which he called *Slide Mantra*. Created specially for the exhibition, the 120-tonne slide was shipped through Venice's canal

network in seven pieces before being assembled on site. While the sculpture could not be more different from the *Akari* in form and function, both were inspired by Noguchi's desire to combine sculptural tradition, functionality and innovation. *Slide Mantra*'s solid white marble was inspired by ancient Greek and Roman ruins, as well as the Jantar Mantar in New Delhi, a large eighteenth-century sculpture based on astronomical instruments. To Noguchi, these were examples of 'useless architecture, useful sculpture'.

With *Slide Mantra*, Noguchi sought to define space in a different way. While the link to European sculpture through the use of marble was important, the artist wanted his artwork to have a purpose that made it both 'useful sculpture' and 'useful architecture'. Instead of exhibiting an aesthetically beautiful and theoretically profound sculpture that required a master's degree to understand fully, Noguchi intended *Slide Mantra* to be experienced on the most basic, physical level – by sliding down it and having fun. It is this sense of celebrating childlike enjoyment, rather than a chin-stroking search for a profound deeper meaning, that redefines the space around the sculpture, creating an atmosphere of carefree enjoyment more associated with playgrounds than with art galleries. Fittingly, the piece now sits in Bayfront Park, Miami, a public space where anyone who wishes can enjoy the sculpture for its artistic value or by sliding down it as fast as possible.

The inclusion of playground equipment in his Biennale

exhibition was important for Noguchi, who enjoyed designing these spaces throughout his career. He considered playground design to be 'a way of creating the world ... on a smaller scale', which could serve as 'a primer of shapes and functions' for children. The effort he put into his designs, most of which were never realized, gives us an insight into Noguchi's mind and personality. Throughout his life, he retained a strong, idealistic belief in the power of sculpture to create a sense of community among those using it. It also reveals the importance he placed on the role of imagination in understanding art. This was clear not only in his playgrounds, which were designed to spark creativity in children, but in his designs for theatre sets. Although he rarely had the chance, Noguchi always enjoyed creating sets for plays because 'the definition of space, or rather, how to define place and mood' was at the heart of the job. He first designed sets for dancer Martha Graham in the 1930s, taking inspiration from Japanese theatre's minimalistic aesthetic. Noguchi's stage design, much like his sculpture, placed as much emphasis on the empty space as the objects he used. The idea was to draw attention to the interactions that form the heart of theatre, both among the actors and between actors and audience. A less obtrusive set, Noguchi thought, allowed the imagination to fill in the gap, enabling every audience member to have a more personal experience of the play.

His was the art of the intersection between sculpture and life. He recognized that the two are bedfellows, not

strangers – hence his artworks, which were designed to draw as much attention to the space they were placed in as to the object itself. From light shades to marble slides, Noguchi was teaching us to appreciate that not only do physical objects change the way we see and perceive a space, they create a stage set – or a landscape – in which we perform our lives. There is a direct relationship between how we exist and our environment; it is just that we don't always see it that way.

Xochipala Sculpture: Seeing Us

The familiar is surprisingly hard to see.
We tend to overlook the beauty in
everyday life. The Xochipala figurines
are a timeless reminder to appreciate the
mundane, to notice what is before our
eyes each morning, noon and night —
the ordinary, routine things we tend to
miss only when they're gone.

Mexico's Federal Highway 95 takes you south from Mexico City to the once glamorous resort of Acapulco on the Pacific coast. It is one of the country's main arterial roads, a 230-mile trade route favoured back in the sixteenth century by Hernán Cortés, the Spanish conquistador held responsible for the fall of the Aztec empire. About 160 miles along the highway is the rugged state of Guerrero, where the road makes its way across the magnificent Sierra Madre del Sur mountain range, shortly after passing by the spectacular Río Balsas with which Highway 95 intersects. If you were to take the next available exit after the river and travel west for ten miles along Highway 196

you would come to the town of Xochipala (pronounced 'so-she-pala'), with its mustard-coloured church and freely grazing mules. It's a rural community of around 3,500 people, a few of whom can trace their lineage back thousands of years to the indigenous communities that originally farmed this previously fertile, now arid, land.

Archaeologists can't agree when precisely humans first established a settlement in this area of the Balsas River basin, but it was a long time ago. The latest academic approximation places it in the Formative, or Pre-classic Age, between 2,000 BC and AD 250. That puts it on a par with the much more famous Olmec civilization over on Mexico's gulf coast, which was based around the cities of Tabasco and Veracruz. The Olmecs get all the attention, with their colossal stone heads carved out of giant boulders of basalt, the faces of which are characterized by droopy mouths and bug eyes. They are credited with being the 'Mother-Culture' of Mesoamerica (a historic geographical area ranging from the top of Costa Rica to the north of Mexico), and one of the first 'cradles of civilization' – the original highly cultured human settlements – along with the people of Mesopotamia (now modern-day Iraq, Syria and Kuwait) and those of the Indus Valley, which connected what we now know as Afghanistan, India and Pakistan.

The Olmecs were successful rubber traders (Olmec is Aztec for 'rubber people'), expert maize farmers, ball-game pioneers, possible inventors of drinking chocolate,

and the creators of a hitherto indecipherable writing system, which might not be a writing system at all. They were also good at art. Besides their 20-tonne basalt heads, they produced an impressive array of carved objects, ranging from stunning decorative ornaments made of jade to delicate stone beads. On top of that, they were first-class ceramicists who crafted sleek bowls in white clay and produced stylized terracotta figurines with bulbous foreheads, elliptical eyes, large ears and downturned mouths. The Olmec aesthetic would go on to dominate future Mesoamerican cultures such as the Maya and the Aztecs, who revered the Olmec artistic accomplishments. Both the Maya and the Aztecs maintained the Olmec tradition of producing large stone sculptures and seated figures, and would pass ancient Olmec art objects down through generations. But beyond the art they left behind we know very little about the Olmecs. We don't know what they believed in, or how they structured their society. We don't know their place of origin or the circumstances that led them to up sticks and leave their tropical lowlands base *c.* 400 BC – never to be seen or heard of again.

There was a school of thought that speculated that their story began just off Highway 196 among the grazing mules in the less glamorous area around Xochipala, a region with an equally long and even more opaque history. That idea was put forward in the 1950s by the Mexican artist, illustrator and archaeologist Miguel Covarrubias, who was great friends with art world

A-listers Frida Kahlo and her husband Diego Rivera, as well as being a trailblazing expert on the Olmecs. He noticed a distinct similarity between the carved stone models excavated around Xochipala and those found at the Olmecs' HQ on Mexico's gulf coast. So, he reasoned, that is where they must have originated. Covarrubias's hypothesis was not universally accepted then, nor is it now, but it did have the effect of stimulating interest in Xochipala among Western collectors, curators and dealers. One of their number was a man called Gillett Griffin, an academic at Princeton University Art Museum, who had spent a considerable amount of time in Mexico researching the pre-Columbian cultures of the ancient Americas. In the late 1960s he drove his trusty old red Volkswagen Beetle along the rocky roads and dirt tracks that connected the various communities of indigenous people living near to what is today a dried-out ancient lake in central Guerrero.

Griffin visited Xochipala and met the locals. They were welcoming but not naive. Instead of leading the scholar and his wealthy friends to interesting archaeological spots to dig for archaic trophies, they brought the archaic trophies to Griffin. This way the townspeople cornered an emerging market in the West, eager to be supplied with the splendid artefacts from the south. It was an astute business strategy, but in retrospect probably a misguided approach by both buyer and seller. The upshot was poorly excavated and managed sites, which led to important Mexican cultural objects leaving the

country without due process. And that resulted in a sparsity of information about what was found and sold, including where exactly the objects were unearthed. Nevertheless, some extraordinarily beautiful, previously hidden, and completely unknown pieces came to light, many of which Gillett Griffin studiously collected and took back with him to New Jersey.

Among the treasures he acquired – either from Mexican traders or New York dealers – was a series of remarkable solid-clay figurines, which look modern but were in fact fired and finished between 2,400 and 1,500 years ago: post-Olmec, pre-Aztec. They have a vivid naturalistic quality, quite unlike the stock expressions found on many ancient Mexican effigies. Gillett's hand-modelled ceramic pieces were not archetypes, they were more akin to portraits of real people with distinct individual physical and psychological properties. The artists of ancient Greece idealized their subjects, the early Egyptians stylized theirs – those in Iron Age Xochipala seemed to have taken a far more realistic view: their sculptures of people were so true to life you can almost hear them breathe.

They are all memorable in their own way, but the most astonishing example is a work consisting of two modestly sized figures, *Seated Adult and Youth* (400 BC – AD 200). It depicts a middle-aged man sitting cross-legged on the floor, his arms open and welcoming, his head tilted slightly forward as he chats to a teenage boy – also sitting cross-legged – to his left. They are engrossed in an animated

discussion, the topic of which is obviously of great interest to them both; so much so your impulse is to lean in and listen to what they are saying.

It would be fascinating to know more about this odd couple, and where they came from. But these are sculptures without provenance. They might not be local to Xochipala at all, but that seems unlikely. At least we have a rough idea of their age. A sample was taken from the left buttock of the old man and sent to scientists in Oxford, who used a thermoluminescence technique, which determines when the clay was last fired. In this instance it was around 2,000 years ago, but the date could be out by 500 years either side.

Unsurprisingly, the two clay models are showing signs of their advanced years. Both have been glued back together in several places, and neither has survived the trials and tribulations of a couple of millennia without losing a finger or three. But substantial elements of the piece are still intact; it remains a sculpture that its original creator would immediately recognize, unlike modern-day Xochipala.

In an essay written in 1972, Gillett Griffin described Guerrero as 'a wild, rather primitive state'. His successor at Princeton University Art Museum says it has become even less hospitable today for visiting academics and archaeologists wanting to establish a professionally managed excavation of its sensitive historical sites. This has never happened, even though thousands of ancient artefacts have been removed and sold in a spree of

wide-scale looting which has taken place over decades. Today the region in which Xochipala is located is considered a no-go area by the American government, which warns of roadblocks, kidnappings, and extreme violence undertaken by armed gangs and drug cartels.

It all seems a long way from a sculpture of a gentle old man talking to an innocent young boy. It is an accomplished work of art in both composition and style. You wouldn't bat an eyelid if told the clay models were made last week for an Aardman Animation stop-frame animated film. To know they are from the ancient world makes their apparent modernity particularly striking. The vast majority of early Mesoamerican sculpture featuring a human form has the subject looking directly at the viewer, or in profile, or staring off into the distance. In each case the presence of a viewer is implicit, the figure is performing for us. Not so with *Seated Adult and Youth*, where the two protagonists are in a world of their own, having a chat about who knows what.

One interpretation is that the youngster is taking instruction from an elder, a father and son maybe, or pupil and teacher. Alternatively, the boy could be telling his grandfather about how well he played in the village ballgame, scoring the only goal because nobody was quick enough to catch him – maybe he was showing off a winner's cup, now gone, in his left hand. Another possibility is that the two figures were toys, or part of a large tableau that would be displayed on certain occasions. They don't seem to be deities to worship, or effigies to

ward off bad spirits, which marks them out from a lot of ancient art. They are ordinary people giving us a window into their ancient community.

It is reasonable to deduce from the figures that the artist lived in a community that had a social side to it, regardless of the hardships of a more basic life without mod cons. There is a bond between the two that is trusting and loving; their body language is friendly and welcoming. If they are portraits of people known to the sculptor, then the way in which they have been presented suggests a mutual friendship – the artist clearly liked the subjects. Good anatomical knowledge is evident: the figures are well proportioned, their fleshy bodies and twisting forms indicating an understanding of musculo-skeletal structure – as is made visible by the older man's collarbone. It's worth noting they are both naked with no genitalia shown, suggesting a reserved culture in regard to male sexuality (female effigies from a similar time and location depict breasts), or one that preferred some characters to be androgynes, a common feature of sculpture made before the arrival of Christopher Columbus (pre-Columbian) from Spain in the early 1490s. A supportive inter-generational culture is suggested, in which the young and old share a mutual respect. An artistic sensibility is evident in the movement and emotion communicated by the figures. That's a skill which doesn't come easily. Whoever modelled the reddish-brown micaceous clay had the time and space and education to become a master of their craft.

The universal appeal of *Seated Adult and Youth* is what makes the sculpture so special. Art often favours grand subjects or big ideas rather than everyday folk having a quiet chat. There's no action taking place here, no drama to report – there is absolutely nothing to get excited about. It is, in that regard, a humdrum composition. But, seen another way, it has a tremendous inner beauty. It gives status to the status quo. It celebrates the mundane and elevates the prosaic. It gives us pause for thought and a chance to look at what we tend to disregard: the joy that is inherent in the unremarkable interactions we have with family and friends in our daily lives.

The rapport between the *Seated Adult and Youth* is charming, their expressiveness a sign of a very fine artist. It is a sculpture for the ages. No matter how crazed the world becomes, these two figures have risen above the noise and the nonsense to share a moment and enjoy each other's company – they are having the best of times. They don't only represent us, they are us.

Paula Rego: Seeing Fantastically

Storytelling was Paula Rego's way of
seeing. She looked inside herself for
hidden memories and then turned
those autobiographical details into
highly charged, fantastical images. This
was how she expressed her very
particular point of view.

The Dance (1988) is a hauntingly brilliant piece of narrative
picture-making by the Portuguese-born artist Paula Rego
(1935–2022). Packed full of intrigue and disquiet, it is like
an entire film noir movie boiled down into one intense
image. The cast of eight characters dance under a full
moon on a sandy beach in front of a calm sea on a still
night. There are two smartly attired young couples, a lone
woman in the foreground dressed in a white blouse and
brown skirt, and a multi-generational female group con-
sisting of an elderly mother, her middle-aged daughter
and her little girl. A purple haze washes over the picture,
giving it a surreal coolness: as ever with this artist, nothing
is quite as it seems. The single lady on the left is far too big

for the composition; she towers above the other figures. Oddly, nobody appears to notice her – or each other for that matter. These players are self-absorbed and aloof, inhabiting worlds of their own, harbouring their personal fantasies and fears. They dance, but not for joy, in fact they give the distinct impression of being stuck in the moment, as if a spell has been cast to turn them into statues. They are heavy and lumpen and throw off long dark shadows that spread ominously across the sand. In the background, on top of a jagged rock, is the roof of a large building. It could be a castle, it could be a hotel, it could be a fort, or it could be the home to one, or all, of the group dancing below. Who knows what they are dancing to – there is no obvious source of music. Maybe it's to the gentle rhythm of the waves lapping around the rock? There is a distinct Agatha Christie vibe to the scene.

The grandmother and her daughter look a touch fore-bodingly at the little girl, who merrily holds their hands while they move in a circle. She is having a fine time, blissfully unaware she represents hope and innocence in this ultimately doomed cycle-of-life trio. As for the couples, well, they both have an eerie air. The woman in one pair looks to be pregnant and quizzical, the other has her head turned away from her partner. Is the oversized lady on the left of the picture an interloper, or is she a figment of the imagination of one of the men: a lover perhaps, who looms large in his thoughts? One thing is for sure, something sinister is bubbling under the surface and nobody is letting on.

The Dance is a combination of Rego's vivid imagination and her past personal experiences. The beach is likely a childhood memory from Portugal, as is the silhouetted building, which one academic has identified as an old military fort on the coast a few miles from Lisbon, Rego's birthplace. The action taking place is a work of fiction, a gothic tale into which we are all being invited, to make of it what we will. The artist expects us to see things she cannot see, to invent narratives she never intended, to be free to create our own fantastical way of seeing. She has her story, we have ours.

'It's terribly important to have a story,' she said in the award-winning documentary her son, Nick Willing, made about her life and work in 2017. 'Pictures are about what's inside you as much as what's outside you . . . You've got secrets and stories that you want to put out there in the pictures.' She talks about how her characters take on a life of their own as she paints or draws them, much as they do for novelists, who often report feeling like a medium through which a drama is being delivered.

Storytelling was Paula Rego's way of seeing. She looked inside herself for hidden memories and previous experiences, and then turned those autobiographical details into highly charged, rather ominous fables (as every would-be author is told, write about what you know). Recalling a past event that goes on to inform a new painting allowed Rego to express her very particular point of view. It's an approach to self-expression any of us could replicate by filtering our inner landscape into a

fictional story. Maybe the result would be a comic caper or a romantic adventure. Or, if you were like Paula Rego, an uncanny drama – whatever it was, it would reveal, to you and others, your individual aesthetic, your point of view: your way of seeing.

To encounter a Rego image is to be thrust into her world view of foreboding situations, and strange combinations. A fat-ankled lady wearing a walnut-like skirt bends down to lift a prone dog by its front legs in *Snare* (1987). She leans forward as if to give the animal a sensual kiss; a red rose in the foreground suggests love. Nearby, a crab lies powerless on its back, mirroring the dog's vulnerability. The painting is rich with symbolism and menace, and technically very good. The red-to-brown palette has the tonal harmony of Picasso's impeccable *Portrait of Gertrude Stein* (1905–6). The suggested volume of the figures is convincing. The weight born by the lady's legs is palpable, as is the vice-like grip with which she holds the hound.

The picture marks the moment Rego found her signature style. There had always been a strong narrative element to her work, all the way back to the 1960s when she was making cut-up collages like *The Imposter* (1964), critiquing the Estado Novo authoritarian regime in Portugal. Or, in the early 80s, with abstracted, cartoon-like paintings such as *Red Monkey Offers Bear a Poisoned Dove* (1981), lampooning the love triangle she constructed between her husband and her paramour. But these were works in progress towards the stylized tableaux and

heavy-featured figures that are now instantly recognizable as by Paula Rego. Her way of painting was heightened later by the use of oil pastel crayons instead of acrylic paint, a mid-career decision made – she said – to help her stop smoking.

Her psychologically charged *Dog Women* pictures from the early 1990s turn women into werewolves, snarling creatures that are both fiercely loyal and fiercely independent. The series was a response to the death of her husband, the artist Victor (Vic) Willing, whom she met while a student at London's Slade School of Fine Art in the mid-1950s. She considered Vic her intellectual and artistic superior, a point of view he was in no rush to counter. His critical eye helped her work develop but petrified his own. Life got complicated. He was already married. She went back to her parents in Portugal. Vic eventually left his wife and went to live with Paula, after which point he was diagnosed with multiple sclerosis. They both had affairs. Her father, whom she loved dearly, passed away. Vic took over the family business, a factory that he was not able to keep going. They returned to London, penniless. Paula found a lover who was happy to help out financially. Vic began to paint again shortly before he died.

Theirs was a passionate and painful relationship, which Rego renders in pastel with disarming sincerity in her dog pictures, partially inspired by a superb early painting by Vic of her crouching naked on a bed. His *Standing Figure and Nude* (1957) is gentle and sensual,

whereas Paula's dog pictures are ferocious. The female figure takes on the attitude of an animal, part domesticated pet and part wild beast. She lies on her owner's jacket in *Sleeper* (1994), is kicked out of bed in *Bad Dog* (1994), and roars in rage in *Dog Woman* (1994). But it is in *Sit* (1994) that Rego captures the nature of her marriage to Vic with an emotional intensity that is not quickly forgotten. The female character is doing as she has been told, sitting obediently in her chair. Her hands are behind her back, possibly bound. Her feet are crossed in the manner of the crucified Christ. She is pregnant. She looks up and away from her tormentor, her owner, her lover. She is trapped, subjugated, but in no way tamed. Her eyes blaze with defiance, her body emits power. There is an air of sexuality and violence, love and hate, beauty and the grotesque. We've seen plenty of male artists picturing women in myriad different ways, but who else has painted the world from a female point of view in the manner described by Paula Rego?

Louise Bourgeois and Frida Kahlo had similar concerns, and expressed them just as unflinchingly, but Rego's voice is more literary, painterly and poetic in the way of Edgar Allan Poe. She references the Brontë sisters, Edvard Munch, Max Ernst, Joan Miró, William Hogarth and Francisco Goya as influences. You could describe her style as romantic surrealist with a satirist's cutting edge: a combination of influences and attitudes that has led to some very dark, uncanny art.

Back in the summer of 1998 she was provoked to

make some of her most powerful, direct pictures. Her people, the Portuguese people, had not turned up to vote in sufficient numbers at the recently held national referendum to change the country's conservative abortion law. The result of the vote had only just reached her, but the London-based artist was already plotting. As someone who had endured the life-threatening brutality of back-street terminations multiple times, she was dismayed that the Portuguese – particularly the women – were passing up the chance to legalize the termination of pregnancies on request up to ten weeks from conception. She was concerned that the wholly avoidable deaths and distress suffered by thousands of women resorting to illegal abortions every year would continue.

Rego, now over sixty, sat in her Camden Town studio determined to do something about the situation, to change public opinion back home; to lobby for the draconian law to be changed. She walked across her studio floor and stood in front of her easel, on which rested a large piece of blank paper mounted on aluminium. She looked down at the pastel sticks scattered on top of the table to her side, and got to work.

What followed was a series of harsh, intense pictures and etchings depicting the nature of a back-street abortion. Collectively, they are as unsentimental and uncompromising as a gangland boss dealing with an informer. There's no flim-flam, no tiptoeing around the topic: Rego gets straight to the point, which is at

PAULA REGO

once troubling and bleak while also being psychologi-
cally provocative. The artist is being both explicit and
vague. Each image features a single female figure in an
undecorated, unfurnished room save for a bed or chair
or couch on which the woman is prone and waiting
for, or has just undergone, an illegal termination. The
expressions on the protagonists' faces are defiant and
resolute. There is no blood or gore; the artist was mind-
ful of the viewer, saying, 'What you want to do is make
people look, make pretty colours and make it agree-
able, and in that way make people look at life.' You can
see her point, but she also knows the editing out of any
evidence of a medical procedure allows for the possi-
bility of a visual ambiguity that makes for uncomfortable
viewing. For this artist the grim reality of a clandestine
termination isn't ethically or intellectually straightfor-
ward. It is not simply a case of a bad thing happening.

Any of the imposingly large pictures she made in this
series will unsettle. There is an uneasy eroticism bound
up in the pain and the squalor. The schoolgirls and young
women depicted challenge the unseen figure with a
physicality and stoicism. Have they girded up their loins
in anticipation of an impending termination or some-
thing else?

Welcome to Paula Rego's fantastical universe, where
there is always something nasty in the woodshed. She is
famous for being a fine artist, but what makes her pic-
tures so special is her talent as a narrator. Paula could
always draw, but it was only when her father started to

243

read her Dante's *Inferno*, and she watched early Walt Disney cartoons as a child, that she realized every picture could tell a thousand stories. From that moment on she was unwavering in her approach to image-making, which, for her, wasn't about finding a pleasant still life to paint or an interesting nude to draw, but searching for a fable to share.

Rego was blessed with the eye of an artist and the ear of a novelist. Those semi-fictional termination pastel paintings she made in 1998 were shown in Portugal shortly before the country's second referendum on liberalizing the abortion laws in 2007. This time around, the new law was voted in and passed, partly – it has been said by the campaign's backers – because of Paula Rego's pictures. They spoke a truth to the people of Portugal, who now boast a museum dedicated to the woman who was born in Lisbon in 1935 but went on to make England her home. The name of the institution is Casa das Histórias Paula Rego – a house of stories by Paula Rego. It says it all – about the art she made and the way she saw. She was a story-hunter, forever on the lookout for a tale – it might be a news report, it could be a children's book – wherever she could find that seed of inspiration to begin a process of developing a fantastical picture from her imagination. It was a process through which she accessed previously unacknowledged thoughts and secrets buried deep in her unconscious, which she then revealed to the world, and more importantly, to herself.

Jean-Baptiste-Siméon Chardin: Seeing Everyday Life

There are no pious or symbolic messages being communicated in a Chardin painting, but rather a gentle reminder that we are surrounded by humble objects and everyday scenes that are truly wonderful to behold.

Jean-Baptiste-Siméon Chardin (1699–1779) is not one of the most famous artists who ever lived, but he is one of the best. A quick glance at *The Smoker's Case* (*c.* 1737) is enough to confirm that he had a very special talent. He was a master of technique, composition and mood. That he made a success of being a chronicler of the everyday is all the more notable given where and when he was living.

Chardin was an eighteenth-century oddity: a Parisian painter who produced quiet, simple pictures when all about him were making flamboyant, ostentatious artworks. It was the Rococo age, a time when the upper classes of Europe's grandest cities developed an expensive taste for pictures both frivolous and flirtatious. They

wanted grandiose scenes of amorous young lovers surrounded by splendid ornamentation set in mythological landscapes. Among the most popular exponents of the crowd-pleasing exuberant style were the French artists François Boucher and Jean-Honoré Fragonard. Their names were at the top of the list of all the high-society types who were in the market for a wall-filling canvas full of lively colours, voluptuous curves, billowing silk gowns and lovestruck couples.

Chardin's reserved style could not have been further from the frills and frolics of his Rococo peers. He had no interest in highfalutin displays of whimsical romanticism. His father had been a craftsman, a respected cabinet-maker with an appreciation of good materials. He had developed a loyal client base among the city's bourgeois, although not the aristocracy. Young Jean was a man of the middle classes. He painted naturalistic pictures that were small enough to fit into a modest house but classy enough to impress the neighbours. So classy, in fact, that it wasn't long before the eyes of royalty were turning away from Rococo and towards his serene domestic scenes and exquisite still-life arrangements.

Louis XV, the King of France, became first a customer and then a patron and eventually Chardin's landlord, providing the artist with a studio and accommodation in the Louvre Museum, together with a generous annual pension. The artist had come a long way in a short time, having initially gained a modicum of recognition as a capable painter of 'animals and fruits'.

24. Seeing Us: *Seated Adult and Youth* (400 BC – AD 200), Xochipala sculpture

25. Seeing Fantastically: *The Dance* (1988) by Paula Rego

26. Seeing Everyday Life: *The Smoker's Case* (*c.*1737) by Jean-Baptiste-Siméon Chardin

27. Seeing the Invisible: *The Ten Largest, No. 7 Adulthood Group IV* (1907) by Hilma af Klint

28. Seeing Absurdity: *Ennead* (1966) by Eva Hesse

29. Seeing Shapes: *Poppy* (1927) by Georgia O'Keeffe

樹纔發葉溪
橋復攬閣仙
居家上層不
籍栽關亦
似蓬山早兄
氣如蒸
己卯春月
尚起

30. Seeing Harmony: *Early Spring* (1072) by Guo Xi

31. Seeing Politically: *Minerva Protects Pax from Mars* (1629–30) by Peter Paul Rubens

32. Seeing Beauty in Ugliness: *Dhôtel Nuancé d'Abricot* (1947) by Jean Dubuffet

That qualified assessment was soon upgraded following the monarch's endorsement, which brought the artist to the attention of the crowned heads of Europe, who now all wanted a Chardin painting in their palaces. They were not the sort of people accustomed to having to wait for what they wanted, but in this instance there was no choice. Chardin didn't so much work at a snail's pace, more at the speed of a glacier. Prolific he was not.

He was astute, though. At a time when history painting was considered the most prestigious subject in the hierarchy of genres, and still life the lowliest, the canny artist realized the Académie's snobbery presented him with an opportunity. He spotted that there wasn't a great deal of competition for paintings of fresh fruit and flowers. So Chardin decided to make the genre his own. While other artists produced ever more opulent and fanciful Rococo artworks, he devoted himself to studying mundane household objects such as jugs, bowls, fruit, bread and carving knives. Chardin showed the world that the unglamorous tools of life we routinely ignore were actually a wonder to behold – when looked at in the right way. He found beauty in simplicity.

The Smoker's Case depicts an arrangement of typical objects that would have been found in a French bourgeois home around 300 years ago. A jug, a goblet, a glass bottle and a smoker's box. There's nothing special about any of it, yet the way in which Chardin has placed the items gives them a dignity and presence. They are at once reassuring and alluring, familiar and noble. He has

taken a slice of ordinary life and, with the subtlest of artistic dimmer-switches, shone a diffuse light on to it, bringing the inherent qualities of the objects to our attention. He is not dressing anything up to suggest it is more than quotidian, nor is he attempting to imbue the scene with weighty religiosity or allegory. He is telling it like it is: that there is no need for over-pictorial hyperbole to appreciate the gloriousness of our daily existence – it is right there under our noses, hidden in plain sight.

It is a painting that doctors and psychologists could prescribe to the anxiety-ridden and wrung-out (ideally with a free ticket to the Louvre to see it). If *The Smoker's Case* doesn't bring a little peace and calm to a troubled mind, nothing will. The overall tone of the picture is one of warmth and comfort. The palette of creams and browns – complemented with the occasional brush-stroke of cool blue and hot red – is designed to be as relaxing as a hot bath on an autumn evening. Everything about it says 'take it easy'. The gentle puffs of smoke drift upwards from the base of the long-stemmed pipe, the blackened bottom of which Chardin has glowing with a dab of scarlet paint. There's a pewter chalice frothing with a creamy top, and a tall porcelain jug, next to which is a tobacco jar with its silver-rimmed top removed and placed in the foreground. The light from the left makes the varnish on the rosewood smoker's case gleam, and its brass handle shine, before extending across the pipes and assorted paraphernalia stashed

inside. The bluey-green colour of the satin inlay adorning the box's opened lid is echoed in the decorative pattern on both the jug, mug and lid, creating a pyramidal dynamic that draws you into the picture. The composition encourages your eyes down the long diagonal pipe stem to the glass bottle and silver vessel, and then across to the frothing goblet and back to the box. The brightness of the sun-soaked pot and erupting foam is counterbalanced by the deep shadows cast across the box and the shaded stone wall behind.

Chardin has meticulously arranged his composition on a stone entablature, adding a sense of permanence to objects that represent a fleeting moment of leisure and pleasure. It is obvious that his father passed on a love of quality materials to his son; it is evident in the close attention the artist has paid to rendering the surface textures of each and every item. He clearly appreciates the craftsmanship involved in the making of the jug and the box, the pewter vessel, and his favourite silver cup (stolen on one occasion from his Louvre apartment before eventually being recovered by police).

The Smoker's Case is a surprisingly modern painting in many ways. The stripped-back aesthetic, the geometric nature of the objects, and the horizontal and vertical grid established by the stones in the back wall, which is then repeated in the foreground with the stone tabletop, and the large pillar on the far left of the picture. The diagonal lines of the long-and short-stemmed pipes, together with the positioning of the box, provide the

orthogonal lines, which help hold the picture together with a single vanishing point slap bang in the middle.

The esteemed French art critic and philosopher Denis Diderot was a Chardin fan, describing a painting by the artist in the 1763 Salon with poetic enthusiasm: 'This is nature itself; these objects, whose truthfulness tricks the eye, exist outside the canvas ... O Chardin! On your palette you grind not white, red, and black pigment but the very substance of objects, it is the air and the light you take with the tip of your brush and that you fix to the canvas!'

He was mightily impressed by the artist's use of colour, which was both highly sophisticated and subtly bold. Chardin united his pictures with the subtle application of colour. You can see in *The Smoker's Case* how he has added a lick of black paint to the stem of the pewter chalice on the right-hand edge of the image. The same colour note is then repeated along the horizontal line in the small pile of tobacco arranged in front of the jug on the table-top, and again with a tiny dab between the silver goblet and the wooden box, then he finally resolves the sequence with the blackened pipe bowl in the bottom left-hand corner of the painting. He does it again with the accents of white paint on the rim of the silver cup, the top of the glass bottle behind it, and the stem of the pipe that intersects them both.

These are examples at the finely detailed end of how Chardin worked as a colourist. More obvious is the way in which he created visual effects by placing blocks of

colour side by side with very little mixing. For instance, he sets the dark brown of the box against the light grey-white of the vase and pot, which produces a dramatic contrast that gives both objects more urgency and pictorial presence. Meanwhile, the blue used for the box's inlay and the porcelain patterning adds a complementary colour to the grouping, which helps achieve a collective harmonious tone. The objective, he said, was to make use of colours but 'paint with feeling'.

Jean-Baptiste-Siméon Chardin was born on the 2nd of November 1699 in Paris, a city from which he never moved. He studied under the history painter Pierre-Jacques Cazes and the rococo artist Noël-Nicolas Coypel. Whether it was through a lack of interest or a lack of formal education, Jean decided against following his teachers' lead into the fashionable genres of allegory and history painting. Instead, he committed to producing still lifes, before developing a reputation later in his career for painting Parisian bourgeois scenes featuring domestic servants working, and young children playing.

Chardin was accepted into the prestigious Académie Royale de Peinture et de Sculpture shortly before his thirtieth birthday, after which he married his long-time partner Marguerite Saintard, with whom he had a boy and a girl. It was the beginning of a personal life that went as badly as his professional life went well. Marguerite died four years after they married, followed by their daughter a little over a year later. He married for a second

time, a union which brought him improved financial circumstances because of his new wife's wealth, but no more luck with the Grim Reaper. They had a daughter but she too died in infancy. By now his son, Jean-Pierre, had also become a painter. Good news, at last! Until, that is, he was discovered drowned in a canal in Venice, with suicide thought to be the probable cause of his death.

Chardin responded to personal misfortune by becoming more and more involved with the Académie. He was made a counsellor, then its treasurer, and, in due course, the curator of its famous Salon exhibitions. He was, he said, a 'dedicated academician'. The extra work involved in helping run the institution, together with his comfortable financial situation, meant he painted fewer and fewer pictures. Even those he did produce were often 'repeats' of previous works. His lack of productivity wasn't helped by failing eyesight, which promoted a move away from oil paints and the creation of a late-career body of work made with pastels. He died in 1779 aged eighty, having only produced around 240 paintings.

Never mind the quantity, though, it is the quality that matters, a metric on which Chardin scores very highly. *The Smoker's Case* is a fine example of a fine work by a fine artist. It is an intimate painting in which you can almost smell the smoke from the pipe, and feel the warmth in the room. Time has been slowed down, tranquillity has descended, a moment of meditation and peace is upon us. The artist has taken humble, everyday objects and

shown us through his intense gaze and artist's eye their inherent charm and beauty. There are no pious or symbolic messages being communicated in the painting, other than the artist's gentle reminder that we are surrounded by visual wonders to lift our spirits and satisfy our souls – we just have to look.

Hilma af Klint: Seeing the Invisible

Hilma af Klint was willing to look
beyond the material world to access a
different way of seeing. She didn't so
much observe our universe as
channel its energies. It enabled her to
make the invisible, visible. They say
seeing is believing. Af Klint showed
us the opposite, that believing
is seeing.

Charles Darwin published *On the Origin of Species* in 1859, having withheld the text for years in fear of upsetting the Church. His ideas about natural selection and the evolution of species fundamentally undermined current theological teaching and its core belief in creationism. The English scientist suspected the publication would annoy a powerful brotherhood of heavyweight bishops and archdeacons, not to mention the Pope over in Rome. He was right, the Church gave the ground-breaking book a very chilly reception. Nevertheless, it was published and Darwin was not damned. In fact, *On the Origin of*

Species had a surprisingly positive consequence for religious leaders: it contributed to a boom in spiritualism.

Darwin gets the credit for coming up with the concept of natural selection, but he wasn't a lone voice. Another heavily bearded British naturalist, Alfred Russel Wallace, thought along the same lines as Darwin. The two men produced a joint paper in 1858 presenting the case for their notion of a 'survival of the fittest' (a term coined later in 1866 by the philosopher Herbert Spencer), establishing Wallace as co-discoverer of evolutionary theory. They were in broad agreement on most things, but diverged significantly when it came to us humans. Darwin thought we are as we are because environmental conditions had caused us to develop into sentient *Homo sapiens*. Wallace begged to differ. He argued that our upright, hairless bodies were indeed the result of natural selection, but that didn't explain our extraordinary brain power. All we needed to survive and thrive was a mind a notch or two above an ape's, and yet our intelligence had exceeded that requirement many times over, to such an extent that we can write operas, make sense of the most complex mathematical problems, and design buildings of gravity-defying complexity. Wallace believed such an intellectual over-development ran counter to evolutionary theory, and that Man's mental prowess was down to 'something which he has not derived from his animal progenitors – a spiritual essence of nature . . . [that] can only find an explanation in the unseen universe of the Spirit'.

SEE WHAT YOU'RE MISSING

To Darwin's consternation, Wallace believed in a 'higher intelligence', and duly put aside the strict materialism of fact-based science by enthusiastically embracing the less tangible claims of psychics and mystics. He wasn't the only intellectual sensing there was more to life on earth than the visible or scientifically explicable. The pioneering chemist William Crookes was on board with the occult, as were the novelist Arthur Conan Doyle – creator of Sherlock Holmes, a character who was an empiricist down to his bootstraps – and the inventor Thomas Edison, who spoke mischievously of manufacturing a 'spirit phone' to communicate with the dead. None of this is surprising when you consider the period, a time when X-rays and radio waves and other previously unknown forces were being routinely discovered. What mysterious law of nature might be next – self-driving carriages taking instructions from the ether?

Unexplained phenomena were the talk of high society. The Fox sisters in New York became celebrities for their 'knock three times' séances, while novel religious movements popped up all over the place like an ageing rock band on a world tour. Among them was an esoteric doctrine called Theosophy, an amalgam of religions and philosophies including Tibetan Buddhism and stories from the astral plane. Its promise was to reveal the 'eternal truth' that underpinned everything: the material, the spiritual and the universal.

Edison signed up to its ranks; Wallace was sympathetic. Its founder and proponent was Helena Petrovna

Blavatsky, a well-travelled Russian woman who claimed to be a telepathic clairvoyant. Her books were widely read by the intelligentsia on both sides of the Atlantic, as well as by avant-garde artists taken with Mme Blavatsky's personality and ideas. Acolytes included Piet Mondrian, František Kupka, Kazimir Malevich and Wassily Kandinsky, each of whom would go on to be individually credited as the originator of abstract art. They weren't. As we know, abstract art – or non-figurative art – goes back millennia, to the ancient peoples of Africa, Australia and the South Pacific islands. Images constructed from marks and geometric symbols are as old as art itself. But, in the context of the Western art canon, the 'inventor' of abstract art is open to debate. Kandinsky is usually given the bragging rights for a painting he produced in 1911, about which he later said, 'Indeed, it's the world's first ever abstract picture.' It has since been lost, and so might his crown as the inventor of European abstract art. Coming up on the rails is Hilma af Klint (1862–1944), a Swedish painter and committed member of the occult cult, who many believe beat Kandinsky to abstraction by five years.

Af Klint was the fourth of five children born into a well-to-do naval family with a summer estate on the island of Adelsö in Lake Mälaren. In 1882, her father, Captain Fredrik Victor af Klint, supported his twenty-year-old daughter's entry into the Royal Academy of Fine Arts in Stockholm, a highly prestigious institution that had only just started to accept female students. She

did well. So well, in fact, that upon graduation five years later the Academy granted the fledgling artist free use of a studio in its atelier above Blanch's Café in Stockholm's hipster district. She quickly established her reputation as a talented painter of portraits and landscapes in a naturalistic style. It was around this time that Hilma developed an intense interest in science, leading to commissions to produce detailed botanical drawings and intricate animal studies. So far, so figurative.

But there was another side to the well-dressed young painter with a burgeoning clientele. She was an enthusiastic and devout spiritualist. Maybe it was the death of her sister when Hilma was eighteen, or simply because she had a vivid imagination and an enquiring mind, but af Klint had been participating in séances since her late teens. By the time she was an established artist she had explored the Edelweiss Society, the Rosicrucian Order, and several other mystical movements advancing spiritual and metaphysical concepts. None, though, caught Hilma's imagination like Theosophy, which arrived in Sweden in 1889.

She signed up straight away, and, for good measure, started her own small group of fellow Christian spiritualists called The Five, which consisted of Hilma and four female friends who met every Friday for tea, cakes and a séance. They prayed, read passages from the New Testament and then got down to the serious business of summoning 'The High Ones', via a celestial intermediary who would communicate through that night's

designated medium. Whichever one of The Five was the evening's appointed receiver was responsible for transcribing the messages sent from beyond – her job was to be the vessel, not an interlocutor. It was a precursor to what the Surrealists would call 'automatic' art thirty years later: a stream of conscious revelation transmitted through a human soul.

The ladies made copious, meticulous notes about the communiqués they received from their ministry of guiding spirits (whom they called Amaliel, Ananda, Clemens, Esther, Georg and Gregor), a practice they maintained for years. Each week they would hope and pray for a specific instruction but none was forthcoming, until one Friday in 1904 when Amaliel messaged to say The Five should produce paintings on the astral plane, paintings that would represent the spirit of the world. And once they'd completed that task, they should build a temple to house the works. As commissions go, it was a whopper. Four of the women moved aside, but Hilma stepped up and got to work with these words from Amaliel ringing in her ears: 'You are to proclaim a new philosophy of life and you yourself are to be a part of the new kingdom. Your labours will bear fruit.'

Amaliel's prediction about Hilma's productivity was spot on, as you would expect from a guiding spirit. In response to the command, af Klint produced 193 artworks between 1906 and 1915, collectively known as the *Paintings for the Temple*. She said they were made 'directly through' her by supernatural forces, that she was merely

a channel. Each painting made visible an ethereal message from beyond. It might sound far-fetched today, but otherworldliness was the height of fashion then. Over in Paris, for example, Picasso was making work heavily influenced by ancient African gods, which would result in his 1907 masterpiece *Les Demoiselles d'Avignon*.

You don't have to be into the occult to believe that there is more to life than the physical world. Take our imagination, for instance: it is immaterial and inexplicable and completely invisible, but it is also entirely tangible. As are the geometric representations Hilma af Klint rendered. No matter that she says her inspiration came from a 'higher intelligence', few would question the existence of unseen energies such as gravity and radiation and atoms, our unconscious, and much else besides. She was able to discover and paint hidden powers because she was willing to look beyond the material world to access a different way of seeing. She didn't observe as such, she transmitted energies. It enabled her to shed light on dark matter: to make the invisible, visible. Why paint a boring house when you can depict all the otherwise unseen forces that flow through the heavens and the earth?

Oneness was a central Theosophical belief – the notion that in the beginning we were a whole, pure spirit, which had subsequently been split apart and shattered by the material world, but could be brought back together by reuniting the dualities: male and female, mind and body and so on. The symbols that represented

this return to oneness formed the basis for the images Hilma af Klint started to make in autumn 1906, when she produced her first raft of temple pictures, called *Primordial Chaos*.

The series consists of twenty-six small oil paintings, largely rendered in a palette of green, yellow and blue. The colour choices are symbolic. Blue is female, yellow is male, and green is the unity of the two. They are also the fundamental colours of life: earth, light and water. Taken as a whole, the series has a cosmic harmony, with light rays heading off into space, and strange tubular spiral forms relating to our relationship to nature. Some have words written on them, others have letters, typically a 'U', which represents the spiritual realm, and a 'W' for the material world. *Primordial Chaos No. 16* has a rich blue background with spring-like shapes sprouting from the bottom left-hand corner, which then loosen into ever-widening concentric circles moving diagonally towards the top right-hand corner. To the modern eye the shapes could be mistaken for a cellular diagram, or an electronic circuit – neither of which should be discounted given its mystical source – but from an art historical perspective they would be described as being abstract. Making *Primordial Chaos* . . . drum roll . . . the first abstract paintings of the Western canon!

That's the claim, anyway, although there are a couple of health warnings. First, is it really abstract or are the shapes specific symbols? Kandinsky, Mondrian et al were consciously making non-representational art free

from references to the known world or interpretation. That was not af Klint's objective. She was the medium through which geometric signs were being produced that formed a code to the root of all knowledge. Her paintings weren't supposed to be abstract and elusive, they were messages from beyond.

There is another reason why one shouldn't rush to crown Hilma as the originator of abstract art, a reason which can be found in Victorian Britain in the shape of Georgina Houghton. She, too, was a spiritualist medium who made abstract paintings guided by angelic beings and other spirits. Hers were also full of spirals and heavenly forms. The difference being that she produced her watercolours thirty years earlier, in the 1860s and 1870s. If mediumistic paintings are to be deemed abstract in the formal sense, then it is Ms Houghton and not Ms af Klint who should be credited with being the inventor of European abstraction.

That, though, is a sideshow. What matters is the quality of the work, which, in the case of Hilma af Klint, was often exceptional. A year after her *Primordial Chaos* series, the Swedish artist made *The Ten Largest* (1907), which, as the title suggests, consists of ten very big artworks, measuring around 3.3m x 2.4m. They represent the human life cycle, from childhood to old age. When shown as a group they are astonishing: 'a beautiful wall covering', as Hilma said. Great swathes of blue and pink and orange act as backdrops for a euphoric dance of biomorphic shapes, intersecting discs and psychedelic

landscapes. There are two paintings for childhood, two for youth, four for adulthood and two for old age. If I had to pick one out, it would be *No. 7 Adulthood Group IV*, which, like all the others, is painted in tempera on paper, mounted on canvas.

Three lemon-yellow, balloon-shaped objects dominate the centre of the ebullient composition. They are arranged as an inverted triangle, like a posing muscleman or a 1950s leading lady with a pinched waist. A network of curving lines interconnects them, while organic and botanical forms orbit around their edges: a geometric core anchored in a mauve sea of floating flora and fauna. This is adulthood as seen through the bottom of a glass half full. It is not depicting what adulthood is, but what it could be. It's a visionary picture of transcendental hope by an artist who sincerely believed that the spirits could communicate with the living. 'It was not the case that I was always to obey the high lords of the mysteries, but I was to imagine they were standing there by my side,' she said. All art is about belief: a picture of a house, for example, isn't really a house and yet we read it as such and accept the artist's fabrication.

Hilma af Klint died in 1944, the same year as two of the other pioneers of European abstract art, Wassily Kandinsky and Piet Mondrian. By then both men were famous for their non-representative paintings, which were also heavily influenced by Theosophy and the spiritual. Af Klint's abstract works were completely unknown. They were never fully exhibited in her lifetime, and she

instructed that they shouldn't be displayed in public until at least twenty years after her death, when the world would be ready for them. As it turned out, it wasn't until an exhibition called *Spiritual Art* in Los Angeles in 1986 that they were properly shown, after which they were largely forgotten again until very recently, when they have suddenly become the subject of a series of blockbuster exhibitions.

It seems we are now ready for the 1,300 mystical artworks she left behind along with her 125 notebooks codifying her vast output. Her time has come. Our perceptions have changed. We want to see how Hilma af Klint saw.

Eva Hesse: Seeing Absurdity

Eva Hesse saw truth in the absurd.
The weird everyday combinations that
we all tend to overlook were the
subject of her sculptures, in which
order and disorder coexist in an
awkwardly beautiful harmony. They
make you stop and see how dull things
would be without both the sacred
and the profane.

Eva Hesse died on Friday May 29th, 1970. She was thirty-four years old. A blossoming career as one of the most exciting artists working in the Western world had been abruptly ended by an aggressive brain tumour. Some would call it a tragically young age to die, just when her reputation as an outstanding sculptor had been firmly established. Had she been able to comment on the matter, I reckon Eva Hesse would have summed up her unnaturally early demise with one word: 'absurd'.

As far as she was concerned, her life – and her death – had been a series of extreme events for which only this

particular adjective could satisfactorily describe her experience. It defined her and the art she produced, as she explained to the writer, curator and art historian Cindy Nemser in an interview that appeared in *Art Forum* magazine in 1970, shortly before her death: '. . . absurdity is the key word . . . It has to do with contradictions and oppositions. In the forms I use in my work the contradictions are certainly there.' They sure are. She brought chaos to order, stringiness to solidity, and awkwardness to conformity by playing with scale and placement. 'I was always aware of their absurdity and also their formal contradictions and it was always more interesting than making something average, normal, right size, right proportion . . .'

Art is about life, and her life, she deemed, was absurd. That's how she saw it. But how do you depict that? What does absurd look like? The Surrealists of the previous generation, such as Salvador Dalí, Joan Miró, Leonora Carrington, René Magritte and Max Ernst, had all played around with the idea of absurdity, had explored the absurdity of life by attempting to expose the repressed thoughts we have buried deep in our unconscious psyche. Hesse took note of these artists from a previous generation, but her absurdity was different. Absurdity was the reality of her everyday life, not some buried notion that had to be dredged from dreams. The Irish playwright Samuel Beckett put into words what she aspired to visualize in her art. She would talk about his absurdist play *Waiting for Godot*, in which two tramps

endlessly and pointlessly speculate about an event (the appearance of Godot) that is never going to happen. It was, though, another Beckett text that perhaps helped her most in her quest to make the absurd visible. It was a text called *The End*, which the Irishman had finished shortly after the Second World War but was not published until eight years later – in French (Beckett later translated it into English himself). *The End* is a monologue featuring another tramp-like figure who is hopelessly seeking salvation of some kind. We meet him just as he is being thrown out of a homeless shelter or similar and then overhears a conversation between a child and his mum:

> A small boy, holding out his hands and looking up at the blue sky, asked his mother how such a thing was possible. Fuck off, she said.

It is the incongruity and aggression of the sentence, which, with its coarseness, changes the shape and tone of the rest of the text. The passage is, to me, the essence of an Eva Hesse sculpture, it being brilliantly, thrillingly, unexpectedly, awkwardly dissonant. Nearly beautiful, almost ugly, it creates the sort of asymmetric tension that brings art alive, a type of absurd artwork at which Eva Hesse became a master once she had found her way with a piece called *Hang Up* (1966).

Before *Hang Up*, Hesse had thought herself a painter: afterwards she knew she was a sculptor. The piece looks like a giant, empty picture frame (183cm × 213cm) made

of cord and rope, from which protrudes a looping, snake-like appendage as if an alien form were reaching out to ensnare passers-by. 'It was the first time my idea of absurdity or extreme feeling came through,' she told Nemser, before adding, 'The whole thing is ludicrous. It is the most ridiculous structure that I ever made and that's why it is really good.'

Ludicrous, ridiculous and absurd are words we all hear frequently: they represent familiar events ranging from cosmetic surgery that makes you look worse to the inexplicable actions of a political leader. We know what incongruous looks like – a dad dancing, a shark embedded in the roof of a terraced house – but seeing the irrational presented formally as a work of art has the effect of making us consciously aware of the ubiquity of the illogical and bizarre in our daily lives. It triggers a sensation of disquieting familiarity.

Eva Hesse's sculpture *Ennead* (1966), completed the same year as *Hang Up*, is a vision of ordered disorder: a polite conversation in which neither party means what they say, a long-awaited holiday that has ended badly, a newsreader wearing shorts and socks. It doesn't matter how hard you try to do the right thing, she's showing us, life gets messy. We can see that. But there's an added complexity to the work that marks it out as both original and exceptional. The piece takes us from a structured geometric grid of nine dyed strings presented in a neat row (hence *Ennead* – meaning a group of nine), which emerge, hanging, from small holes made in the papier-mâché board.

Each string is the same length, which is fine to begin with but becomes unruly when Hesse adds more and more rows to the grey, rectangular panel. To stop the cascade of string pooling on the floor in a tangled heap, she lifts as much as she can manage and secures the loose ends to the side wall. By now the whole thing has become a knotty mass, making it impossible to trace any individual string back to its source. It is absurd. But it is also absurdly attractive, a marvellous work of art to behold, which owes its arresting visual power to the coagulated jumble that the artist pulled across the corner of the room. This lopsided arrangement is Hesse's version of Beckett's preposterous 'fuck off'. It acts as a shocking and invigorating counterbalance to the symmetry of the grid on the board, adding a jolting dynamism to the entire composition. Remove either component – the rigid formality or the chaotic strands – and the piece is dull, if not lifeless. Hesse shows us with *Ennead* that we might yearn for order, but the truth is we also need a little bit of chaos. 'Nice parallel lines make me sick,' she told Nemser.

Few artists before or since have captured the absurdity of life with the force and directness of Eva Hesse. She saw it so clearly, combining the offbeat and funny with the dark and ominous. She hung sculpture on a wall when we expect to see it on a plinth; she made pieces out of brittle materials such as latex and fibreglass rather than immutable stone and bronze (creating a nightmare for today's art conservators, responsible for maintaining her disintegrating artworks). We have come to think of

sculpture as robust and heavy: hers were fragile and light.

Hesse was bold and ingenious when it came to pairing contradictory ideas. She combined the ascetic aesthetic of 1960s Minimalism with the flamboyance of Jackson Pollock's Abstract Expressionism. She made voluptuous erotic allusions in the form of domed breasts and dangling testicles and then presented them in compositions based on the cold frigidity of geometric abstraction. The balance between the two opposites was always on a knife edge. We are all swimming in absurdity, we just don't necessarily see it as clearly as Eva Hesse, who, it should be said, had a lot of experience.

She was born in Hamburg in 1936. Her mother studied art; her father was a criminal lawyer. She had a sister called Helen who was two years older. The Hesses were a Jewish family in Nazi Germany, which was her earliest experience of an extremely uncomfortable combination. Her parents managed to find a place for Helen and Eva on one of the last Kindertransport trains to leave for the Netherlands. Most of Eva's relations were murdered by the Nazis but fortunately not her parents, who came to find their daughters six months later. The family went to England and then on to America, settling in Washington Heights, New York City. Anxiety caused by a fear of abandonment and displacement was now hard-wired into little Eva's soul. It was 1939.

Her mother found it hard adapting to life in Manhattan. She missed Germany. Her mental health suffered,

possibly compounded by bipolar disorder. Life at home became strained. More anxiety, more mood swings, more absurdity. In 1944 Eva's parents divorced. A year later her father remarried. A year after that, in 1946, her mother killed herself by jumping from the top of a building. Eva was ten. She was devastated, once again abandoned, apart and alone – different.

She didn't enjoy school and left at sixteen, managing to land herself a job on *Seventeen* magazine in the early 1950s. After that she went to study art at Cooper Union and loved it. From there she went to Yale, where she was taught by the legendary artist and Bauhaus alumnus Josef Albers, before graduating in 1959. She returned to New York and became a member of the art crowd, which was dominated by men. For any female artist it was not an easy world to inhabit, but for one so full of anxieties and self-doubt it was – as she would say – extreme.

In 1961 she fell in love with an up-and-coming sculptor called Tom Doyle, a hard-drinking, hard-partying kinda guy. Another extreme, another odd combination, another example of the absurdity of opposites attracting. They married the same year, shortly before Pop Art burst on the scene in 1962 with a show at the Sidney Janis Gallery called *International Exhibition of the New Realists*, which included pieces by Andy Warhol and Roy Lichtenstein. The atmosphere in Manhattan was changing, Eva's confidence was shot, so when Tom was offered the chance of a residency abroad, they both saw it as an opportunity to get away and recharge their creative

batteries. There was one major problem, though. The residency was in Germany, a country that still made Eva shudder to her core with fear. Would she be arrested and killed if she returned after all these years? Would the secret police be lying in wait? She was traumatized by the prospect of going back, but was also becoming increasingly frustrated in New York, where she was suffering from 'artist's block'. In the end, she decided to go to Germany. It turned out to be the making of her. But it was also very nearly the breaking of her.

Eva and Tom had been invited by the industrialist and art collector Friedrich Arnhard Scheidt, who provided them with a large studio space in the shape of his disused textile factory near Essen, in Kettwig an der Ruhr. After taking some time out to see a few galleries around Europe, the young artists got down to work. It went well, but their relationship did not. Tom was drinking too much; arguments were frequent, happier moments increasingly rare. Eva started to draw and paint machine-like contraptions – 'nonsense' images, she called them. They looked a bit like a diagrammatic instruction manual put together by someone who'd dropped a tab of LSD. They were eccentric and surreal, inspired, in part, by Marcel Duchamp's famous free-standing glass panel *The Bride Stripped Bare by Her Bachelors, Even*, but also by her immediate surroundings. The old machinery and detritus left behind when the factory closed was scattered all about on the floor,

providing a rich resource of visual stimuli for an artist on the lookout for inspiration.

One morning she bent down and picked up some copper wire from a dusty corner and placed it on a work bench. She coiled it up and went back to her easel to make a sketch. She studied it for a while and then went back to the bench. It was 1965; soon she would be thirty, a 'mid-career' artist who had yet to find her voice. She stood and looked at the coiled wire with its centre rising like a nipple on a breast and then started to compose a letter to her dear friend and fellow artist Sol LeWitt. She told him about being unsure of herself as an artist, of not being clear about what direction to take. He wrote back on the 14th of April 1965 with what must be one of the greatest letters ever written about overcoming a creative impasse, in which he implored:

> Just stop thinking, worrying, looking over your shoulder, wondering, doubting, fearing, hurting, hoping for some easy way out, struggling, grasping, confusing, itching, scratching, mumbling, bumbling, grumbling, humbling, stumbling, numbling, rambling, gambling, tumbling, scumbling, scrambling, hitching, hatching, bitching, moaning, groaning, honing, boning, horse-shitting, hair-splitting, nit-picking, piss-trickling, nose sticking, ass-gouging, eyeball-poking, finger-pointing, alleyway-sneaking, long waiting, small stepping, evil-eyeing, back-scratching, searching, perching, besmirching,

grinding, grinding, grinding away at yourself. Stop it and just DO!

It did the trick. Eva's creative block was blasted away; she could see clearly now. She needed to be more extreme, more absurd. She didn't return to her easel to get to work, instead she went to the bench and the coiled electrical wire. She covered it in cloth, and mounted it on a piece of Masonite. She painted the rim of the wire red and the rest a creamy golden colour, with a dab of pink for the nipple. She added another, smaller, conical-shaped wire above it, giving the composition the appearance of a snowman, or a plate and saucer, or two wide-brimmed hats of different sizes as seen from above. She called the work *Ringaround Arosie* (1965), in honour of her pregnant friend Rosie Goldman, and announced the piece as a finished artwork. It changed her life. She was no longer a troubled painter without an established style; she was a pioneering sculptor using unusual material combinations to create abstract-minimalist-surrealist pieces that would inspire generations of artists to this day.

During the next four years, from 1966 to 1970, Eva Hesse would come to be recognized as one of the world's foremost artists. A brilliant sculptor of perfectly imperfect shapes that captured those awkward opposites and forced them to coexist in the same space. Her personal and professional life would continue to be a mixture of triumphs and disasters. Her marriage fell

EVA HESSE

apart and her father died, leaving her abandoned once more. But, at the very same time, she started to enjoy great success as an artist. Galleries queued up to show her work, magazine editors waited in turn to run profiles. Her gift was to show us how to see the absurdity of life through the art she made, which reflected the absurdity of her own life. It seems almost inevitable that just as her star was shining at its brightest the tell-tale signs of a fast-growing brain tumour would start. Three times surgeons attempted to remove the cancerous growth, but ultimately it was to no avail. Eva Hesse died far too young, but not before she made a body of work that will live long in our imagination. A body of work that helps us all see the ridiculous, ironic, messy side of life.

Georgia O'Keeffe: Seeing Shapes

Georgia O'Keeffe learnt to describe
in pictures what she found hard to
describe in words. She did it by
reducing what she saw to shapes and
relationships, knowing that fussy
details can obscure the view.

Georgia O'Keeffe is one of those rare artists who
painted her subject with such directness and character
that you can never see it in quite the same way again. Her
painting *Poppy* (1927) is a good example of what I mean.
We know poppies are fragile, wispy flowers with translu-
cent petals that look like brightly coloured tissue paper.
We've seen loads of them by the side of country roads
and in fallow fields on sunny days in June. But ever since
I saw O'Keeffe's painting of a poppy I can only picture
in my mind her sumptuous rendering of the flower, with
its coal-black centre and flaming orangey-red silky pet-
als. Her poppy is more poppyish than a real poppy. That
is because Georgia O'Keeffe didn't merely paint a poppy,
she painted what she felt about it – she captured its very

essence. The artist from Sun Prairie, Wisconsin, incorporated her own feelings for the flower into her painting so successfully she gave it an extra dimension. It is a poppy, plus. A poppy with an emotional aura.

The animal skulls, rock faces, cityscapes and flowers she became famous for depicting all bear the hallmarks of her very particular way of seeing. She made no attempt to paint with forensic precision. Her pictures are not dry facsimiles. Her aim was not to record, but to reveal. To produce a recognizable likeness of a cow's skull or distant mountain range was not enough; she wanted to express simultaneously what it was about them she found attractive or moving. What exactly did she see in a flowering Jimson weed, or a New York skyscraper, or a desert landscape that touched her soul? What were the relationships between colours, line and context that made her sit up and pay attention? How could she authentically reflect her subjectivity while also being true to her subject? These were the philosophical concerns she spent a lifetime exploring.

She realized that to see properly – to perceive beyond the superficial in order to expose the fundamental – required a process of elimination. As an artist, that meant cutting out anything non-essential to get to the heart of the matter. And so, bit by bit, she would gradually strip away extraneous detail, simplifying the visual properties of her subject, and smooth its appearance with flowing lines and curving contours. She focused on form and tone, producing seamless transitions in which planes

overlapped against a flattened, muted background, against which the subject's radiance shone. 'It's as if my mind creates shapes that I don't know about,' she said. 'I can't say it any other way. I can see shapes.' That was the basis of her genius. There should be an app for it.

Her approach to composition was not unlike that of a film director choosing the best shot for a scene in a movie. She would experiment with different angles, with zooming in and out, with cropping to one side, and altering light levels by painting at various times of day and night. And like a director, O'Keeffe understood that less was often more. By painting only a fragment of rock or a section of a flower, she could convey more about the object's inherent qualities than if presented in its entirety. She was, without doubt, a pioneer of perception.

Georgia O'Keeffe was born in the same century Napoleon died, and only 100 years after George Washington became the first president of the United States. Queen Victoria was still overseeing a sprawling British empire, the Ford Motor Company had yet to be founded, and women didn't have the vote in America (she was an early member of the National Woman's Party). She was living in a disrupted world, a world in transition from industrialization to mechanization. Seismic changes were also afoot in the arena of the visual arts. The quick-fix, upstart medium of photography was lobbying for its place on the gallery wall, and the Impressionists in Paris had rewritten the painter's playbook with their sketchy pictures of urban life. Added to this was the prevailing

fashion for the occult and interest in spiritual phenomena, and the popularity of the Symbolists, who argued art should be an expression of an artist's reaction to a subject, not a slavish copy. Feelings and impressions were deemed more important than literal pictorial accuracy: the inner life more interesting than the outer object, which ought to be clothed 'in a sensuous form'.

This was the intellectual climate in which Georgia O'Keeffe was working. She was standing on the threshold of a new epoch in which she would play a leading part as one of the founders of Modernism in America. There was no pre-existing roadmap for her to follow. She had to discover for herself how to produce paintings that captured her sensations in a visible form. What did her emotional or spiritual reaction to a flower or a rock or a sheep's skull actually look like? How could she learn to see outside in and inside out?

She found the answer through two very different teachers. One was Arthur Dow, an artist who had painted with the French symbolist Paul Gauguin, and had learnt the importance of foreshortened perspective as perfected by Japanese ukiyo-e masters such as Hokusai, famous for his *Great Wave*. Having returned to America, Dow took a job at Teachers' College, Columbia University, where O'Keeffe enrolled in 1914, specifically to be taught by him. She had not enjoyed the various art schools she had previously attended, finding them uninspiring and old-fashioned: 'It was all academic,' she said. 'You were taught to paint like somebody else. Made me

not want to paint at all. You paint to paint your own way.' Dow was different. He discouraged copying other artists or bothering with fine details; instead he encouraged his students to express themselves. O'Keeffe said he told her 'to fill a space in a beautiful way', a novel attitude she found exciting and liberating, saying later: 'I had a few things in my head that I never thought of putting down, that nobody else taught me.'

O'Keeffe's second influential mentor was an avant-garde photographer whom she met while studying in New York, where she would routinely visit the city's museums and art galleries with her friend and fellow student Anita Pollitzer. There was one place to which they kept on returning, the trendy 291 Gallery on Fifth Avenue run by Alfred Stieglitz, a photographer-cum-artist-cum-art dealer. He was exhibiting the most radical, cutting-edge work being produced anywhere in the world, including the experimental Cubism of Pablo Picasso and Georges Braque, the Post-Impressionism of Henri Matisse, and his own ground-breaking photography. When O'Keeffe left the city to teach in South Carolina, she went with one eye full of ideas, and the other on Mr Stieglitz.

She made a series of abstract charcoal drawings that owed a lot to Dow and a little to Marcel Duchamp. She sent the images to her old college friend Anita Pollitzer, who was still in New York. Without asking Georgia's permission, Pollitzer took them down to the 291 Gallery to show Stieglitz. He thought they were wonderful, and

just what he had been looking for: an original and authentic contemporary American voice. He began corresponding with O'Keeffe, who willingly wrote back. Soon, their letters took on a more personal tone. He included her early work in a group show at his gallery, and then gave her a solo exhibition in 1917, which had to close early as the First World War proved bad for business. But their burgeoning love affair continued to flourish. Neither minded that he was twenty-three years older than her and married with a child, although one imagines Emmeline, his long-suffering wife, was less relaxed about the situation. Stieglitz wrote to O'Keeffe with an offer to subsidize a year-long stay in New York so she could concentrate on her painting. She accepted and quit her teaching job, moving to Manhattan with the gum on his letter still wet.

They fell in love, Alfred left Emmeline, and in due course they married. Georgia wanted a child, Stieglitz refused. He said it would disrupt her professional progress, but in reality, he was probably still haunted by the post-natal depression his daughter had suffered after childbirth, leaving her with schizophrenia and a life locked up in a mental asylum. Stieglitz couldn't entertain the thought of a similar fate for his young wife, who was not only his protégée and collaborator, but also an exhibitor at his gallery: an artist whose work he held in the highest regard. So much so, he tried not to sell it even though he was her dealer, as O'Keeffe recollected in later life:

He was interested in what I did and I was interested in what he did. Very interested. So much that his favourite word was 'no' . . . to anyone who wanted anything . . . he didn't want people to have anything, he wanted to keep it all. He liked it [her work] and he didn't want to sell it. He tried to keep people from buying. If I had any particular feeling about money we would have been fighting all the time but I didn't care. He'd come home and tell how somebody wanted a particular painting and he didn't want them to have it. And I'd say 'Alfred, you know it'd be nice if I made my living this year.'

What O'Keeffe found harder to go along with was her role as his muse. Initially she had been a willing nude model, but after he held an exhibition containing many of the pictures he had taken of her – several distinctly erotic – she discovered to her dismay that art critics started to attribute Freudian meanings to her paintings. The flowers, they said, were an overt and explicit meditation on female sexuality. That upset her. Even more annoying for O'Keeffe, much of what the critics were saying about her work had been suggested to them by Stieglitz!

Nevertheless, she learnt a great deal from her discussions with her husband about art, and from studying his photography. He encouraged her to apply photographic techniques to her painting, showing her what effects could be achieved by flattening the depth of field, cropping aggressively, experimenting with shadow, removing visual detail and constructing composites. Dow told her

not to copy, Stieglitz showed her how to compose. It is one of the notable aspects of O'Keeffe's art, and maybe a reason it still feels so fresh today around a century later, that her paintings also have a photographic quality.

There was a third great influence on O'Keeffe's art; one that was perhaps of even more importance than either Dow or Stieglitz. And that was her love affair with the American West. It started when she tired of living in Manhattan and always holidaying at Stieglitz's upstate summer house on Lake George. She wanted space to develop her ideas away from lascivious critics and a husband on the threshold of another affair. And so, in the summer of 1929, Alfred went north to Lake George as usual, and Georgia went way out west.

Her first stay was at Taos in New Mexico, a town and a region she immediately felt an affinity for, so much so it is now sometimes referred to as Georgia O'Keeffe country. 'I'd never seen anything like it before but it fitted to me exactly,' she said. 'There's something that's in the air, it's just different. The sky is different, the stars are different, the wind is different.' For the next fifty years she would paint that difference: the ravines and the rocks, the mountains and the rivers of the southernmost area of the Chama River Valley. She'd drive into the wilderness in an old car and paint all day long. When it got too hot, she took shade under the chassis. If it got too late, she'd sleep in the back. The paintings she made out there are some of the finest landscapes produced by any

artist at any time. She brought a modernist's eye to an ancient land, which has been home to the Native American Pueblo people for the last 5,000 years.

Where the more romantically inclined might have been tempted to amplify the sublime scenery with theatrical awe, O'Keeffe made friends with the mighty sights before her and captured the simple beauty of nature's unity. With their soft edges and plump folds, she gave us waves of fleshy brown rock rising and falling together like sand dunes after a storm, smooth and warm to the touch. Behind, in the distant mesa, cooler purples and blues add a crisp note to the melodious baritone of the foreground. There are no over-embellishments in her spare, abstract landscapes designed to reflect a mood, to represent a feeling. 'I seem to be hunting for something of myself out there,' she wrote.

Alfred Stieglitz died in 1946. O'Keeffe spent two years tidying up his affairs, making sure of his artistic legacy, then moved permanently to New Mexico, having spent every winter and spring with Stieglitz in New York. By the early 1970s her eyesight started to fail as macular degeneration set in to such a degree that she could no longer paint unassisted, but she continued to draw. She eventually died aged ninety-eight in 1986, leaving an incredible body of work, much of it at the forefront of art at the time, created because she saw and showed us 'lines and colors as an expression of living'.

Guo Xi: Seeing Harmony

Xi saw the natural world as a source of
refuge, beauty and, above all,
knowledge. Political, societal and
spiritual harmony does not come from
trying to control our environment, but
from understanding and learning from
nature's principles.

Before starting to paint, eleventh-century artist Guo Xi
performed a ritual to prepare his mind and equipment.
He would sit down at a clean table beneath a bright win-
dow, pick out his finest brushes and best ink, wash his
hands and wait until his mind became calm and clear.
Only then would he make his first brushstroke. From
this first mark of ink on silk, Xi allowed his landscapes
to grow naturally as he painted (although he would have
planned the overall composition). Drawing inspiration
from the trees, rivers and distinctive mountains of his
native Henan province, Xi aimed to create detailed and
atmospheric landscapes which observers would not rush
across, but 'in which you may wander, and through which

you may live'. The monumental *Early Spring*, a 2-metre-tall silk scroll signed by Xi and dated 1072, is a landscape in which it is easy to lose yourself. As we wander among the crisp waterfalls and foggy peaks, we stumble across political and philosophical messages the artist hid within the landscape, allowing us to understand how Guo Xi saw the world.

Giving people the opportunity to live among the mountains, if only temporarily, was important to Guo Xi. As a formally trained artist, Xi spent much of his career in the rapidly expanding city of Kaifeng, working as a court painter for the Northern Song emperor Shenzong (r. 1067–85). The longer Xi stayed in the city, the more he came to yearn for the mountains. 'The haze, mist and haunting spirits of the mountains,' he wrote, 'are what human nature seeks, and yet can rarely find.'

The size of *Early Spring* means that, in order to appreciate all 2 metres of the artwork, you have to take your time ambling through the landscape with your eyes. It is customary to read hanging scrolls such as *Early Spring* from bottom to top, a tradition (that remains today) which dates back to the time when large scrolls were not designed to be permanently hung, but instead were kept rolled up in a safe place only to be unfurled on special occasions. Then, the story would reveal itself to the invited viewer centimetre by centimetre as it was unrolled, thus avoiding any plot spoilers that might lie ahead further up the mountain!

Guo Xi designed his painting with this in mind. The

large central mountain subtly invites us to follow its S-shaped curve upwards, letting our eyes trace the streams and paths carved into the rock. As we ascend the mountain, the scenery becomes increasingly sublime. From bare rock and withered trees, we move upwards through misty valleys and waterfalls to the lofty peak of the mountain, covered in trees and rising above the fog. The atmospheric mist draws us in, while the intricate detail encourages us to spend time living in *Early Spring*'s fresh morning landscape. The effect is to transport us into the crisp clean morning air of the mountains, with the steady trickle of mountain water animating our adventure.

Within this natural beauty, Guo Xi placed a political message, as painters of the Northern Song tradition often did. Given Xi's role serving the Emperor Shenzong, it is not surprising that *Early Spring* is highly complimentary to his boss. Xi's son, Guo Si, recorded the meaning behind some of the imagery in his father's painting. He wrote that the towering central peak represents the upstanding emperor, with the lower peak being a reference to his strong and supportive government. The tall pine trees adorning the mountains are an allusion to the important members of Chinese society, and the clouds blanketing the landscape signify good government. The season of spring also seems significant, showing how the emperor and his associates remained resolute through a cold, dark winter period to thrive in an atmosphere of growth and optimism. The

unfortunate withered trees below, however, are those who have not been able to adapt to changes around them, suffering as a result.

The artist wrote that he wanted the mountain to look like 'an emperor sitting majestically in all his glory . . . giving audience to his subjects without any sign of arrogance'. One way he achieved this was to use a technique frequently seen in Chinese landscape painting, floating perspective, to make the mountain look taller and more imposing. It was an effect achieved by depicting the same scene from different viewpoints – an idea Pablo Picasso and Georges Braque rediscovered around a millennium later in 1910s Paris with their multi-perspectival experimental paintings, which led to Cubism.

So, if you look at the bottom third of *Early Spring*, you will see we are given a bird's-eye view, while we are at eye level for the middle section, and looking up towards the highest third of the mountain. Three views in one picture, which not only acted as a storytelling device, but also provided a political message. Looking up towards the peak gives the viewer the impression of the emperor's superiority, remaining out of our reach and rising above the clouds that blanket the rest of his subjects.

As well as complimenting his employer, Guo Xi used *Early Spring* to illustrate his views on social harmony. If you look very closely you will find some people hidden among the natural scenery. Much like the upstanding pines at the mountain's summit and the bare trees at the

base, the human figures are ordered according to their place in eleventh-century China's social hierarchy. At the base of the mountain there are a couple of fishermen in a boat on the right, and on the left is a family with two children carrying supplies towards a house. Higher up, there are three people and a donkey in a valley on the left moving towards their likely destination, a temple complex just above the waterfall on the right of the artwork, probably full of scholars and Buddhist monks.

By including fishermen and spiritual men as part of his idyllic natural scene, Guo Xi is illustrating the Confucian idea of social harmony. For the ancient philosopher Confucius, harmony in society relied on everyone, from the emperor to schoolchildren, recognizing their role and carrying it out as well as they could. Despite differences in social status between scholars and fishermen, they are equally important to the smooth running of society. Just as the peak of the mountain could not rise above the mist without the sturdy base, the emperor could not rule without food provided by fishermen.

Guo Xi's human figures serve another, perhaps more important, purpose: they remind us where we stand in nature's hierarchy. Mountains, trees and waterfalls take centre stage in *Early Spring*, with the tiny depictions of people relegated to shady corners of the landscape. Unlike in European art, where landscapes were often used as backgrounds for human portraits until the sixteenth century, people are not indispensable to Xi's work. Take the humans out and the scene does not fall

apart. The trees continue to grow steadily upwards and the streams continue to flow steadily onwards. No matter how important we think we are, everybody is equally insignificant when placed in the shadow of a monumental mountain. Today, as we struggle to slow and reverse the impact of human behaviour on the natural world, we would do well to remember this point, before Mother Nature steps in to show us how insignificant we truly are.

The use of mountains, rather than people, as a subject became so popular that this genre of ink-on-silk painting became known as Shan Shui, meaning Mountain and Water. The style originated during the Five Dynasties period (907–79), when nature, and mountains in particular, became vitally important to scholars and artists. Amid the political instability of competing states vying for control following the fall of the Tang Dynasty, intellectuals who had served in the Tang imperial court retreated to the mountains for fear of persecution. Finding refuge in Buddhist temples and hermitages, this group of intellectuals reconnected with both nature and Chinese spiritual traditions to produce poetry and paintings inspired by their surroundings. The stability that came with the rise of the Song Dynasty prompted a return to civilization, but Shan Shui remained. The role of reflection and religion in the development of the style means that, as well as cold, hard politics, works such as *Early Spring* provide windows into Chinese spiritual tradition.

In the top right corner of *Early Spring*, just above the mountain, there is a poem. It was not written by Guo Xi, but was added almost 700 years later by the Qianlong emperor, in 1759. The poem contains the emperor's interpretation of the artwork and includes a description of the temple as 'placed on the highest ground where immortals reside'. This matter-of-fact mention of immortals reveals a lot about how mountains were understood in Chinese culture and adds another facet to our interpretation of Xi's work. The artists who retreated to the mountains during the Five Dynasties period did not just find refuge and reflection, but reconnected with spiritual interpretations of their surroundings.

Perhaps most familiar of these principles to those of us outside China are *yin* and *yang*. Mountains became well established as representations of *yang*, the male principle, and water came to embody *yin*, the female principle. The mountain is resolute, solid and strong, representing integrity, while water is dynamic, fluid and adaptive, representing wisdom. The two are complementary and co-dependent; it is the interaction between these two opposites that maintains stability. One cannot exist without the other. Without the mountain waterfalls and rivers cannot flow, while the river's flow helps shape the mountain's surface. Guo Xi mirrors this relationship with his use of black ink and empty space, two complementary opposites which, when carefully combined, create something beautiful.

Mountain and water are so closely intertwined that

Early Spring begins to look like a single living organism. The streams resemble arteries feeding the mountain and there is little differentiation between parts of the landscape, which flow into each other, showing growth and change. Guo Xi's brush technique is crucial in breathing life into his landscape and giving the impression of a world in flux. Xi uses multiple brushstrokes and as many as eight layers of ink to soften the borders of trees and rocks, creating a gradual shift in texture. The removal of the stone's rough surface suggests the warmth and flexibility of a living thing. The spring mist increases this effect, obscuring the boundaries between elements of the scenery and allowing them to melt into one another. Living and transforming, the mountain is the very embodiment of spring, a time of new life, growth and change.

Early Spring is Guo Xi's love letter to the grandeur of nature. Drawing inspiration from the mountains themselves, combined with Confucian, Buddhist and Taoist tradition, Xi created landscapes infused with his unique perspective on the world. The legacy of Xi's art has lasted for centuries after his death, with his rich landscapes and innovative brushwork continuing to inspire artists to this day. Xi saw the natural world as a source of refuge, beauty and, above all, knowledge. Political, societal and spiritual harmony does not come from trying to control our environment, but from understanding and learning from nature's principles. As Lao Tzu, founder of the ancient philosophy of Taoism, wrote, 'Man

models himself on earth, earth on heaven, heaven on the way, and the way on that which is naturally so.' In an age when technological innovations are dragging us ever further from nature, it has never been more important to take the time to wander through our surroundings, appreciating and absorbing as we go.

Peter Paul Rubens: Seeing Politically

Peter Paul Rubens saw what we often
miss: that art matters far more than
we tend to think it does. It is not
merely an entertainment or a pleasant
distraction, it is a potent and
influential form of communication.
Newspapers report on events; great
art shapes them.

Only a fool would underestimate the power of art. There
is a reason totalitarian states incarcerate poets and ideo-
logical extremists destroy sculptures. Art is about the
expression of ideas and ideals, which when done well can
change the way people think and see. Governments
around the world know this. They use art as a sophisti-
cated way of influencing other countries and cultures to
be sympathetic to them and their politics. It is called 'soft
power', and is increasingly seen as a very effective form
of ideological persuasion. Hollywood is more than a
money-making machine for the American studios, it is an
international platform for cultural proselytization. The

same can be said of Britain's state-sponsored exporting of Shakespeare, or South Korea's multi-million-dollar investment in pop music, and China's globe-spanning Confucius Institutes, in which calligraphy and Mandarin are taught. Nations around the world are ever supportive of art and artists, when they are doing approved work, that is. But when the power of art is turned on the establishment, things quickly get nasty.

Paintings affect us. It doesn't matter that they are illusions, our imagination is enough to give them agency. It is an act of willing self-delusion René Magritte, the Belgian Surrealist, made the subject of his famous painting *The Treachery of Images* (1929), in which the text '*Ceci n'est pas une pipe*' (this is not a pipe) appears below a painting of a pipe. Magritte is questioning not only what we are looking at, but also the words used to describe what we are seeing. The word 'pipe' is no more a pipe than a picture of the object. They are both attributions and associations we are making about something that doesn't physically exist in that space: a pipe is neither a word nor an image. Our capacity to convey meaning on to an idea expressed through art and relate to it as if it was real – flinching during a scary scene in a horror movie, or marvelling at the beauty of Michelangelo's sculpture of David – is hard-wired, we can't stop ourselves: it is an uncontrollable urge. When art speaks, we listen.

Hence, those seeking to eliminate a culture do so by destroying its artistic heritage. Books are burnt, statues are smashed, paintings are destroyed. It's been standard

practice across creeds and cultures for millennia. In many ways, art is the meaning of life, or, at least, art gives life meaning. A point not lost on those wishing to crush a culture, nor on those hoping to establish a new one.

Back in the early twentieth century Vladimir Lenin and his Bolshevik comrades needed a visual language with which to express their revolutionary beliefs. Communism required a brand identity. Artists were recruited to the cause, with the likes of Lyubov Popova and Aleksandr Rodchenko coming on board to help create a bespoke new abstract art movement called Constructivism. Their radical geometric designs were so forward-thinking they would go on to inform the aesthetic of Germany's Bauhaus, which in turn led to Modernism, which, ironically, became the defining look of twentieth-century capitalist consumer culture, from the design of BMW cars to the clean-cut lines of the Sydney opera house.

Around 400 years earlier there had been another nascent art movement emerging, which also had socio-political aspirations. Led by the Italian painter Caravaggio (1571–1610), the artists of the Counter-Reformation took on the weighty responsibility of producing paintings of such emotional and devotional potency that they would push back the progress of Protestantism, which had suppressed Catholicism in an attempt to become the leading Christian doctrine in Europe. Rome was shocked by Queen Elizabeth I's anti-Catholic Royal Injunction of 1559 insisting that 'all signs of superstition and idolatry' were eradicated from any place of

worship, 'so that there remain no memory of the same in walls, glasses, windows or elsewhere within their churches and houses'. She recognized the power of art, but then so did the Papacy, which had been successfully deploying its 'soft power' for centuries. In 1545 the leaders of the Catholic Church got together to form the Council of Trent, a strategic forum to respond to the threat of the Protestant Reformation. They hatched a plan to weaponize art. Henceforth, there would be no more stiff and lifeless paintings in the Mannerist style by old bores such as Parmigianino, whose pictures were deemed too intellectual, too self-aggrandizing and too off-putting to the public. Instead, they called for a more popular style based on simple pictorial storytelling (most people were illiterate), focusing on the main Biblical events conveyed with realistic portrayals. You could say that the Catholic Church wanted to go from today's niche European art-house films to Hollywood blockbusters with mass appeal.

Caravaggio set the tone, but died too soon to fill Europe's churches with his dramatically lit Biblical scenes, an overtly theatrical style that would come to be known as Baroque. The mantle was picked up by a very different character from the hard-drinking, short-tempered Italian. Peter Paul Rubens (1577–1640) was a model gentleman from Antwerp, who spoke five languages fluently, had been educated classically, and had spent several years in Italy learning the artistic ropes. His father, Jan, had been a respected Protestant lawyer before becoming the lover

of William I's second wife, Anna of Saxony, which was a career-limiting decision. After a spell in jail for impregnating the King's spouse, he went back to his own wife, who gave birth to Peter Paul in 1577. A decade later the philandering Jan was dead and his now ten-year-old son was brought up as a Catholic.

The maturing Peter Paul Rubens quickly established himself as the go-to artist for royal courts throughout Europe, where his swirling, whirling religious paintings were greatly admired. Even England's Protestant King Charles I – married to the Catholic Henrietta Maria of France – was a signed-up member of the Rubens Supporters' Club, an affiliation that was held against him by the puritanical Oliver Cromwell when later condoning the beheading of the art-loving monarch. One of the doomed King's final sights in 1649 before heading off to the scaffold was the magnificent paintings he had commissioned Rubens to produce on the ceiling of Banqueting House at Whitehall Palace in London. As so often when it comes to the Flemish master, there was more than a hint of propaganda about his glorifying depiction of the apotheosis of Charles's father, James I. The artist was making it clear to all that the English king ruled by divine right.

Charles was fully aware of Rubens's knack for combining art and politics. They first met in 1629, when the artist was sent to England by his patron Archduchess Isabella, governor of the Spanish-controlled Southern Netherlands. The painter from Antwerp didn't arrive

wearing an artist's beret, instead he entered sporting a diplomat's hat. He was on official business as the Arch- duchess's envoy, with the explicit task of encouraging a peace treaty between England and Spain. It was a clever move, backed by the Spanish king, Philip IV. There were very few individuals who would be welcomed into royal courts across northern and southern Europe, where the ongoing arm-wrestle between Protestantism and Cathol- icism meant an almost constant state of conflict between nations. Rubens was that rare beast: a charming scholar who could gently persuade while painting a splendid portrait of the resident monarch. And, if he wasn't win- ning with words, he could always turn to pictures, as he did with Charles I.

Minerva Protects Pax from Mars (1629–30), otherwise known as *Peace and War*, is a classic Rubens painting: a flamboyant masterpiece and a diplomatic message of power rolled into one. It is also an example of northern Baroque at its opulent best, an epic 3m x 2m allegory proclaiming the virtues of peace over the destruction of war. Front and centre is the naked Pax (Peace), to whom Rubens has added the attributes associated with Ceres, Mother Earth. She's squeezing milk from her left breast into the mouth of the infant Plutus, the juvenile god of wealth. They appear blissfully unaware of the argy-bargy going on behind them as Minerva (goddess of wisdom) sends Mars (god of war) packing with a mighty shove and the sort of uncompromising 'you're barred!' stare publicans reserve for known troublemakers. It's enough

to frighten off a Fury (goddess of vengeance) and a nasty harpy lurking in the clouds. With the baddies at bay, the plentiful fruits of peace can be enjoyed by a group of little children – suggesting innocence and wealthy inheritance – who are based on a family portrait Rubens had previously painted for Balthazar Gerbier, the King's Dutch adviser with whom the artist lodged. The presence of Gerbier's young children, whom the King would have quickly recognized, was intended to give the picture a sobering dose of reality. The message is clear, it is their future at stake. With that important point made, Rubens takes a more subtle approach to communicating a broader political message, which is largely delivered through a portfolio of literary sources. A tamed leopard is seen playing with the children, while a hovering putto (a chubby cherub) carrying a short staff with entwined snakes suggests a message from Mercury, alluding to fair dealing and reasonable negotiation. The point is being made: put war aside and you will enjoy prosperity, harmony and peace.

The King was delighted with his gift from Rubens. He knighted the artist-diplomat, who had duly returned to Antwerp in March 1630. In November, Charles I signed a peace treaty with Spain. Job done.

This particular picture – *Minerva Protects Pax from Mars* – is more than an elegant piece of statecraft. It is an exceptional painting. Rubens brought to bear everything he had learnt on his travels across France, Italy and Spain: Titian's lively colours, Caravaggio's

chiaroscuro, Michelangelo's sensuality and – from his own neck of the woods – Pieter Bruegel the Elder's compositional flair. To this he adds his own signature style: the centrifugal whirlpool of movement, the inter-connected poses, the expressive fleshiness of his characters, the dynamic energy of eliding contours, the weight of his figures, the exaggerated gesture and the luminosity of colour.

Notwithstanding its erotic elements and mythical narrative, the painting has a distinct Counter-Reformation feel, with its Baroque sense of the sublime, direct story-telling, and mood of exaltation as good overcomes evil. It was far too 'Catholic' for the dour Protestant Oliver Cromwell, who had signed Charles I's death warrant before taking on the role of Lord Protector, the title of the new republican ruler of England. He was having none of its fancy exuberance and got rid of the painting for a modest £100 at the first opportunity in the 1649 Commonwealth Sale.

For an establishment stalwart with a Stoic's measured outlook on life, Rubens was quite a showman when it came to painting. He was also quite a businessman when it came to making money. He had an art-making factory centuries before the idea dawned on Andy Warhol. Such was his popularity with the crowned heads of Europe that he found himself unable to fulfil all their orders. So he turned one wing of his enormous mansion in Ant-werp into a studio and packed it with assistants to churn out pictures in his name, while he stood in their midst

overseeing their output like a conductor of an orchestra. When time allowed, he'd sit down at his desk and write letters pitching his services, such as the one he had written to William Trumbull, the English envoy at the Court in Brussels, when suggesting he be commissioned to paint the ceiling of Banqueting House: 'My talent is such that no undertaking, however vast in size or diversified in subject, has ever surpassed my courage.' His was the highly lucrative business of making big pictures for big spaces for big money. That was his talent. His gift, though, was for harnessing and appreciating the power of art, a gift he used for the greater good: to promote peace, tolerance and understanding. He is often described as a painter and diplomat, but he was in fact a diplomatic painter with an impresario's spirit who knew art had a higher purpose and that his job was to serve it.

Jean Dubuffet: Seeing Beauty in Ugliness

The idea that there are beautiful
objects and ugly objects, people
endowed with beauty and others who
cannot claim it, has surely no other
foundation than convention – old
poppycock – and I declare that
convention unhealthy.
– Jean Dubuffet

Jean Dubuffet (1901–85) was an artist with strong opin-
ions. The Frenchman thought, for example, that
paintings that attempted to trick the eye by suggesting
pictorial depth were deceitful and repellent. 'It offends
against reason and taste,' he wrote in 1946, adding, 'It is
clumsy and idle.' And with that, he consigned the vast
majority of the Western canon of art – from the time of
Leonardo da Vinci to the present day – to the dustbin.

He was no fan of hard work, either: 'Let us reject tedi-
ous work. It goes against human nature, against cosmic
rhythms . . . It is pleasure and ease, without harshness
and constraint, which create grace in every human

gesture.' So spoke a bourgeois rebel from the comfort of a well-to-do background.

Intellectuals got his goat, too: 'They ape each other marvellously; they practise an artificial Esperanto art tirelessly copied everywhere . . . The intellectual type seems . . . directionless, impenetrable, lacking in vitamins, a swimmer in pap. Empty, without magnetism, without vision.' Unsurprisingly, the surprisingly clever Dubuffet didn't enjoy his time as an art student at the prestigious Académie Julian in Paris: 'It didn't take me long to realize that no education was provided in this academy.' But all these gripes pale into insignificance when compared to his withering disdain for Western curatorial values, most notably embedded in notions of good and bad taste, on which he elucidated in a lecture he gave in 1951 at the Arts Club of Chicago. He called the talk 'Anticultural Positions', a title he explained early on with this assessment:

I, personally, have a very high regard for the values of primitive peoples: instinct, passion, caprice, violence, madness.

He said that the Western world also had the same values but they were obscured by contrived values that promoted a lie, namely that the West was somehow more civilized:

But the values celebrated by our culture do not strike me as corresponding to the true dynamics of our

minds. Our culture is an ill-fitting coat – or at least one that no longer fits us. It's like a dead tongue that has nothing in common with the language now spoken in the street.

Dubuffet criticized contemporary Western civilization for its detachment from reality and nature. He was at pains to attribute the word 'primitive' – an art term then widely used to describe other world cultures – to an arrogant European and American art world establishment with whose dismissive and patronizing genre classification he comprehensively disagreed. He passionately believed that Europe and America had more to learn from those global societies they considered 'primitive' than they had to learn from the Western world.

It could very well be that in various domains, their solutions and approaches, which have struck us as simplistic, are ultimately wiser than ours. It could very well be that we're the ones with simplistic attitudes. It could very well be that they rather than we are characterized by refinement, mental ability, and depth of mind.

He then came to the main thrust of his argument, which centred on the subject of beauty:

For most western people, there are objects that are beautiful and others that are ugly; there are beautiful people and ugly people, beautiful places and ugly ones. But not for me, beauty does not enter into the picture for me.

He considered the Western idea of beauty to be totally misplaced and would not accept the notion that there are ugly people and ugly objects. 'Such an idea strikes me as stifling and revolting. I think it was the Greeks who invented the notion that some objects are more beautiful than others.'

This is Dubuffet's manifesto. He was calling for a new way of looking and thinking based on the belief that 'any object in the world may fascinate and illuminate'. He argued that Western art effectively stopped people from seeing, that it was reductive and detached from real life; that it took the viewer further away from reality and not closer to it. An ancient Greek statue or a painting by Raphael depicting an idealized version of beauty as authorized by the ruling European elite was 'meagre' and 'unintelligent'. Far better, he said, would be to remove the shackles of making 'pleasing arrangements' from artists, thereby freeing them to do what only art can do, which is to communicate, and forcefully evoke, the visible world and our psychological reaction to it as experienced through our 'inner voices'. Painting can enlighten in a way words cannot, he claimed, as it is a more direct and less abstract language.

He went about proving his point with a series of marvellously unflattering portraits depicting friends and acquaintances he'd met among the Parisian literary set. Blandishments were not on his agenda. Nor was painting a conventional likeness. Dubuffet was aiming at something very specific. He said he wanted to capture a

person's 'droll little ballet dances of wrinkles, the little theatre of grimaces and contortions', which he believed would reveal their true temperament. The resulting portraits were unapologetically crude in style, featuring flayed and flattened faces scratched into thick paint like effigies carved into wood. They were intentionally ugly and assertively 'anticultural', in so much as their aesthetic inspiration came from academically untrained artists rather than those adhering to the formal European modes of representation.

Dhôtel Nuancé d'Abricot (1947) was one of around 150 portraits Dubuffet made in 1946–7. It is of the French writer André Dhôtel (looking not unlike your author) wearing a pair of round-rimmed spectacles and a serious countenance. An almost non-existent pair of ultra-weedy shoulders lead to a thin triangular neck that supports a head that appears far too big and heavy for such inadequate support. A few sprigs of apricot-coloured hair sprout out of Dhôtel's great dome, from which his mouth and chin drop down like an elevator carrying a set of teeth to the floor below. His eyes are awkwardly close together, his ears have been chopped off, and his shallow forehead is scored by deep and dense worry lines. He is not what you'd call 'a looker'; nor for that matter were any of the other people Dubuffet painted, a fact the artist mischievously acknowledged when exhibiting them in October 1947 under the title *People Are Much More Handsome Than They Think. Long Live Their True Face.*

On first reading it might seem a flippant title, but soon enough you realize it is serving the purpose of reinforcing the artist's core manifesto: Western notions of beauty obscured the truth, whereas an unvarnished account of someone produced without pretence or forethought could have an extraordinary veracity. Dubuffet is not attempting to make an image that shows the viewer what someone looks like, he is trying to show what the person he is painting *is* like. The artist's firmly held conviction was that visual art was a much more lucid and accurate form of communication than words, either when spoken or when written.

His stylized painting of André Dhôtel was, in his opinion, a startlingly accurate likeness, which he produced from memory, not life, after spending many hours observing the writer. There is no denying that Dhôtel's character is evident. He looks like an earnest chap to me, a little anxious too: an intellectual, for sure. The image has a force that is often lacking in a more traditional portrait. There's no flim-flam with Dubuffet, no pretence, just the essential information to reveal a subject's nature. And, although it is ugly and raw in a traditional western sense, the picture also has its own kind of beauty. There is an urgency and immediacy to the painting that makes it compelling, particularly when compared to a portrait by, say, Auguste Renoir (1841–1919) or Pierre Bonnard (1867–1947), which tend to tell us very little of the people they depict. Dubuffet's approach to portraiture is as different as graffiti scrawled on a wall to the front cover of a glossy magazine.

He admired the unfettered naivety of folk art, and the directness of paintings produced under the influence of a spiritual medium, or while delirious. He felt there was an authenticity in the work of self-taught artists that was absent in paintings by the academically trained. This discrepancy was at its starkest, he argued, when it came to the work made by patients in psychiatric hospitals, which Dubuffet described as 'a very direct and very sincere expression of our real life and our real moods'.

His opinions about the validity of art made by the untrained and the psychotic were initially informed by a book he had come across called *Artistry of the Mentally Ill* (1922), by Hans Prinzhorn. It sparked an interest that became something of an obsession following a trip to Switzerland in the summer of 1945, shortly before the end of the Second World War. Dubuffet took a couple of friends along for company: the writer and critic Jean Paulhan, and an architect named Charles-Édouard Jeanneret – known more widely by his pseudonym, Le Corbusier. They visited the Ethnography Museum in Geneva, where they met the institution's founder, the respected anthropologist Eugène Pittard, and its future director, ethnologist Marguerite Lobsiger-Dellenbach. The two curators showed their enthralled visitors around the museum's collection of Oceanic artefacts, and introduced them to psychiatrists with whom they could meet to see pictures made by their patients.

By the end of the trip Dubuffet was convinced: art made by trained 'professional' artists lacked the impact

and directness of the work produced by the so-called primitive cultures, and those suffering from mental illness. The 'Outsider Art' these underrated artists created was not encumbered by the establishment's dominant codes, and was far better for it, displaying a freedom of expression missing in most Western painting and sculpture. He started to collect paintings by the 'naive' artists he discovered (possibly at rates disadvantageous to them) and decided they deserved to be given an art historical genre of their own, which he called Art Brut:

> Anything produced by persons unscathed by artistic culture, where mimicry plays little or no part (contrary to the activities of intellectuals). These artists derive everything – subjects, choice of materials, means of transposition, rhythms, styles of writing, etc. – from their own reserves rather than from the stereotypes of classical or fashionable art.

As ever with this particular artist, there was a playfulness contained within the title he chose. The word 'brut' when translated into English means 'raw' – as in raw art. But, in this instance, it also had a very specific double meaning for Dubuffet, who had only recently become a full-time artist following a mid-life, mid-war career change made just three years earlier. For the first two decades of his working life he made his living as a wine merchant. Originally, it was in the role of running the family wine business, and then subsequently his own firm. The word 'brut' when applied to wine and

champagne means 'driest' – and is considered by those with a discerning palate to be the most sophisticated style. This double meaning was not lost on the wine connoisseur-cum-artist.

Art Brut became Dubuffet's abiding passion. He collected thousands of examples, so many in fact that he had to ask wealthy friends to provide space in which they could be stored and shown. Today, many of them can be seen in the Collection de l'Art Brut in Lausanne, where the work is treated with the same care and reverence as any other art of significance. The works don't seem so shocking now. Time has tamed them to some extent, while also clouding the all-important context in which Dubuffet established the collection.

It was 1945. The Second World War was yet to end. Millions of people had been killed, cities had been razed to the ground, and countless lives had been destroyed in a merciless period of death and destruction. Jean Dubuffet, like many others, was angry at what he saw as the complete failure of 'civilized society'. How could any society consider itself civilized when its laws, practices and politics could lead to such carnage? And so, just as the First World War gave rise to the Dada movement in 1915, it was now the Surrealists of the early 1930s who sought to destroy a broken old system and replace it with a radical new philosophy for the second half of the twentieth century.

Dubuffet had become friends with André Breton, the founder and leader of the Surrealists, who preached that

we all suppress an unpleasant darkness lurking in our unconscious minds under a thin veneer of politeness. Surrealism was about uncovering our depraved 'inner voices' by making art in a mind-altered state or as an act of improvisation. Only once exposed could we confront the uncomfortable truth of our terrible selves and create the necessary systems to stop us perpetrating future horrific acts. Dubuffet argued that there was a certain beauty in facing the ugly truth, which was the beauty of recognition: he considered his art to be 'directly plugged in to our current life, an art that starts out from this current life that immediately emanates from our real life and our real moods'. This was the ugly beauty Dubuffet was seeking to reveal, a sensational truth we miss altogether by reconstructing a semi-fictional, sentimental interpretation of the world around us.

'I am a tourist of a very special kind,' he said. 'What is picturesque disturbs me. It is when the picturesque is absent that I am in a state of constant amazement.' There is a lot in what he says, which is evident when looking at his portraits or knobbly sculptures. The first response is one of derision if not revulsion. But soon enough their 'inner voices' start to speak – and they tell the truth. A Dubuffet sculpture made of a burnt-out car has a veracity you will not find in an ancient Greek statue of an idealized body. The classical work of art is accepted as beautiful, while the Frenchman's modern piece is seen as ugly. But when put side by side, it is Dubuffet's work that radiates and connects, while the Greek Adonis is petrified.

His portrait of André Dhôtel was made after the glutinous oil paint he slathered all over the canvas had settled like cooling lava. He then added dust, sand and ashes to give extra texture to the surface. Next came a layer of light paint followed by a layer of dark paint and a period of drying to allow the molten mass to form a crust. It was then that he got to work scratching out a face with a palette knife and the wooden end of a paintbrush. He worked like an archaeologist, digging away to find the image below, 'gropings', he said, 'going backwards!' To him, the process was more important than the finished result; it was when in the midst of creation that he felt his ideas were most potent, not towards the end. Dubuffet never classified himself as an Art Brut artist, but he was clearly inspired to make art with a similar rawness and attitude. He could see what they could see, that the only truly beautiful thing in the world is the truth – even if it is ugly.

Conclusion

One of the joys of writing a book is what you learn along the way. While researching the chapters in *See What You're Missing* I was delighted to discover new and fascinating aspects of the featured artists' work. That was to be expected. What came as more of a surprise, however, was that I learnt so much about something I thought I knew about, and that is looking at art! Exploring the idiosyncrasies of each artist's way of seeing has taught me to approach art differently. Instead of prioritizing narrative or meaning or technique when first encountering a painting or a sculpture, I now think first about the artist's point of view. Why does David Hockney choose bright colours and optimistic subjects, while Artemisia Gentileschi painted powerful women with a dramatic single light source? Style, fashion and aesthetics are part of the answer, of course. The main reason, though – as you and I now both know – is down to the individual artist's psychology and lived experience. They are showing us how *they* see, the unique lens through which they observe the world and their place in it. Understanding that is not only the key to truly comprehending their art; it is also an open invitation from them to us to see what we are missing.

It is that aspect of genuine enlightenment that has

been most revelatory for me. I now wake up on a cloudy day with glee, not gloom, having been shown the magnificence of a brooding skyscape by the romantic painter John Constable. If I'm feeling a little down, I think about Agnes Martin sitting alone in her adobe house in New Mexico and wonder how she sat waiting for an optimistic feeling, which then cheers me up. And, when I open a bottle of beer – which is quite frequently – I hold the metal top in my hand for a moment and see it as a dab of 'paint' in one of El Anatsui's wonderful hanging mosaic sculptures.

To have the opportunity to perceive the world through the eyes of artists has been a joy for me, and hopefully for you, too. A pair of glasses might enable us to see better, but a great artist can help us see differently – and that is quite an eye-opener!

Acknowledgements

This book was written largely during the 2020–21 Covid pandemic, a time during which many people put their communities first. Health workers, schoolteachers, shopkeepers, street cleaners, refuse collectors, delivery drivers, virologists, scientists, journalists and countless others helped get us through a time of great uncertainty. Thank you, thank you.

There is a misconception that books are the creation of a single person, working alone, crouched over a desk with a glass of wine next to a keyboard. That does happen – only after 7pm! – but writing non-fiction is far from a solitary affair. This book is the result of a collaboration between many people. It started with a meandering conversation in Covent Garden, London, with Daniel Crewe and Venetia Butterfield, my fantastic publishers at Penguin. The conversation continued with a happy to-and-fro between me and my editors at Viking, Conor Brown and Greg Clowes. Annie Lee joined in when it came to copy-editing, as did Ellie Smith, and Annie Underwood with matters concerning production. They are but a few of the hundreds of people who have contributed to *See What You're Missing*, among whom are all the academics, artists and critics to whose work I have turned during my research. And then there is my dear family, especially

my eldest son, Arthur, who helped research and shape some chapters in the book, and who generously contributed text that I have used unedited.

I would also like to thank my publishers across the globe who have supported me for over a decade, while bringing me the great joy of meeting them and their readers, from Rio to Beijing.

Finally, and very importantly, thank you to all those magnificent enthusiasts who make up the bookselling community. It is their knowledge and passion that brings an author's work to the attention of you – the reader – who, having got this far, I must thank for picking my book up!

Illustration credits

Colour Plates

Inset 2

13. Photo Scala, Florence – courtesy of the Ministero Beni e Att. Culturali e del Turismo; 14. © digital image, the Museum of Modern Art, New York / Scala, Florence © Agnes Martin Foundation, New York / DACS, 2022; 15. Courtesy the Artist, Corvi-Mora, London, and Sikkema Jenkins & Co., New York; 16. © The Estate of Alice Neel. Courtesy David Zwirner, New York / London and Victoria Miro, London; 17. Bridgeman Images; 18. © Tracey Emin. All rights reserved, DACS / Artimage, 2022. Image courtesy Saatchi Gallery, London. Photo: Prudence Cuming Associates Ltd; 19. © Tracey Emin. All rights reserved, DACS / Artimage, 2022. Image courtesy White Cube; 20. Tate / Tate Images © Cy Twombly Foundation; 21. Digital image, the Museum of Modern Art, New York / Scala, Florence © Cy Twombly Foundation; 22. Courtesy of the Artist, Corvi-Mora, London, and Jack Shainman Gallery, New York; 23. Image courtesy of the Kagawa Museum, Japan © The Isamu Noguchi Foundation and Garden Museum / ARS, New York, and DACS, London, 2022

Inset 3

24. Princeton University Art Museum / Art Resource NY / Scala, Florence; 25. Paula Rego, *The Dance* (1988), acrylic on paper on canvas, 213.3 x 274.3cm (84 x 108in), Tate Images © Paula Rego / Courtesy Ostrich Arts Ltd and Victoria Miro; 26. RMN-Grand Palais / Dist. Photo SCALA, Florence; 27. Heritage Image Partnership Ltd /

Alamy Stock Photo; 28. Photo: Abby Robinson, New York © The Estate of Eva Hesse. Courtesy Hauser and Wirth, Private Collection, Boston, MA; 29. Ken Howard / Alamy Stock Photo © Georgia O'Keeffe Museum / DACS, 2022; 30. Pictures from History / Bridgeman Images; 31. Bridgeman Images; 32. Album / Alamy Stock Photo © ADAGP, Paris, and DACS, London, 2022

Index

INDEX